ADOLESCENTS
AND ONLINE FAN FICTION

new
literacies
q

AND DIGITAL EPISTEMOLOGIES

Colin Lankshear, Michele Knobel,
and Michael Peters
General Editors

Vol. 23

PETER LANG
New York • Washington, D.C./Baltimore • Bern
Frankfurt am Main • Berlin • Brussels • Vienna • Oxford

Rebecca W. Black

ADOLESCENTS
AND ONLINE FAN FICTION

PETER LANG
New York • Washington, D.C./Baltimore • Bern
Frankfurt am Main • Berlin • Brussels • Vienna • Oxford

Library of Congress Cataloging-in-Publication Data

Black, Rebecca W.
Adolescents and online fan fiction / Rebecca W. Black.
p. cm.—(New literacies and digital epistemologies; v. 23)
Includes bibliographical references and index.
1. Fan fiction—Social aspects. 2. Literacy—Social aspects.
3. Popular culture—Social aspects. 4. Teenagers—
Books and reading. I. Title.
PN3377.5.F33B53 809.3—dc22 2008006310
ISBN 978-1-4331-0305-6 (hardcover)
ISBN 978-0-8204-9738-9 (paperback)
ISSN 1523-9543

Bibliographic information published by **Die Deutsche Bibliothek.**
Die Deutsche Bibliothek lists this publication in the "Deutsche
Nationalbibliografie"; detailed bibliographic data is available
on the Internet at http://dnb.ddb.de/.

Cover design by Joni Holst
Cover art by Alysha Smagorinsky

The paper in this book meets the guidelines for permanence and durability
of the Committee on Production Guidelines for Book Longevity
of the Council of Library Resources.

Contents

Foreword

It's Getting Ugly Out There. That's the title of CNN political commentator Jack Cafferty's new book (Cafferty, 2007). Certainly the title captures how I and many others feel when we look at our politicians, our policies, and our institutions. It all gets pretty depressing pretty fast.

Cafferty isn't talking just about our schools, but that's where I want to start, and what I say will, indeed, be depressing. But luckily, Rebecca Black's book *Adolescents and Online Fan Fiction* will "un-depress" you. It will tell you that if you don't look at our politicians, policies, and institutions and look instead at our global kids, things look a good deal brighter.

Many policy makers and even much of the public think schools are all about preparing future workers. It is not uncommon today to hear that our schools are designed to produce workers for an industrial economy that no longer exists. At the same time, we are told that our schools are ill-equipped to produce workers who, it is said, need high technical skills fit for the global world and will engage in "knowledge work."

This story is too simple. We all very well know that our global economy produces a massive number of poorly paid service jobs and a much smaller number of highly rewarded jobs that leverage professional knowledge or engage in the design of new products, services, and markets (people who Robert Reich [1992]), former Harvard professor and Clinton's Secretary of Labor, calls "symbol analysts").

Our current back-to-basics, skill-and-drill, standards and accountability, punish and perish schools to me seem to be doing an ideal job of producing students fit only to be service workers. Elite students can find pockets of privileged schools, private and public, where they can gain higher-order skills to track them to elite colleges and, perhaps (see below), rewarding careers in the global economy. However, big problems loom. First of all, even elites are not safe in our global world. Thanks to a global economy in which scientific knowledge and technology has spread everywhere, many jobs that require only standard skills are fast becoming "commodity jobs." Commodity jobs—whether low status (e.g., call center operators) or high (e.g., engineers, computer scien-

tists, or radiologists)—require standard skills that can be taught and carried out in any developed or developing country across the globe.

Just as modern technology has allowed commodities like cars to be produced anywhere across the globe and produced more cheaply outside the United States than in it, so, too, it is more cost effective to train and carry out such commodity jobs in developing economies like India and China than it is in high-cost centers like the United States. The result is that countries like the United States—countries with higher wages—will not long be able to compete in a global economy on the basis of such jobs and such skills (Friedman, 2005).

To survive in this new world, the United States will have to move up the "value chain" and produce more people who can do work centered on innovation and creativity. We will need to stress flexibility, innovation, creativity, and breaking the mold—things on which we have historically prided ourselves, but which are, indeed, today in short supply in our schools. Unfortunately, at a time where to be competitive U.S. students must begin to "major" in innovation, creativity, and problem solving, not just in passing paper-and-pencil tests of factual knowledge, our students are majoring in test preparation.

Our national response to global competition and the innovation crisis has been to push "STEM": more courses and more teachers in science, technology, engineering, and math. The arts, the humanities, and the social sciences can be damned. Alas, this response is based on a profoundly outdated idea that the humanities and technology, and the arts and science are radically separate enterprises. But in the world we actually live in, more and more art forms use highly technical digital tools and more and more scientific and technological areas use graphic arts resources. In fact, at the university, I regularly work with artists who are more tech savvy than scientists.

In a global age where we all live in the midst of many high-risk complex systems, scientific reasoning needs to be married to sound policy thinking, deep ethical insights, and keen understandings of the human condition that are key goals of the humanities and the social sciences. Furthermore, "design" is a core skill for the twenty-first century—design of new social, institutional, and economic ideas, products, and systems—and such design thinking almost always requires melding technological, scientific, social, and artistic ways of thinking and doing (Gee, 2007).

It is a nonstarter to think we are going to get innovation and creativity by moving our test prep curriculum to science, math, and technology. It is equally a mistake to think STEM is by itself a source of innovation and creativity.

As we rush to STEM, as we seek innovation and creativity, we still face our long-standing "reading crisis"—the fact that poor kids learn to read much less well than more well-off kids. The No Child Left Behind legislation was a mas-

sive federal investment in early reading instruction, meant to close the reading gap between rich and poor students, and between some minority groups and white students. It was a large part of what gave us test prep as a curriculum.

But the gaps have not closed. While many states lower standards to make themselves look good in the testing game, National Assessment of Education Progress (NAEP) scores show little real progress in reading by U.S. students, rich or poor. Results from the 2007 NAEP—the nation's "report card"—shows some progress in math at fourth-grade, but little or no progress at eighth-grade math or reading at any level. Gaps are either not closing or doing so only very slowly.

Both proponents and advocates of No Child Left Behind legislation agree that progress needs to improve dramatically, though they disagree on how this can be done. The United States' poor performance in international assessments on mathematics and science is particularly bothersome in a world where science, technology, and mathematics will be crucial for innovation and tackling the global world's often dangerous and complex problems, though, as I have pointed out, not when they are divorced from the arts, humanities, and the social sciences.

Of course, as we continue to struggle with the enduring reading crisis in school, we live in an age of digital media. And with the advent of digital media, we enter an era in which we now face a new "gap" to go with our old reading gap: a digital gap, a gap not just in access to technology, but in how much academic learning different sorts of children gain from encounters with digital media. It is becoming apparent that simply having access to digital media for learning does not narrow achievement gaps. In regard to both traditional literacy and newer digital literacies, what is crucial for learning is access not only to books or digital tools, but also to support, community, and mentorship of certain sorts.

In a recent study of high-end computers and good learning software placed into libraries in economically diverse communities (Neuman & Celano, 2006), it was found that well-off families went to the library with their children and mentored them to read at or above their reading levels, to challenge themselves, and to sustain their engagement with particular learning activities, and to do so in reflective and strategic ways. Less well-off families engaged much less in such mentoring. In such cases, digital media—much as print literacy—can make the "rich richer and the poor poorer."

The No Child Left Behind legislation and our test prep curriculum have had one major effect: to fuel the "fourth-grade slump," the well-known phenomenon whereby children who appear to be learning to read in the early grades—and who pass their reading tests—cannot read well to learn content at

fourth grade and beyond (Gee, 2004). By fourth grade both talk and texts in school get much more complex as students must learn content couched in "academic language." Victims of the fourth-grade slump were not taught to read to learn; rather, they were taught to read just to pass a reading test and often a dumbed down one at that.

So gaps and crises everywhere: the old reading gap, the new digital media gap, the innovation crisis. But it gets worse. Let's return to the fact that in a country like the United States the global economy demands and the schools supply a great many poorly paid service workers. Surely we are going to face an immense problem when the majority of people find themselves in jobs where they are poorly paid and can gain little status in a country where wages and status are both tied to markets that offer little of either to most workers. People want and need to have status and to feel control, and markets in our global world cannot supply either of these to most people. A service economy is not going to produce a lot of people with a real investment in their society.

You may have noticed, too, that the United States is now full of people whose native language is not English. It is also full of people who are bothered by the fact that many of these nonnative speakers are not learning English as well as the bothered people would like. The bothered people, however, keep passing laws that mandate that beginning readers learn to read in English, not their native language, early in school, despite the fact that research shows beyond any doubt that if children learn to read first in their native language, this learning transfers to and facilitates learning to read in English. This is most certainly true in the case of Spanish, a language written in a form that greatly facilitates learning to decode, something that English writing does not do.

The bothered people also keep mandating ESL classes in school—classes that often become stigmatized ghettos and a fact that ensures English is not learned well, most certainly not academic English. However, we can mention, too, that those who are bothered about nonnative English speakers not learning English well enough are not bothered themselves to learn another language in a global world where the United States is economically, entrepreneurially, and militarily disadvantaged by its failure to know anyone else's language (would that someone learned Iraqi Arabic before invading Iraq).

So, what a mess! *It's Getting Ugly Out There.* However, there are some rays of hope, but they're not shining at most schools. At the same time as our schools are dumbing our kids down, many children, poor and rich, encounter complex specialist language and demanding problem solving in some of their popular culture activities. In video games like *Civilization* or card games like *Yu-Gi-Oh*— and many other such activities—young people encounter language that is as

complicated as anything they see in school and often must engage in complex and strategic systems thinking and problem solving.

For example, consider the technical and logical language in the following definition written on an Internet board discussing *Yu-Gi-Oh*. *Yu-Gi-Oh* is a card game played via video games or face-to-face and depicted on Web sites and in books, movies, and television shows. Children as young as seven play it. The site is meant to answer questions players have about the game:

> **Amplify** (Onslaught) - Amplify X means When this creature card is summoned, reveal X creatures of the summoned creature's creature type(s). If you do, put X times N+1/+1 counters on that creature (X = Amplify X. N = Number of revealed creatures).
>
> (http://www.pojo.biz/board/showthread.php?t=15266)

No dumbing down here. Any kid who can read this has the linguistic skills needed to read his or her textbooks in school. The trouble is—as I will point out in a moment—*Yu-Gi-Oh* is organized for learning in a much better way than are our textbooks and the pedagogies we build around them.

Digital media hold out the potential to enhance learning fit for our global world. Digital media's main source of promise for learning resides in their ability to "situate" meaning, to show people what words and symbols mean in ways that make them useable for problem solving (Gee, 2004). Oddly enough, we can see excellent examples of how this process works if we look at *Yu-Gi-Oh*. Each card in the game—and there are 10,000 of them—has a complex, technical written description on it that tells the player just what role the card plays in the game, relative to specific situations in the game. Furthermore, players can look up rules and settle disputes by going to Web sites (like the one above) that recruit complex language and thinking.

However, each word and phrase on the cards and Web sites is associated with explicit actions the player takes in the game; with images the player sees in games, in books, and on television shows and movies; and with rich dialogue the player hears and reads as part and parcel of the player "community of practice" tied to game play in different contexts and to Web sites where the player interacts (with no real age-grading) with players of all different skill levels, including mentors and masters.

Yu-Gi-Oh is a classic example of what Henry Jenkins calls "media convergence." Different media, digital and nondigital, and the real world meld together to support a single focus, often one where everyday people become experts.

There are, for the most part, no "official" teachers in *Yu-Gi-Oh*, though you can go to Web sites to get explicit instruction and kids often give explicit instruction to newcomers. But there is constant teaching from lots of different sources and in lots of different settings, including in-game and out-of-game on

Web sites, shows, and books. Language—quite complex language—is rendered completely lucid, because it is so clearly tied to action, interaction, images, and dialogue as well as to many different types of texts.

Yu-Gi-Oh and other popular culture practice show us effective ways to organize learning and knowledge building communities. But, of course, we have to begin to build such learning communities in areas we value. Rebecca Black's new book, *Adolescents and Online Fan Fiction,* will show you, up close and personal, kids using digital tools to learn to write and to learn English in rich and varied learning communities organized in cutting-edge ways for effective and deep learning. The skills these kids pick up are already, in many respects, school-based. Furthermore, how they interact to learn has profound implications for how we ought to organize school learning in the twenty-first century when we finally get ready to break the mold.

These kids are getting status and gaining productive control over their own learning, but not in any market. For the most part, they pay nothing and they charge nothing. They are training for participation, not jobs and certainly not service jobs. They are learning English and keeping or gaining a heritage language, as well, for a global world. They read and the write with passion. No reading gap here. And they learn to obey the laws of genres, even as they seek and honor innovation and creativity. They become global citizens. They are tech savvy to boot. It is, indeed, getting ugly out there, but Rebecca Black will take you to one of the many places today where antibodies are fast forming to the ugliness. Politicians beware.

James Paul Gee
Mary Lou Fulton Presidential Professor of Literacy Studies
Arizona State University

References

Cafferty, J. (2007). *It's getting ugly out there: The frauds, bunglers, liars, and losers who are hurting America.* Hoboken, NJ: John Wiley.

Friedman, T. (2005). *The world is flat: A brief history of the twenty-first century.* New York: Farrar, Straus and Giroux.

Gee, J. P. (2004). *Situated language and learning: A critique of traditional schooling.* London: Routledge.

Gee, J. P. (2007). *Good video games and good learning: Collected essays on video games, learning, and literacy.* New York: Peter Lang.

Neuman, S. B., & Celano, D. (2006). The knowledge gap: Implications of leveling the playing field for low-income and middle-income children. *Reading Research Quarterly*, 41 (2): 176–201.

Reich, R. B. (1992). *The work of nations.* New York: Vintage Books.

Preface

As a child, I desperately wanted to be a writer. I remember the fear and uncertainty of putting my thoughts and feelings into words on paper and then sharing this textual self with others. I remember watching my parents and friends read my stories and distinctly recall how a raised eyebrow, a frown, a tug of the lip could be excruciating if they came at the wrong point in the story. I desperately wanted to be seen as as a legitimate *author* who had important and meaningful things to say. The various books and media that I was engaged with at the time served as a primary resource for my writing. I mined these texts for characters, settings, and sometimes plots and then infused them with the ideas and issues that were meaningful in my young adult life. These texts were hybrids—mixtures of real life and media scenarios—and not really recognizable by many of the standard genres and formats for writing that were taught in my English classes; so, it's not altogether surprising that parents, teachers, and friends found many of these texts to be puzzling and at times amusing.

It wasn't until graduate school, when I began working with a research group exploring youths' online literacy practices, that I realized I was not alone in creating these media-based texts. In fact, they even had a name: *fan fictions*. Fan fictions are fan-created texts that are based on forms of popular culture such as books, movies, television, music, sports, and video games. Though such texts are derivative in the sense that they depict available images of popular culture, I argue that the fans producing these fictions are far from being "mindless consumers" and reproducers of existing media, as they actively engage with, rework, and appropriate the ideological messages and materials of the original text (Dyson, 1997; Jenkins, 1992). The fans described in this book draw on available media to engage in a wide range of innovative and sophisticated literate practices, such as creating robust characterizations, developing new histories for characters, and/or generating alternate settings and plotlines that are not present in the original media, to name just a few.

Although fan fiction in its various print-based forms has existed for an indeterminate amount of time, the advent of the Internet has had a profound effect on the scope of the genre, as it has enabled large numbers of fans from

across the globe to meet online to share and take part in substantive discussion of fictions produced online by their peers. Online fan fiction is now a ubiquitous literacy phenomenon that is difficult to overlook. There are hundreds of thousands of online Web sites devoted to fan fiction based on every media genre available. Moreover, these fictions are being written, read, and discussed by youth from across the globe. With the rapid proliferation of networked information and communication technologies (ICTs) and online youth spaces, there is a need for literacy educators to become acquainted with and potentially integrate elements of adolescents' out-of-school literate practices and existing technological competencies into classroom instruction and activity. In such a spirit, this book attempts to further our knowledge of youths' informal learning and literacy activities through an account of writing and socializing in online fan fiction spaces.

The first part of the book, Chapters 1, 2, and 3, provides an in-depth introduction to the research context as well as to the theoretical and methodological underpinnings of the study. The first chapter introduces three topical phenomena—anime (Japanese animation), manga (Japanese graphic novels), and fan fiction—in terms of historical background, existing research, and literacy-related fan practices. These three phenomena provide particularly salient examples of how new ICTs have led to the development of literacy and social practices that traverse traditional geographic, linguistic, and producer-consumer boundaries. Moreover, they illustrate how new ICTs have facilitated the global dispersion of a range of fan-produced cultural and intellectual products via circulation in online communities. After providing a review of existing research on these phenomena—research that primarily is guided by historical timelines, rooted in isolated fan communities, and directed at adults—the chapter turns to the surprisingly small number of studies of school-age fans' literacy and social practices surrounding online fan fiction.

The second chapter draws from a range of perspectives in literacy, media, and cultural studies to establish a framework and rationale for studying the informal learning and literacy practices that youth are engaging with in out-of-school spaces. This chapter also describes some of the particularities of online ethnography and ethical considerations in Web-based research that are relevant to this study. The third chapter offers a robust exploration of the primary research context, *FanFiction.net* (FFN), which is the largest online multi-fandom fan fiction archive on the Web. By conceptualizing FFN as an affinity space—a site that is organized around a common passion or endeavor—the chapter demonstrates how certain paradigmatic features of affinity spaces affect youths' access to and levels of affiliation with literacy activities on the site. Discussion in this chapter emphasizes how the highly networked structure and communica-

tive nature of FFN, coupled with the popular cultural subject matter, potentially contribute to powerful forms of learning in this space.

The next part of the book, Chapters 4, 5, and 6, presents empirical analyses of adolescent English language learners' (ELLs') literate and social practices in the fan community. Chapter 4 explores how three different ELL youth use their participation on FFN to socialize and represent their identities in unique ways. Analysis also focuses on how each of these young women uses fan fiction texts to create narrative and social spaces that afford each of them opportunities to use their existing linguistic skills in ways that further their literacy development and that suit their needs as individual language learners. The fifth chapter presents a more detailed case study analysis of one of the young women introduced in the preceding chapter. Drawing from constructs in Second Language Acquisition and literacy studies, analysis describes how networked ICTs and fan culture provide this particular ELL youth with a site for developing an online identity as a popular multiliterate writer. Analysis also highlights how popular culture and technology converge to provide a context in which this English learning youth is able to develop a powerful transcultural identity that is discursively constructed through the distinct cultural and linguistic perspectives that she and other fans from across the globe bring to this space.

While previous chapters primarily emphasize the writing and social practices of participants on FFN, Chapter 6 shifts the focus to forms of peer review and editing in the community. Specifically, analysis explores the dialogic interaction between authors and readers in order to understand how the digital review process scaffolds nonnative speakers' development of English language and composition skills. In addition, this chapter examines how the immediate nature and forms of feedback offered via FFN helps to emphasize the highly social nature of writing and foregrounds the importance of feedback from peers, colleagues, and expert others in the composition process.

The book concludes with a discussion of the changing nature of literacy and learning in the twenty-first century. Operating from the premise that traditional, print-based forms of literacy are necessary but no longer sufficient for effective participation in a network society, Chapter 7 explores the digital skills and forms of literacy that are increasingly valued in modern academic, work, and leisure spaces. Discussion is based on a juxtaposition of the sort of skills and abilities that youth are acquiring in online spaces such as FFN and those that are valued in many traditional composition classrooms.

Many of the fan writing, reading, and learning practices described in this book are aligned with issues that language and literacy educators have grappled with in their pedagogy for years. This includes issues such as how to provide ELLs with opportunities to use their first languages for authentic and meaning-

ful purposes, how to create learning environments in which students feel comfortable enough to take risks while interacting in English, and how to recognize the multiple linguistic and cultural resources that students bring to classroom learning activities. Through such an exploration, this text aims to provide not only an understanding of the sophisticated out-of-school literacy activities that youth are already engaging in but also some initial insights into how such digital modes of communication and publishing might serve to promote learners' access to and affiliation with composition in areas that many school-based literacy programs have not succeeded. Moreover, the study of indigenous online writing sites such as FFN can yield useful insights into how technology and students' out-of-school interests might be used to develop classroom affinity spaces where all students are engaged in activities that promote authentic uses of and learning through language and technology.

Acknowledgments

First and foremost, I would like to extend my heartfelt thanks to the young women who were kind and brave enough to share something as personal as their writing with me. This project would not have been possible without their artistry and insights. ^_^

Next, I would like to express my gratitude to Jim Gee and Donaldo Macedo for their wisdom, humor, support, and for always giving me something new to think about and aspire to. Thank you also to Mary Louise Gomez and Martin Nystrand for helping me to look at this project from new and interesting perspectives. I would also like to thank my friends and colleagues at the University of Wisconsin, Madison—Annie Allen, Cassie Cleverly, Katie Clinton, Heidi Hallman, Kelly Hatch, Betty Hayes, Amy Johnson, Kerrie Kephart, Alice Robison, Kurt Squire, Constance Steinkuehler, and Jennifer Stone, as well as Eva Lam at Northwestern University—who provided invaluable insight and support during this study. I would also like to thank my colleague Bill Tomlinson at the University of California, Irvine, for taking the time to read and provide feedback on this manuscript. I am also very grateful to Henry Jenkins, the guru of fan communities, for sharing his wisdom about fandom with me. I am also indebted to Colin Lankshear, Michele Knobel, and Donna Alvermann, not only for their inspirational research, but also for their inspirational ways of being in the world.

It is also important to mention that the generosity of the Spencer Foundation supported part of this study. Portions of this book derive in part from some of my previous publications. These include: "Digital Design: English Language Learners and Reader Reviews in Online Fiction" from *The New Literacies Sampler* and "Language, Culture and Identity in Online Fanfiction" as well as "Fanfiction Writing and the Construction of Space" from *E-Learning*. The wonderful cover art for this book was done by Alysha Smagorinsky (http://starchanchan. deviantart.com; star_karashii@hotmail.com). I would also like to thank Sophie Appel and Chris Myers at Peter Lang for their help during the production process.

And last but certainly not least, I would like to thank my family for their love and support—Jill, Nick, Sabrina, and Michael, who helped me find this path; Jennifer, who has provided infinite wisdom; my aunt Linda, who allowed me to tag along in her ESL classes; my father, Tom, who taught me perseverance; my mother, Anne, who taught me to speak my own truth; and my unforgettable grandmother, Anne Ward, who was always my biggest fan.

Anime, Manga, and Fan Fiction

New Media and Literacy Landscapes

Recent scholarship across a range of academic disciplines has started to explore the contours of a media and cultural landscape that are in constant flux as a result of new information and communication technologies (ICTs) that allow for traversal across temporal and spatial boundaries (Leander & McKim, 2003; Leander & Sheehy, 2004), traditional linguistic and cultural borders (Lam, 2006; New London Group, 1996), and also across long-established divisions between producers and consumers of intellectual property (Jenkins, 2006). Such scholarship underscores the importance of attending, not only to the nature of new technologies and tools, but also to the uses within and across networked life spaces that these new media and tools are being put to. A robust understanding of these digital technologies situated in youths' authentic everyday practices is necessary if we, as educators and researchers, aim to successfully engage new generations of students that are entering, currently attending, or indeed are dropping out of schools with "mindsets" (Lankshear & Knobel, 2003) that in many ways are in direct opposition to the mindsets underpinning traditional systems of education.

New Literacy Studies scholars (New London Group, 1996) have pointed out that many schools still operate from a mindset rooted in the Industrial Revolution that is "forged in physical space" and organized around the production of material goods (Lankshear & Knobel, 2003). Contemporary students, however, are entering classrooms with a mindset that is "forged in cyberspace" and organized around the production and distribution of information and various texts, including traditional print documents, graphic arts, spoken and embodied language, and other forms of online and post-typographic communication (Castells, 1996; Lankshear & Knobel, 2003). Most students today are accustomed to active participation in such information-based economies, where graphic art and online publishing software enable new forms of semiotic engagement and symbolic manipulation of media. For example, Lankshear and Knobel (2003, 2006) review a range of new literacy practices related

to *remixing* or the "practice of taking cultural artifacts and combining and manipulating them into a new kind of creative blend" (Lankshear & Knobel, 2006, p. 106).

Common types of remixes might include music videos that consist of a "blend" of popular music, images culled from real life, and/or cuts or stills from television or movies; *machinima* created through a blend of music and video game recordings; and *memes* fashioned by combining pop cultural materials with mainstream media images or text as a means of drawing from existing messages to "redesign" (New London Group, 1996) and create new information and meaning. As Lankshear and Knobel point out, remixing has arguably become a common "writing" practice for a number of youth who frequent online spaces (Lessig, 2005, as cited in Lankshear & Knobel, 2006). Many such youth are also well versed in new ICTs such as video and imaging software, synchronous chatting, voice-over-Internet-protocol (VOIP), webcams, avatars, blogs, and an array of social networking, forums, and Web sites that make possible the sort of public performance of self that provides social and intellectual cachet in today's multicultural, multilingual, and multitextual networked spaces.

This chapter introduces three topical phenomena that are central to this book, *anime* (Japanese animation), *manga* (Japanese graphic novels), and *fan fiction* (fan-created texts that are derived from popular media), in terms of historical background, content, existing research, and related fan practices. These three phenomena provide salient examples of how new ICTs have led to the development of literacy and social practices that traverse accustomed national, cultural, linguistic, temporal, and producer-consumer boundaries. Moreover, they illustrate how new ICTs have facilitated the global dispersion of a range of fan-produced, cultural and intellectual products via circulation in online communities. The chapter begins with a general introduction to the development and history of anime and manga and an overview of the artistic and generic characteristics of these media. This introduction is followed by a review of anime- and manga-related research—research that primarily is guided by historical timelines, focused on generic content and audience reception, and directed at adults. The focus then shifts to research devoted to fan activities surrounding these media, ultimately narrowing in scope to emphasize the small amount of work that explicitly addresses how school-age fans are integrating these media into their daily social and literate interactions.

Interestingly enough, as the latter portion of the chapter details, one of the most salient ways that anime and manga have been integrated into school-age fans' lives is through the production of online anime and manga-based fan fiction. Moreover, research on fan fiction has followed a similar trajectory to that of anime and manga studies—with primary foci being genre, audience reception

(and production), and adult fans. After a brief review of adult-oriented fan fiction studies, the chapter then turns to an emerging body of work that explores *school-age* fans' literacy and social practices surrounding online fan fiction.

More Than Just Cartoons

Japanese Anime and Manga

Neither anime, which originated in Japan in the early twentieth century (1915/17) (Clements & McCarthy, 2001; Napier, 2001; Patten, 2004), nor its graphic counterpart, manga, which has been traced as far back as the "sequential storytelling" picture scrolls from medieval Japan (Ito, 2005; Pandey, 2000), can be held up as novel in terms of the chronological development of "new literacies." The term "manga" is purported to have been coined at the start of the nineteenth century with Katsushika Hokusai's multicolored woodblock prints (Ito, 2005), and over time the medium has become ubiquitous in Japanese culture. Contemporary manga genres (these categories apply to anime as well) address markedly diverse target audiences and can be broadly categorized as follows: *josei/redikomi* manga, which are, as a rule, created by female artists and feature the daily aspects of Japanese women's lives, and *seinen*, which are generally created by and for men with texts ranging from horror to war stories to mild pornography. Other types include the whimsical and fantasy laden *kodomo,* which is intended mostly for children, *sh jo* for young females with its romantic themes and strong magical girl characters, and the high action *sh nen* for young and teenage boys (Ito, 2005; Wikipedia, Anime, 2005). In Japan, manga also encompass an array of informative texts ranging from government-produced pamphlets on the economy to instructional texts on home or auto repairs (Ito, 2005). The relatively low manufacturing costs and flexibility of the medium allow for creative experimentation across myriad landscapes, character styles, and artistic techniques and facilitates the expression of all types of information in a widely accessible format (Napier, 2001).

While short animated films were produced throughout the early twentieth century in prewar and postwar Japan, the manga-influenced productions that most of us associate with contemporary anime began decades later with the release of Osamu Tezuka's *Tetsuwan Atomu (Astro Boy)* in Japanese theaters in 1963 (Leonard, 2004). Whereas the cartoon industry in many countries confined the medium mostly to the realm of child-fare, comedy, and action hero adventures, as anime scholar Gilles Poitras (1999) points out, "the Japanese have been using anime to cover every literary and cinematic genre imaginable" (p. viii) for years.

Prevalent genres of anime vary across the sexually explicit *hentai*, to the highly popular *science fiction* productions and its subgenres of *mecha* or giant robots, *cyberpunk* with its dystopian representations of the ills of corporate greed and technology, and the quasi-historical *steampunk* (Ito, 2005; Wikipedia, Anime, 2005). Anime genres also include biting humor, heart-wrenching drama, historical samurai-era productions, and sports-inspired shows, to name just a few. Characterized by its vibrant colors, fine lines, and the exaggerated expressions of its characters, Japanese animation has attracted the worldwide attention of fans and researchers alike as an alternative to the sort of commodified and child-oriented narratives that dominate the animation market in many other countries (Napier, 2001).

Manga and anime have become some of Japan's most important cultural exports (Napier, 2001). Achieving international reach, these media have been translated into many languages in countries across the globe, including China, France, Germany, Italy, the United Kingdom, Spain, and the United States (Ito, 2005). Outside of Japan, the United States is one of the largest markets for anime (Napier, 2001; Patten, 2004), as anime offers many fans an alternative to American animation monoliths such as Disney. In recent years, Japanese animation and manga have made a conspicuous return to mainstream media space in several countries with popular children's television *sh nen* genres such as *Pokémon, Yu-Gi-Oh!, Ranma 1/2,* and *Dragonball Z,* and *sh jo* genres such as *Sailor Moon, Card Captor Sakura,* and *Inuyasha.* Major motion pictures such as the blockbuster hit *Spirited Away* and other popular films such as *Princess Mononoke, Castle in the Sky, My Neighbor Totoro,* and *Kiki's Delivery Service* have brought the stunning graphics, complex themes, and often whimsical nature of *kawaii* or "cute" culture (Allison, 2004) and the fantasy genre into the twenty-first century spotlight.

Manga and Anime Research

Although manga and anime are often derided for being violent and pornographic, or dismissed as being child-fare, manga and anime scholars, aficionados, and fans concur that these media are far more than just cartoons. Anyone who has watched a significant amount of anime or read enough manga must at minimum cede to these media a wealth of complex, believable characters, intricate narrative structures, and many themes that address the light and dark aspects of the human condition. To date, scholarship has examined anime and manga primarily in terms of existing genres and past trends, artistic characteristics, and in relation to the social and historical contexts of production of these media. Identifiable categories of academic writing include introductory

works that offer historical, cultural, and thematic overviews of both manga (Schodt, 1983, 1996) and anime (Drazen, 2002; Levi, 1996; Poitras, 2001) in relation to specific series and/or the work of individual creators/artists (Ledoux, 1997). In addition, the "explosion" (Drazen, 2002) of anime in recent years has inspired some scholars to expand readers' knowledge about anime via exposition on the cultural and historical significance of objects such as "historical personages, organizations, corporations, [and] gestures" that are found in and across different genres of anime (Poitras, 1999), or through broad surveys of and guides to the numerous anime and manga series produced in the past several decades (Clements & McCarthy, 2001; Ledoux & Ranney, 1997; McCarthy, 1996; Pelletier, 2000).

Susan Napier (2001), a well-known name in anime research and Japanese studies, uses a cultural and literary lens to examine how anime might move audiences to consider contemporary issues in Japanese society in ways that older art forms may not be able to. She explores the unique narrative and aesthetic qualities of contemporary anime in terms of characteristic modes such as the *apocalyptic* (end of the world), *elegiac* (melancholy or nostalgia), and *festival* (play or ritual) that reflect the complex and sometimes conflicting cultural backdrops of historical and modern Japan (Napier, 2001). Other scholars have also examined the apocalyptic in these media in terms of representations of disaster (Napier, 1993), war, and the bombings of Hiroshima and Nagasaki (Crawford, 1996; Freiberg, 1996). Many studies also focus on issues such as ideology (Kinsella, 1998, 2000; Morris-Suzuki & Rimmer, 2002; Napier, 2001; Newitz, 1995), gender representation (Fujimoto, 1991; Grigsby, 1998; Ito, K., 1994, 2003; Ledden & Fejes, 1987; Napier, 1998; Ogi, 2001; Orbaugh, 2003; Shiokawa, 1999), sex (Napier, 2001; Perper & Cornog, 2002), and the representation of sexuality (Matsui, 1993; McLelland, 2000a, 2000b; Sabucco, 2003) in anime and manga. Also, recent work is beginning to address these media in terms of their global spread as pop culture (Grigsby, 1998; Lai & Dixon, 2001), the broader topic of Japan's place within global flows of information in the twenty-first century, and the complex and multimodal literacy practices used by college students reading manga (Allen & Ingulsrud, 2003).

Although these studies focused primarily on adult anime and manga, they highlight the sophistication and complexity of these "cartoons" and work toward establishing their legitimacy as media productions that are worthy of increased academic attention as their popularity and mainstream visibility grow. In addition, such broad surveys and in-depth explorations of these increasingly popular media genres have relevance for literacy education in that they provide insight into the sort of generic conventions and narrative structures that students are becoming familiar with. Moreover, such work details the various rep-

resentations of sexuality, gender, culture, and history—representations that often present a stark contrast to those of mainstream U.S. animation—that are becoming part of many youths' pop cultural repertoires and may influence the possibilities for social and narrative action that they envision for themselves.

Otaku Fandom

Otaku is a much contested term that has been used in conversations around Japanese media and is used in Japan as a derisive label to describe fans who are "so involved with a particular type of fan subculture that he or she becomes obsessed, even insane" (Newitz, 1994, n.p.). The meaning of otaku has shifted, over time and space, to a more positive connotation for anime and manga fans outside of Japan (Eng, 2001a, 2001b, 2002; Volker, 1990). The genesis of organized anime and manga fandom in the United States has been located in the late 1970s and early 1980s with the grassroots establishment of Science-Fiction/Fantasy fan clubs and conventions (Patten, 2004). Though these fan clubs were created with the purpose of promoting preexisting anime media in the United States, they also engaged in the production and distribution of a wide range of fan-created texts. Such fan texts engage with an array of sophisticated literacy practices such as *fansubbing*, a practice by which fans synchronize the video signals from the television, a VCR, and computer to write and inscribe their own subtitles onto anime videos with a Japanese soundtrack, or *digisubbing*, which is essentially the modern version of fansubbing, by which fansubs are created entirely on the computer (Leonard, 2004). A related practice is creating *scanlations*, a practice by which fans scan and translate manga by using imaging software to insert translations. At present, scanlations are generally translated into English and French. Other fan practices include creating fanzines and producing *d jinshi* (amateur works such as manga, fan art collections, and fan guides), producing anime music videos (AMV), and writing fan fictions that, in spite of their present day prominence and widespread dissemination on the Web, remain largely unexplored in academic research. The following section includes a brief introduction to the ways that anime and manga have been taken up within fan communities, and then goes on to discuss how academic research has approached such fannish activities.

Many self-identified otaku or aficionados have entered the global flows of information surrounding anime and manga by forming Web sites and mailing lists devoted to meta-discussion of the artistic, thematic, and social elements of these media. These sites include articles and commentary by the administrators and links to scholarship that is published and disseminated via fan networks, on the Web, and in online journals. These sites also serve as clearinghouses or

guides for finding the aforementioned sorts of fan texts such as digisubs and d jinshi. Some of the more prominent sites include AnimeResearch.com, the Anime Manga Research Circle (http://www.cjas.org/~leng/amrc.htm), the Anime Manga Web Essay Archive (http://corneredangel.com/amwess), and AnimeFandom.org (http://animefandom.org). Such spaces should not be overlooked, as the fans running and participating in these sites provide a unique brand of meta-commentary and nuanced perspectives that are informed by years of devoted consideration and appreciation of anime and manga. Moreover, if we are to truly understand how students use new literacies and operate from a mindset rooted in digital space, then we must begin to think about the online proliferation of networked, participatory "centers of learning" (Purves, 1998) and to understand the roles they might play in global flows of information surrounding media and popular culture. Also, in terms of education, perhaps it is time to address how such prolific, networked, and interactive sources of information may influence students' attitudes toward and facility with more traditional, structured, and enclosed "centers of learning" such as books, encyclopedias, classrooms, and even libraries.

In a recently published text, Sean Leonard (2004) takes a unique perspective on fan-produced texts in terms of globalization. Leonard analyzes the practice of fansubbing as a driving force in the licensed distribution of subtitled anime in the U.S. market, essentially positing that fan practices "pulled" licensed copies of these media to the West. Though Leonard provides a thorough discussion and overview of fansubs, from their debut in American fandom in 1989 through subsequent eras of anime production and distribution both in Japan and in the United States, his primary focus is on the historical, legal, and global rather than literacy-related aspects of fansubbing. Albeit outside the scope of Leonard's article, fansubbing and its contemporary online counterparts, such as digisubs and Web sites that provide translations and/or Cliffnotes for various anime and manga, are complex new literacy practices that involve sophisticated processes of "translation, reconstitution, and reproduction" of the original texts (Leonard, 2004, p. 4) and are worthy of exploration in their own right. Moreover, such practices have much to offer for understanding the role of such literacy practices in Western youths' understandings and perceptions of Japanese history, culture, and society.

Once a fandom dominated primarily by over thirty-something males, the contemporary otaku demographics have shifted to include a substantial base of young school-age males and females alike, and a limited amount of research is beginning to follow suit. For example, popular anime series such as *Pokémon*, *Digimon*, and *Yu-Gi-Oh!* have received a fair amount of academic attention for their unique status as media mixes (Ito, 2001), media franchises (Lemke, 2004),

or as sets of cultural practices (Buckingham & Sefton-Green, 2004) that, combined with technological advances and new ICTs, make it possible for children to integrate fandom into multiple aspects of their daily lives. Over the course of a day, or in some cases simultaneously, children can eat Pokémon candy, play Digimon games on handhelds as they ride in the family car, sleep with a Pikachu stuffed animal, watch *Yu-Gi-Oh!* on a laptop, and/or IM with their friends about what might happen on the next Pokémon episode. As Lemke (2004) points out, such media franchises facilitate and, in the interest of profit, encourage fans' engagement with the worlds of popular culture across "multiple timescales" and a range of networked social spaces. Such networks and confluence of media also enable fans to engage in a range of productive activities through which the division between producer and consumer is blurred. For instance, fans can actively participate in a pop cultural imaginary while they trade paper playing cards with their friends on the playground (just as the *Yu-Gi-Oh!* characters do in the series), gather online in fan Web rings to discuss discrete characteristics of different Pokémon, create and post fan art, design personal Web pages, and publish their own anime-based fan fictions online for other fans to read and respond to.

In response to the widespread visibility of the Pokémon craze, the University of Hawaii sponsored a conference in 2002 that was devoted entirely to consideration of this anime phenomenon and emphasized school-age children's interactions with the series. Joseph Tobin (2000, 2004), an authority on children's engagement with media and popular culture, edited a volume of proceedings from the conference that features discussion from teachers and researchers across fields including anthropology, sociology, cultural, and media studies. Individual essays address such diverse topics as the implications for cultural identity as anime and manga are increasingly consumed by non-Japanese audiences (Iwabuchi, 2004; Katsuno & Maret, 2004; Yano, 2004), how children productively engage with Pokémon in local cultural contexts (Brougère, 2004; Lemish & Bloch, 2004) and use their interactions around these media to construct and enact multiple identities through narrative play (Bromley, 2004; Tobin, S., 2004) and through writing (Willett, 2004) in schools. As a whole, this work addresses issues that have clear implications for education, such as how children actively navigate, make use of, and at times resist the pedagogical structures built into many of the Pokémon products (Buckingham & Sefton-Green, 2004); what children acquire in terms of learning skills and strategies through their engagement with these media across multiple sites; how this might carry over into academic contexts; and how such media mixes have fostered a sort of community that enables students to develop self-extending learning skills, facility in negotia-

tion, and self-confidence as teachers and as experts on this globally circulating media.

Literacy Research

In his book *Situated Language and Learning: A Critique of Traditional Schooling*, James Gee (2004b) draws from a case study to demonstrate how Pokémon was a motivating factor in one young boy's experience of learning to read. Gee argues that this child's desire to participate in the Pokémon fan community spurred his literacy development, as successful participation required him to decode and encode complex game and character guides. Another professor, Vivian Vasquez (2003), draws from Gee's work with video games and popular culture to discuss another case study of a youth's participation in what she calls "Pokediscourse." In a similar vein, Buckingham and Sefton-Green (2004) provide a thorough account of a young boy who, through an autodidactic process of trial and error, employs various learning strategies in mastering the Pokémon video game and, in the process, acquires new forms of literacy and numeracy required for successful participation in the Pokémon fan community.

Such work underscores the point that attending to children's engagement with popular culture can help us understand the "new symbolic and discursive practices" (Vasquez, 2003, p. 121) that youth are engaging with, in which print is only one mode of many within the complex semiotic systems they are mastering to successfully participate in fan communities. These pieces also underscore how language in these spaces is not dumbed-down, decontextualized, and "separated from value-laden action, interaction, and dialogue, as it is for so many children in school" (Gee, 2004b, p. 48). But rather, Pokediscourse is complex, authentic, and wholly relevant to meaningful activity and is tied to these students' identities as anime fans and experts on the media. Moreover, both the Buckingham and Sefton-Green and Gee pieces raise crucial questions about how the sort of informal styles of learning and the types of knowledge bases surrounding popular culture may complement or indeed may conflict with dominant pedagogies and forms of learning found in most Western educational systems and how this might affect students' performance in and/or attitudes toward traditional schooling.

A relatively small number of ethnographic studies of school-age youths' productive fan activities around anime and manga are becoming visible in literacy-related research (Black, 2005, 2006, 2007; Chandler-Olcott & Mahar, 2003a, 2003b; Lam, 2000, 2004; Lankshear & Knobel, 2006; Yi, 2005, 2007, in press). Interestingly enough, a common theme emerging across this work is the production of Web-based writing and/or fan fiction based on various anime and

manga series. The following section introduces the phenomenon of fan fiction in terms of history and several decades of existing research that has centered primarily on adult fans. It concludes by focusing on the small amount of research that has been done with school-age fans' practices of reading, writing, and reviewing online fan fiction and discusses how further research has the potential to shed light on a range of emerging literacy practices that are aligned with issues that literacy educators grapple with in their pedagogy.

(Tech)tual Poaching

Fan Fiction

Fan fiction, simply defined, is fiction written by fans about preexisting plots, characters, and/or settings from their favorite media. However, the boundaries of fan fiction are porous, and definitions vary widely. For example, Tushnet (1997) defines fan fiction as "any kind of written creativity that is based on an identifiable segment of popular culture, such as a television show, and is not produced as 'professional' writing,"(n.p.) thus drawing a distinction between "fanfics" (short for fan fiction) and "profics" (short for professional fiction). Specifically, this distinction is drawn on the premise that fanfics are written for love of a particular media or text while profics are written for monetary gain. Others have likened fan fiction to derivative forms of literature that draw from myth, oral traditions, and folktales (Derecho, 2006). As Pugh (2005) points out, "Hero-figures like Robin, Arthur and the characters of ancient myth have always accreted stories to themselves through the generations and their legend grows and changes according to what each set of new readers and listeners needs from it" (p. 9).

Definitions aside, fan fiction authors draw from their favorite media, such as books, movies, video games, and television shows, to artfully engage in a range of literate practices. Jenkins (1992) describes how fans "play with the rough spots of the text—its narrative gaps, its excess details, its loose ends and contradictions—in order to find openings for [their] elaborations of its world and speculations about characters" (p. 74). For example, in *gen* (abbreviation for general) fictions authors may develop alternate universes (A/U) as settings for preexisting media (e.g., moving the characters from *Star Trek* to an investment bank in downtown Boston), construct alternate plotlines (e.g., creating a new villain for Scooby Doo and the gang to defeat), and/or develop prequels and sequels (e.g., creating a journal detailing the many regrets of Darth Vader before his death). Fan writers also introduce new characters (e.g., creating a character

that turns out to be the love child of Captain Kirk and an alien leader from a fabricated planet), refocus attention on peripheral characters (e.g., creating lore related to Murlocs from the video game *World of Warcraft*), and at times may write themselves into the texts. Fan authors might also create *shipper* (abbreviation for relationship) fictions that extend (e.g., exploring Elizabeth Bennet and Mr. Darcy's life after marriage) or realize relationships between various characters (e.g., crafting a budding romantic relationship between Harry Potter and Hermione Granger). However, these are just a few examples of the many creative contributions such fan texts make to the public media and pop cultural imaginary.

Though not generally recognized as *fanfics*, such derivative or appropriative writing can arguably be traced to a variety of texts such as John Lydgate and Robert Henryson's extensions of Geoffrey Chaucer's work (Carlson, 2004; Pugh, 2005; Super Cat, 1999), "uncommissioned sequels" to novels such as Jane Austen's *Pride and Prejudice* (Super Cat, 1999) and Daphne du Maurier's *Rebecca* (Pugh, 2005), William Gillette's play based on Conan Doyle's character Sherlock Holmes (Pugh, 2005), and plot suggestions that were sent to serial writers such as Doyle and Charles Dickens by avid followers (Jenkins, 1992). The genesis of contemporary fan fiction can be traced from the 1930s Pulp Fiction amateur fan magazines known as *fanzines* (Thomas, 2005) to the better-known textual productions of Trekkers, or devotees of *Star Trek*, that were discussed and distributed at annual sci-fi conventions, regional fan clubs, and via mail in the 1960s (Jenkins, 1992).

The advent of online publishing has brought about changes in fan fiction on a number of significant fronts. First, the demographics of fan fiction have shifted from a majority of adults producing hard-copy print zines to large numbers of tech-savvy adolescents who are writing and publishing fics on fan and personal Web sites as well as in online archives. Also, the proliferation of online sites has opened fan fiction up to a global and multilingual population of writers and readers, while the number of *canons*—that is, the original media that the fictions are based on—has increased exponentially, with *fanons*—or bodies of fan texts—emerging based on almost every book, television show, anime series, video game, or movie imaginable. As an illustration, a Google search for "fan fiction" coupled with the popular online role-playing game "World of Warcraft" yields approximately 468,000 hits; the Japanese animation series *Inuyasha* produces 201,000; and the juvenile fiction series *Harry Potter* brings 269,000. Clearly, as Black and Steinkuehler (in press) point out, "the ubiquity and sheer number of fan fiction texts make it a difficult phenomenon to overlook. Moreover, the fact that much of this fiction is being written and read by adolescents makes it a fascinating topic for education and literacy researchers who

seek to understand the role of new media and online communication technologies in youths' literate, social, and academic worlds" (n.p.).

With the relative ease of online communication and circulation, fan fiction has become much more evident as a social, cultural, and intellectual practice, as evidenced by the research and meta-commentary on fanfic that has started appearing online on personal fan sites, forums (e.g., Fanthropology; The Fanfic Symposium), and in academic texts and journals. There are various sites with fan fiction–specific awards (e.g., Middle Earth Fan Fiction Awards), dictionaries (e.g., The Fanfiction Glossary), grammar guides (e.g., Holy Mother Grammatica's Guide to Good Writing), and numerous help sites. These shifts in demographics, visibility, and accessibility have been brought about by new advances in media and communication technologies and have placed fan fiction squarely within the flows of information and social exchange that are being passed between new generations of adolescents across national, cultural, and linguistic spaces.

Academic attention to fan fiction has varied widely in terms of disciplinary approach and focus, with studies stemming primarily from cultural, communication, media, and literature studies. Also, because fan fiction is derivative work based on copyrighted intellectual property, the genre has also been looked at from legal (McCardle, 2003; Tushnet, 1997) and ethical standpoints (Pugh, 2004), with such studies serving as references for fans who wish to defend their right to continue producing fictions. Early academic writers on fan fiction such as Joanna Russ (1985), Patricia Frazier Lamb and Diana L. Veith (1986), and Camille Bacon-Smith (1992) centered their feminist-inflected work primarily on fanzines and the genre of *slash fiction*—that is, fiction depicting noncanonical homosexual relationships, such as pairing the *Star Trek* characters Kirk/Spock —with the slash between the names denoting romantic pairing. When these studies were conducted, the majority of fan fiction, including slash, was produced by middle-aged females. Thus, their works conceive of slash primarily as female erotica or pornography written by women, for other women (Jenkins, 1992; Russ, 1985) and a means by which these fans are able to project their own feminine romantic and sexual fantasies/desires onto the masculine bodies of the series' characters (Jenkins, 1992). Constance Penley (1991) adds an interesting dimension to research on *Star Trek* slash with her piece on "Brownian Motion" in which she focuses on the genre as a site of debate about male domination in the arenas of technology and sex.

Without a doubt, Henry Jenkins' ethnographic work *Textual Poachers: Television Fans and Participatory Culture* (1992) continues to be the authoritative text on fan culture. In this text, Jenkins, writing as a self-identified fan, draws on Michel de Certeau's notion of "poaching" to liken fans' interpretive and productive

practices to a form of "cultural bricolage through which readers fragment texts and reassemble the broken shards according to their own blueprints, salvaging bits and pieces of the found material in making sense of their own social experience" (De Certeau, 1984, as cited in Jenkins, 1992, p. 26). Through case studies, interviews, and the voiced impressions of numerous fans, Jenkins provides an empathetic and nuanced perspective of fan culture that challenges short-sighted stereotypes of fans as "cultural dupes" that passively ingest the messages of mainstream media or as obsessive followers who need to "get a life." In so doing, Jenkins consciously seeks to redefine public conceptions of fandom and raises seminal questions about the nature of fan culture and audience reception that have spurred years of subsequent fan-related research.

Contemporary work has turned to the multiplicity of online fan fiction archives and discussion boards as data for exploring assorted fandoms, new canons, and different genres of fan fiction. Many such studies are canon-specific investigations of the genre of *shipper* or relationship-based fictions that explore issues such as how women use these fictions to take a counterhegemonic stance against "producers' commercial imperatives, a separate spheres dichotomy, devaluation of the feminine/private sphere, and masculine generic conventions" on series such as *X-Files* (Scodari & Felder, 2000, p. 238). Other studies explore why some women write *het,* or fictions with heterosexual pairings of certain couples, within canons such as *Star Trek: Voyager* that generally inspire slash fiction (Somogyi, 2002). Or, in a similar vein, Rosemary Coombe (1998) looks at shipper fanzines as forms of social critique and satire that enable women to explore their position in patriarchal society.

Over the years, expanding canons of slash fiction, ranging from *Xena: The Warrior Princess* and *Buffy the Vampire Slayer* (Cicioni, 1998) to more obscure manga series (McLelland, 2000a, 2000b), have continued to draw the attention of researchers and fans alike. Anne Kustritz (2003) looks at slash from a literary perspective and posits that, as a genre, slash "offers its own particular challenge to normative constructions of gender and romance, as it allows women to construct narratives that subvert patriarchy by reappropriating those prototypical hero characters who usually reproduce women's position of social disempowerment" (p. 371). In addition, new forms of hybrid academic texts created by fan fiction authors who are also academic researchers are emerging with explorations of female/female or *femmeslash* as a means of contesting and dialoging with hegemonic mass culture and a way of challenging the primacy of representations of heterosexuality in the media (Busse, 2005; Russo, 2002).

For the most part, what these studies all share is continuous movement toward some understanding of the many ways in which fans are taking up elements of pop culture and then redistributing them in new forms that are

imbued with meanings that are grounded in the lived realities and social worlds of fans. However, considering how the demographics of fan fiction have shifted with the advent of online publishing—from a base primarily made up of adult science fiction and daytime soap opera fans to a transnational and multilingual population that is dominated by adolescents from across the globe—it is somewhat surprising that more academic attention to fan fiction has not followed suit. As evidenced by the aforementioned studies, the vast majority of the research corpus to date has focused on adult-authored fictions within certain genres and centers on a largely English-speaking population. In contrast, prominent archival fan fiction sites as well as the vast numbers of personal fan sites on the Web feature fictions based on a range of culturally diverse canons that are composed of multiple languages and posted largely by fans between the ages of thirteen and eighteen. The following section introduces the small amount of research that has looked at literacy-related aspects of youths' engagement with fan fiction. It also identifies some key elements of on- and off-line fan writing and fan culture that have great potential to shed light on how adolescents are using technology to simultaneously learn from and contribute to global flows of information and to meaningfully participate in discourses that are steeped in culturally, linguistically, and semiotically diverse forms of literacy.

Literacy Research

Interestingly enough, the relatively few studies examining adolescents' literacy and social practices surrounding fan fiction mostly center on canons related to anime and manga (Black, 2005; Chandler-Olcott & Mahar, 2003a, 2003b). For example, Kelly Chandler-Olcott and Donna Mahar (2003a, 2003b), a university researcher and educator team, recently conducted a classroom-based ethnographic inquiry into adolescent girls' use of digital technologies in which they found pop cultural texts, particularly anime and manga, to be central to the participants' literacy practices. The authors draw from work in the New Literacy Studies (NLS) tradition (Cope & Kalantzis, 2000; New London Group, 1996) as an analytic lens for viewing focal participants' creative *design* practices of crafting amateur manga, developing anime-based Web sites, and writing fan fiction. Design is a particularly apt construct for looking at adolescents' engagement with media texts, as it emphasizes the relationships between source texts, the often hybrid and intertextual forms that redesigned texts take, and the creative and potentially transformative process of reworking and reshaping existing modes of meaning (Chandler-Olcott & Mahar, 2003a, 2003b; Cope & Kalantzis, 2000; New London Group, 1996).

Chandler-Olcott and Mahar use the notion of design to explore multimodal aspects of one participant's development of anime-inspired Web pages and fan fiction (2003a) and another's creation of manga and participation in an online amateur manga mailing list (2003b), focusing on the visual, spatial, and embodied aspects of their engagement with these technology-mediated activities. The authors make a valuable contribution to fan fiction research in that they are among the first to use a literacy-related and educational lens to examine anime, manga, and fan fiction. In addition, their analyses provide insight into the ways in which some adolescent girls may draw from "conflicting discourses about gender and relationships" in both media and print texts to explore and possibly expand female spaces in a patriarchal society, such as through the construction of fan fictions that feature strong female characters in roles generally reserved for men. Their analyses also provide insight into how these youth used popular culture as a resource in their ongoing social interactions and conversations about "issues such as friendship, loyalty, power, and sexuality" (Chandler-Olcott and Mahar, 2003a, p. 583).

In terms of academic value, Chandler-Olcott and Mahar (2003a) depict fan fiction as a possible entry point for discussions about differences between fan fiction genres and traditional academic text. They also discuss fan fiction's potential value as a diagnostic measure that might help teachers understand students' composition capabilities in nonacademic genres. Although the authors see the value of fan fiction in terms of motivation for and engagement with writing, they construct the genre as both separate and dissimilar from school-based literacy practices. This may be because of the authors' limited exploration of or exposure to the larger fan fiction writing community that exists online, as their data consisted of one focal participant's fictions that were created primarily for her friends and family or were posted on a personal Web site and intended for a limited audience. Thus, although this piece is consonant with many of the emerging perspectives on the role that digital and fan fiction often plays in helping young adolescent girls to construct and enact powerful online identities (Thomas, 2004), it takes a different stance on fan fiction's relevance to school-based literacies (Black, 2005; Jenkins, 2004, 2006).

Thomas' ethnographic work (2005, 2007) also describes how female adolescents use fan fiction texts and collaborative writing activities to create safe discursive spaces for sharing and discussing different perspectives related to relationships and gender roles. For instance, Thomas describes how two focal participants, Tiana and Jandalf, develop narrative representations of themselves, or autobiographical characters known within the fan fiction community as *Mary Sues*, that assist them in understanding past experiences and in "forging new identities" (Thomas, 2005, p. 30). Much like Rhiannon and Eileen from Chan-

dler-Olcott and Mahar's studies (2003a, 2003b), these young women also used their fan fictions to reconfigure gendered identities by casting female fan fiction characters in many of the "hero" roles that are traditionally occupied by men in popular media. Thus, the young women were able to draw from available resources to create fictions that served as a way for them to give voice to themes and issues related to relationships, family, sexuality, and friendship. Moreover, the social and collaborative nature of the writing acts themselves provided an opportunity for them to establish an enduring friendship in spite of their geographical distance.

In his recent work, Jenkins (2004, 2006) provides an overview of one home-schooled student's experiences creating and editing *The Daily Phoenix,* an online "school newspaper" for the fictional Hogwarts Academy from *Harry Potter.* In this work, he explains why the focal student, Heather, and many other fan fiction authors can write—pointing to their participation as *The Daily Phoenix* staff and in various online affinity spaces, such as the archival site Fiction Alley—as a formative part of their writing and literacy development. In these affinity spaces, members have the opportunity to take on identities as writers, editors, reporters, proofreaders, and columnists. In addition, Jenkins (2004) points out that "through online discussions of fan writing, the teen writers develop a vocabulary for talking about writing and learn strategies for rewriting and improving their own work" (n.p.). Moreover, when they talk about the original *Harry Potter* text, "they make comparisons with other literary works or draw connections with philosophical and theological traditions; they debate gender stereotyping of the female characters; they cite interviews with the writer or read critical analysis of the works" and essentially engage in literate and analytical activities that they normally would not encounter and meaningfully engage with until college (Jenkins, 2004, n.p.).

Recent explorations of fan writing communities (Black & Steinkuehler, in press; Chandler-Olcott & Mahar, 2003b; Lankshear & Knobel, 2006; Thomas, 2005, 2007) have also called attention to the vast array of hybrid fan fiction genres. These types of texts combine or hybridize two or more genres, such as songfictions (*songfics*) that combine narrative with song lyrics; poetry fictions (*poetryfics*) that combine narrative and poetry; and chatfictions (*chatfics*) that are fictions written solely as Instant Messenger (IM) or Internet Relay Chat conversations or combine narrative with the IM/Chat register (Black, 2005, 2006; Lankshear & Knobel, 2006). Furthermore, many fan fiction texts "cross over" or combine the characteristics of different media productions. For example, a *moviefic* might contain elements of a *Harry Potter* book and a popular movie. Through these hybrid forms of writing, fans are able to make intertextual connections between distinct genres such as science fiction, fantasy, angst,

comedy, and romance (Black, 2005; Chandler-Olcott & Mahar, 2003a; Lank-shear & Knobel, 2006).

As Black and Steinkuehler (in press) point out, the intertextual, hybrid genres of fan fiction are noteworthy for literacy educators and researchers in several respects. To begin with, to compose fan fiction texts based on screenplays, songs, poetry, short stories, and novels, youth must read and take note of the format and style of such genres. Moreover, young fans often seek help with their fan fiction composing, utilizing online Web sites such as style and grammar guides, as well as other fans as resources as a means of mastering the various forms and conventions of these genres (Black, 2005). Moreover, fans also "conduct extensive research to ensure the authenticity of material presented in fictions, such as investigating different historical periods or the procedures involved in various professions" (Black & Steinkuehler, in press, n.p.).

As can be seen through this review, there currently is very little research on school-age students who are engaging with online fan fiction. This may be due in part to a general tendency in educational settings to dismiss or even outlaw popular culture, deriding it and the media as frivolous pursuits that distract students and take time away from more worthy pursuits such as reading literature, studying, and learning about "high culture" (Jenkins, McPherson, & Shattuc, 2003). It may also be related to skepticism about texts that are not wholly "original." However, as Jenkins (1992) points out, recent work exploring fan culture "directs attention to the meanings texts accumulate through their use. The reader's activity is no longer seen simply as the task of recovering the author's meanings but also as reworking borrowed materials to fit them into the context of lived experience" (p. 51). Thus, although fan fictions are derivative in the sense that their design is mediated through fans' interpretations of media and popular culture, as can be seen from the small amount of scholarly work reviewed in this chapter, the genre lends itself to a great deal of literate innovation that is intimately tied to issues of literacy, learning, and identity that certainly call for further exploration.

Inquiry into Online Spaces

Introduction to the Study

Online Ethnography

Context

A nime-based fan fiction sites are a clear example of spaces in which cultural, historical, ideological, and semiotic elements of available media often simultaneously converge, are redesigned, and then redistributed through various information and communication technologies (ICTs). Thus, traditional offline, single-site approaches to ethnography may prove inadequate for capturing the geographical, temporal, and semiotic fluidity of these networked, online spaces. However, of late, work within literacy (Leander & McKim, 2003), communication (Hine, 2000, and anthropological (Marcus, 1995) studies has put forth a more connective approach to inquiry that moves beyond "the single sites and local situations of conventional ethnographic research designs to examine the circulation of cultural meanings, objects, and identities in diffuse time-space" (Marcus, 1995, p. 96). As George Marcus (1995) points out, this sort of research necessarily "arises in response to empirical changes in the world and therefore to transformed locations of cultural production" (p. 97) where the computer is not only an object of but also a context for study (Hine, 2000). Such an approach enables the researcher to follow "cultural products" such as Japanese anime and manga texts from inception to uptake to redistribution in order to better understand issues raised in previous research related to media producers' structure and promotion of dominant messages versus consumers' or fans' agency, uptake, and/or lack thereof. With the ever-reaching spread of mass media, such issues have been a cause for concern for parents, educators, and policymakers alike, and such research has crucial implications for the development of curriculum and pedagogy in critical media literacy.

This book draws a great deal from insights gained through inquiry into multiple, connected fan fiction spaces that are closely networked through the numerous links that fans create between them. However, the majority of analysis stems from more than three years that I spent as an active participant and observer on FanFiction.net (FFN), the largest automated multi-fandom archive on the Web. Multi-fandom archives house fictions from a variety of media canons, whereas single-fandom archives focus on a particular series. For instance, sites such as The Republic of Pemberley (http://www.pemberley.com/) and Bennet Girls (http://www.bennetgirls.com/) host fictions based on the writings of Jane Austen, whereas the Henneth Annun Story Archive (http://www.henneth-annun.net/) and the Lord of the Rings Fanfiction (http://www.lotrfanfiction.com/) host fictions based solely on Tolkien's tales. Other archival sites such as Anime-Fanfiction.com (http://www.anime-fanfiction.com/) house fictions from a variety of manga and anime series. FFN is by far the largest and best-known archival site, with more than a million and a half fictions spanning 3,000 plus media. Fictions are categorized into anime/manga, books, cartoons, comics, games, miscellaneous, movies, and television shows. Each category is then divided into subcategories; for example, the television shows category contains subcategories such as *Lost* and *CSI*.

FFN is a prime example of the ever-increasing prevalence and popularity of online fan fiction. According to Wikipedia, the site was created and launched in 1998 by a Los Angeles computer programmer named Xing Li (Wikipedia, *FanFiction.net*, 2007). Since the genesis of this research project a little more than four years ago, the site has grown tremendously—now housing well more than a million and a half texts—and canons such as *Harry Potter* seem to expand exponentially, with approximately 330,000 fictions at last count (as of January 3, 2008). The site also hosts an impressive collection of more than 350,000 anime-inspired fan fictions stemming from more than 300 different series. Although precise demographic information is unavailable, based on the biographical information from authors' member pages and the texts themselves, it is clear that a sizeable portion of these texts is composed by adolescents. However, the demographic is often somewhat related to the canon, that is canons such as *Doctor Who* or *Lost* are likely to have a greater proportion of texts composed by adults, whereas *Pokémon* or *The OC* might have more texts composed by a younger audience.

To meet the needs of a significant number of members outside the United States, in 2006/2007 the site expanded to include servers in Europe and Asia and now supports posting in more than thirty different languages. Thus, authors from many parts of the world have the option of posting texts in their native tongue; moreover, there are growing numbers of language-specific fanfic

communities. For example, a search for "fan fiction" and "Tagalog," "German," "French," "Spanish," "Chinese," and many other languages will yield a significant number of LiveJournals, forums, and individual Web sites. Nonetheless, there is a general sense that English will reach a broader readership; therefore, a majority of fictions on FFN are still posted in English. Nonnative English speakers approach posting their fictions in several ways. One common option is to ask a bilingual fan to translate the text into English. Another approach is to compose the text in English and ask another English-speaking fan to review and edit the text before it is posted online (see *beta-reading* in Chapter 3). Yet another option is to compose and post the fiction in English and rely on help and feedback from the general audience to revise and improve the text.

A number of authors on FFN are English language learners (ELLs) not only from the United States but also from other countries. For example, during my first month of participation on the site, I encountered fictions written by members in the United Kingdom, Mexico, Japan, Canada, Argentina, and the Philippines. In reading the biographical sketches posted by these authors, I noted that many of the English learners openly expressed a desire to improve their language skills through writing and participating on the site. As a literacy researcher and former English as a Second Language teacher, I was intrigued by this. I was even more intrigued by the fact that many youth who claimed to hate English class and/or asserted that it was their worst subject, voluntarily composed fan fictions in English and then posted them online. It was even more fascinating as I discovered that many of the activities on this and other fan fiction sites are consonant with many practices that we try to promote when teaching writing, such as collaborative writing, a great deal of writer/reader interaction, and peer review. Thus, an underlying focus in the chapters of this book is inquiry into the ways in which many fannish activities are aligned with or have the potential to inform school-based literacy practices.

Participant Observation
This chapter extends the fan fiction and anime research perspectives introduced in the first chapter into a distinct but related arena with a focus on ELLs' literate and social practice in the *Card Captor Sakura* (*CCS*) section of FFN. The *CCS* anime series originated in manga and then was turned into a two-part movie and a seventy-episode television series that aired first in Japan and then internationally. Because the series aired internationally, there are English learners from many different countries writing and reading fan fictions based on the *CCS* series. This, coupled with the fascinating storyline, was a significant factor in my selection of this series as a focus.

The *CCS* series is a *magical girl* genre of anime. It chronicles the daily life and adventures of a young Japanese girl named Sakura Kinomoto. In the original medium, Sakura opens a mysterious book in her father's study containing a deck of personified magical cards that represent distinct natural elements (i.e., The Firey, The Earthy, The Freeze, The Time, The Dark). Once these cards are released into their elemental forms, they wreak havoc in Sakura's small hometown of Tomoeda, Japan. With the aid of her newfound magical powers, mystical creatures, and good friends, Sakura must recapture all of the cards and return them to a safe place.

During the period of participant observation, I actively participated in the FFN community. This included writing and publicly posting fictions, providing feedback for other writers' texts, and interacting with a diverse group of fans both on FFN and, through following hyperlinks, on other popular fandom-related Web sites that are closely networked with the FFN community. Such activities made it possible for me to develop a nuanced understanding of the many different forms of participation as well as the social and literate roles that were available to youth in this space. These activities also helped me identify areas of the site that were frequented by ELL and adolescent members. Research participants interacted with me not only as an academic but also as a fellow fan fiction writer and anime fan.

Throughout the project, I kept detailed field notes and developed organizational charts to create a "thick description" (Geertz, 1973) of the online social networks of FFN and related fandoms and to develop a situated understanding of what it means to be a participant in these spaces. I downloaded focal participants' fan fiction texts as they were posted. I also downloaded readers' daily reviews of these texts. Artifacts such as fan art, community forums that provide meta-commentary on topics such as grammar, composition, and the etiquette of peer review as well as petitions created by site members were also collected. In addition, I conducted semi-structured interviews and engaged in numerous informal e-mail and Instant Messenger exchanges with focal participants about their activities in the fan community, at school, and at home. I also discussed interpretations of data and asked for clarification from participants on specific aspects of their language use and writing. When possible, I shared all publishable pieces with participants for feedback and tried to ensure that I was adequately representing their ideas about participation in fan spaces. In fact, one research participant's mother sent one of my articles discussing the sophisticated literacy-based activities of the fan fiction community to her daughter's English teacher as evidence of the value of her daughter's online, extracurricular writing activities.

At this point, it seems appropriate to mention the ethics of online research. This recently has become a topic of much debate, especially in light of the increasing amounts of research now being conducted in online communities. The primary question here is this: "Can we justifiably regard online interactions on bulletin boards, mailing lists, and in chat rooms as 'public status' or do they constitute, as others may argue, a form of private conversation which is embedded within a public space?" (Cavanagh, 1999, n.p.). In response to this question, I point out that the fictions and reviews used in this chapter constitute a form of public interaction, open to any reader with Internet access. Thus, an inherent part of online fan fiction writing is the public nature of publishing and reviewing texts. Moreover, the site itself hosts columns that include meta-discussion of excerpts from various publicly posted fictions and reviews. The point being that fans realize their public posts may be taken up and analyzed in a variety of ways. As such, by posting fictions in a public archive, authors are implicitly giving permission for these texts to be analyzed, critiqued, or lauded by readers, reviewers, and the general public.

That being said, as a researcher and educator, I still feel obligated to obtain traditional forms of consent from authors whose work I focus on in my research. I am careful to change identifiable usernames or highly "Googleable" titles. Thus, all of the fan usernames and fan fiction story titles in this text have been changed; however, every attempt was made to preserve as much as possible of the meaning value of the original name or title. I also consider the use of any data that involves "chat" or related correspondence between adolescent fans, even in public chat rooms, and any sort of public or private interviews as bound by the same constraints, ethical codes, and official human subjects limitations as traditional, offline research is bound (Black, 2005). In addition, as I discuss at length in this book, fans often use their texts as a means of exploring issues and concerns from their daily lives. For adolescents, this often includes many potentially sensitive topics. Owing to the highly "searchable" nature of online text, I feel that it is crucial to exercise a great deal of caution when choosing which fictions to include in my academic publications. In addition, as mentioned previously, I consult with focal participants before including any of their materials and request their feedback on the analysis whenever possible.

Also, it is worth noting that within this book, readers will encounter many variations of the term "fan fiction." "Fanfiction," "fan fiction," "ficcies," and "fanfic" are often used interchangeably in the fan community. Though I tend to use these terms interchangeably when I am writing and interacting as a fan, for the sake of editorial consistency, "fan fiction" will be the standard form used in this text. However, various forms of these terms used in artifacts, texts, and titles from the fan community are preserved.

Theory and Analysis

New Literacy Studies

As researchers, our understandings of new ICTs and digital literacies have been and will continue to be shaped extensively by our epistemic frameworks for literacy and the sort of questions that we ask about emerging forms of online, post-typographic communication. This study is firmly grounded within a sociocultural and "new" approach to literacy studies. I find a New Literacy Studies (NLS) theoretical orientation to be particularly apt for looking at the everyday use of emerging ICTs in online spaces, and for relating such work to teaching and learning both in and outside of formal education settings for many reasons. In general, sociocultural perspectives and NLS perspectives have effectively expanded our notions of literacy beyond discrete, rule-governed decoding and encoding skills to include consideration of many shifting forms of semiotic and textual meaning-making practices, such as those that develop in tandem with new technologies, contexts, and intentions of individual and collective literacy users (New London Group, 1996).

This notion of literacy as a social practice (Street, 1984) has helped us move away from "autonomous" models of language and learning. Such models tended to attribute failure to learn standard and academic forms of literacy to individual cognitive deficits, and/or the deficiencies of entire cultural groups. A social practice paradigm, however, facilitates exploration of how an individual's or group's willingness and ability to take on forms of literacy are closely tied to the relevance of various literacies or Discourses (Gee, 1999) to the literacy users' personal, social, cultural, historical, and economic lives (Heath, 1983; Scribner & Cole, 1981). In so doing, this paradigm also turns our research view toward the ways in which literacy as a nonneutral entity might carry and transmit a wealth of historical and ideological perspectives that play a part in reproducing certain social and material contexts, and how individuals, as active, agentive literacy users, take up dominant forms of literacy and refashion them to suit the particular needs and perspectives of local contexts. Such a paradigm is crucial to understanding key issues emerging in research related to online communities, media, and popular culture including: (1) the fact that popular media (such as Japanese anime and manga) carry with them certain generic, ideological, cultural, and literate conventions; (2) how, as these media become part of global flows of information and spectacle, they are taken up by fans and are revised and recontextualized through local literate and social interactions; and (3) how these reworked texts in turn are shared and redisseminated into global networks through new ICTs.

In terms of literacy and learning, there has been a recent push within the NLS (Alvermann, 2002; Hull & Schultz, 2002; Lankshear & Knobel, 2003, 2006) to develop vistas extending beyond traditionally accepted contexts for literacy research—primarily those that are temporally and geographically bounded—to gain a clearer view of students' out-of-school literacy practices and engagement with forms of online and post-typographic communication. Scholarship in this area has shed light on the many ways that youth are using print-based English in tandem with other forms of semiotic expression to engage in (potentially new) varieties of literate interaction in online environments.

A sociocultural framework for literacy is broad enough to allow "literacy pedagogy to be informed and enhanced by models of learning developed within other component 'movements' of the 'social turn'"(Lankshear, 1999, n.p.). As such, it allows for a fair measure of theoretical and methodological flexibility in approaching informal, grassroots learning spaces, such as fan fiction writing sites, to best answer key questions that emerge as a result of the aforementioned push as well as in response to the growing salience of media, popular culture, and technology in youths' lives. This includes some of the questions that are addressed in the various chapters of this book such as What is so engaging about these media and networked, informal learning sites that youth willingly devote hours to participation in them—even in fan fiction writing spaces where participation involves many school-based literacy practices such as composition, editing, and peer review? How might the patterns of participation in these informal, online learning spaces be linked to larger shifts in our increasingly globalized, networked, and linguistically and culturally diverse society? What are the effective and motivating forms of learning and teaching that are taking place around media and popular culture in these sites? What sorts of identities do these spaces recruit, recognize, and reward? In addition, given what we have learned so far in answer to the above questions, how might we or in fact should we bring such understandings to bear on literacy pedagogy in classrooms?

Online Spaces and Discourses

The notion of a "third space" (Bhabha, 1994) entails a meeting place or a convergence of sorts where diverse mindsets, perspectives, and materialities can come together and be articulated into new interconnected and hybrid frames of mind. New forms of communication and media increasingly offer opportunities for the articulation of hybrid perspectives, the synergy of multiple modes of representation, and the development of pluralistic forms of literacy and identity (Cope & Kalantzis, 2000; New London Group, 1996). Affinity spaces such as online fan fiction communities provide a wealth of such articulations for study.

As research described in the previous chapter has shown, modern social shifts and technological advances have led to the development of many third spaces where school-age youth are doing a great deal of learning and "identity work" that is mediated through their online, literate interactions; various forms of semiotic meaning-making; and their activities surrounding popular culture. By identity I mean the ability to be recognized as a certain sort of person within a specific context (Gee, 1999). This fluid notion of identity is discussed further in Chapter 5. From this perspective, language, literacy, and text are integral to the sort of identity work or continuously shifting affiliations with certain social groups that individuals make within different contexts. An NLS theoretical framework is particularly helpful in looking at the sorts of powerful identities that adolescents, particularly ELLs, are able to take on and successfully enact through their literacy and social practices surrounding fan fiction and popular culture.

Gee's (1999) big-D Discourse theory and method of analysis differentiates between little-d discourse, which is language in use, and big-D Discourse, which is the compilation of semiotic, material, and expressive resources, such as gesture, text, and language, that individuals use to "pull off" certain socially situated identities. This is a particularly apt construct for examining traditional print-based language and post-typographic forms of text in the data from this study to answer questions such as What are the genres of fan fiction texts and reader reviews? What are the social registers or discourses of this space? How is language used to define the affinity space and to create and sustain social networks? What does it mean to be an effective (and also ineffective) anime fan or writer or reader in online fan fiction spaces? Also, because big-D Discourse encompasses "ways of behaving, interacting, thinking, believing, speaking, and often reading and writing that are accepted as instantiations of particular roles (or 'types of people' by specific *groups of people*)" (Gee, 1999, p. viii, emphasis in original), this construct is highly applicable to this work. First, it is applicable because it foregrounds literacy and identity as crucially interrelated components of social practice and interaction. Second, it is applicable because it provides an analytic framework for understanding how members use language and text to take on the identities of legitimate anime fans or as authors or readers or legitimate participants on FFN.

Sociocultural approaches to literacy and discourse are also used in this study to understand and to characterize the effective and motivating forms of learning and teaching that are taking place around media and popular culture in fan fiction sites. Of late, there has been a push for Critical Discourse Analysis (CDA) to account for "matters of learning" (Rogers, 2004, p. 14) in educational research. In response, Gee (2004a) expands the CDA framework and draws from

a range of social theories of cognition to posit that learning is "changing patterns of participation in specific social practices" (p. 38). Coupled with such a social perspective on learning, CDA can be applied to texts from the fan fiction community, such as fan fictions, peer reviews of fictions, interactions between writers and readers, and columns featuring meta-commentary about composition. Such analysis provides insight into how and why adolescents voluntarily engage in such patterns of participation in online affinity spaces, as well as how such social and self-directed patterns of participation change over time and aid in learning. A discourse analytic examination of interactions between writers and readers is also a means of understanding the *dialogic* negotiations (Bakhtin, 1981; Nystrand, 1986) taking place as ELLs use language and writing to further learn how to write (Nystrand, 1986). This sort of dialogic negotiation between writers and readers is an inherent part of fan fiction writing and is discussed throughout the book, particularly in Chapters 5 and 6.

In terms of application to education, Gee (2004a) points out that notions from learning sciences and social cognition "like 'distributed cognition', 'collaborative practice', 'networked intelligence' and 'communities of practice'" have yet to be taken up in any serious way in schools (p. 165), in spite of the fact that such forms of learning are related to the needs of modern workplaces and the value system of fast capitalism and a knowledge economy. Interestingly enough, as evidenced by the earlier review of research, such forms of learning are readily apparent in many informal fan spaces and activities. For example, although fan fiction authors and anime fans engage in a range of school-related literacy practices (e.g., reading, reviewing, providing feedback, editing, writing, proofreading), they are all part of authentic social and communicative activities that are meaningful and contribute positively to powerful identities in these shared learning spaces. Fan fiction writers also draw from knowledge that is distributed across the Web and other offline sites. Moreover, they solicit help in thinking through their ideas and collaborate with other authors and actively participate in a space that is organized around common affinity for anime where many different forms of expertise are recognized and valued within the community.

This can be juxtaposed with many classrooms, where literacy is often viewed as a mere tool for content area learning; research is often confined to textbooks and materials in the library; learning is viewed as an individual process; there are established standards for what counts as expertise and successful participation; such standards are determined by administrators and policymakers outside of classroom community; and failure to achieve such standards often has negative effects on students' identities. In this spirit, this book also aims to explore the points of convergence and divergence between the literacy, learn-

ing, and social practices taking place in the informal learning space of FFN and more formal learning environments and pedagogy, and to discuss the implications that such research has for literacy and language education as well as for students' identities.

Data Analysis

Owing to the relatively unexplored nature of interaction on FFN, analysis of the data was an iterative process requiring several different layers of coding and interpretation grounded in discourse analytic (Fairclough, 2003; Gee, 1999) techniques. The first stage involved repeated reading and inductive analysis of texts posted in all sections of FFN and in the broader fan community. This initial stage enabled me to gain a sense of the sort of topics, themes, and genres that often appeared in fan texts. The next stage involved a similar process that was concentrated within the *CCS* subsection of FFN, focusing on individual fan fictions, reviews, and publicly posted interactions.

Next, I examined the macrostructure of focal participants' and other fans' texts, coding for salient sections in the story narratives, including but not limited to categories such as setting, catalyst, crisis, evaluation, resolution, and coda (Gee, 1999). This also involved analysis of unique sections of fan fiction texts known as *headers* and *Author's Notes*. Headers are introductory sections at the start of a fan fiction that provide readers with information about the upcoming content. For example, typical headers contain information such as the story and/or chapter title, author, and media canon. Headers also often identify common genres such as comedy, romance, drama, and angst and/or fan fiction-specific genres such as slash, het, or hurt/comfort. Headers also identify character pairings of the text, rating, and warn readers when the fiction contains a *spoiler,* anything that gives away the ending of an episode or text, or materials that a reader might find objectionable, such as explicit violence or sex. Author's Notes are the fan writer's direct communications with the audience and can contain a variety of information about the text, the author, as well as messages to readers. Author's Notes can be located at the start of a story, may be incorporated into the header or within the story text itself, may come at the end of the story, and/or may be integrated in any combination of these locations. During this process, I coded for recurrent themes as well as structural and generic characteristics of each of these types and sections of multiple fan texts.

Following this, I concentrated on focal participants' interactions in FFN including their headers, Author's Notes, excerpts from their narratives, and reader reviews of their narratives to create a broad typology of meaning-making and information exchange. Through multiple readings, I looked for a correlation

with the themes and characteristics identified in the general fan fiction community texts and also coded for new patterns that were specific to focal participants' texts. Examples of this initial broad coding include categories such as *thematic topics* in all types of texts such as culture, language learning, identity, peer pressure, and fandom; *functional characteristics* of headers and Author's Notes such as informing, introducing, greeting, leave-taking, and self-deprecation; and *functional characteristics* of reader reviews such as scaffolding, positive feedback, negative feedback, and encouragement.

The finer stages of analysis involved breaking texts down into *lines,* which are simple sentences or clauses that, much like "idea units" (Gee, 1986), are counted as separate lines only when the unit introduces new information. The lines were then grouped into topical segments that are similar to what Gee (1996) refers to as *stanzas* or "sets of lines about a single minimal topic, organized rhythmically and syntactically so as to hang together in a particularly tight way" (p. 94). Because data were in written format, segments were often determined by the writer's own spacing. These lines and stanzas were then coded in terms of *genre, discourse,* and *style* (Fairclough, 2003). These stages of analysis are explained in detail in the individual chapters of this book as a means of contextualizing the particular analysis being presented.

Social, Cultural, and Global Contexts

Sociocultural approaches to language and literacy as socially situated practice are also useful for understanding how the patterns of participation in informal online learning spaces might be linked to larger shifts in our increasingly globalized society. A great deal of work within the NLS has foregrounded the relationship between literacy and context in terms of how economic and social changes are linked to new global capitalism and a "knowledge economy" (Lankshear & Knobel, 2003) in which the creation and dissemination of information rivals manufacturing and material objects as a focus both for work and leisure activity in many nations. However, work within new literacies and critical cultural studies can also be particularly helpful for locating such practices within larger patterns in an increasingly globalized, networked, and information-oriented context. As an example, Eva Lam's (2006) innovative work on diasporic populations of adolescent Chinese-American ELLs draws from work in the NLS as well as from cultural studies to examine how "trans-border social networking" and cultural flows of information through new ICTs enable immigrant youth to create online "imagined worlds" or *mediascapes* that serve as "new contexts for language learning, literacy development, and socialization" (2006, p. 1).

Research situated within larger cultural and political contexts enables us to see more clearly how youths' online literacy practices are related to emerging economic and social patterns of globalized participation and communication that carry across national borders. As Lam (2006) argues, within literacy and second language studies, such connections make us aware of larger patterns of movement away from strict nationalism and compel us to consider how approaching language instruction in terms of *acculturation* or assimilation to the culture of one's adopted country perhaps should be replaced with one of *transculturation* or socialization into multiple languages, modes of meaning-making, and of belonging. This notion of transcultural identity is explored further in Chapter 5. Moreover, work within new literacy (Lankshear & Knobel, 2003, 2006; Luke & Carrington, 2002) and cultural (Appadurai, 2001; Castells, 1996) studies that theorizes the new formations of our globalized, networked society can also help us to more clearly apprehend the parallels and discrepancies between the sort of learning and participation taking place within informal learning sites and the sort of learning and participation valued in contemporary global workplaces as well as social spaces. Ideally, this knowledge could then be applied to the development of curriculum and pedagogy in formal learning sites such as schools that would also mirror and offer students options for successful participation in transnational society.

Fan Fiction and Affinity Spaces

Access and Affiliation in New Spaces

Access and Affiliation

During my observations across FanFiction.net (FFN) and other fan fiction–related sites, the notions of "access" to and "affiliation" with second language acquisition (SLA) and writing emerged as salient themes. David and Yvonne Freeman (1994) posit a series of in- and out-of-school factors that affect language learner's *access* to SLA such as the student's background knowledge and experiences, interactions with peers and teachers, teaching and learning approaches, and level of acceptance within the community. These all seemed to be salient elements of FFN that influenced English language learners' (ELLs') participation within this space. In addition, the concept of *affiliation* emerged in a variety of ways, including the notion of "language affiliation" or the level of identification or allegiance learners have with the target language (Rampton, 1990), fans' commitment to or affiliation with a specific fandom, their "affiliatory" activities with other fans (Alvermann & Hagood, 2000), as well as fans' dedication to or affiliation with online composing and publishing (see [Black, 2005] for further discussion of these concepts). As such, a spatial lens is useful for viewing the totality of the FFN archive situated within the broader fan community, as a means of understanding how fans' literacy and social practices, coupled with the design features of the site, interact to shape a writing space that engenders affiliation with and facilitates access to literacy and language learning.

Defining New Spaces

If asked to give a definition of space, the vast majority of individuals most likely would rely on metaphors and descriptive terms rooted in physical and material dimensions. However, in recent decades the development and proliferation of new information and communication technologies (ICTs), such as the Internet

and the World Wide Web (WWW), have forced us to rethink our notions of space. Explorations of text-based Multi-User Dungeons (MUDs) and Multi-user Object-Oriented Domains (MOOs) (Cherny, 1995; Turkle, 1994, 1995), online discussions (Mitra, 1997), journaling (Guzzetti & Gamboa, 2005), instant messaging (Lewis & Fabos, 2005), Web sites (Lam, 2000; Stone, 2005, 2007), chatrooms (Lam, 2004, Merchant, 2001), Usenet groups (Baym, 1995; 1996), virtual communities (Rheingold, 1993), and Massively Multiplayer Online (MMOGs) and Video Games (Black & Steinkuehler, in press; Gee, 2003, 2004b; Purushotma, 2005; Robison, 2006; Squire, 2002; Squire & Jenkins, 2003; Steinkuehler, Black, & Clinton, 2005; Steinkuehler, 2006; Thorne, forthcoming; Thorne & Black, forthcoming) have called attention to the range of complex social interactions and forms of participation and learning that take place and play a formative role in the development of such "virtual" spaces. Conceptualizing spatiality in this way requires acknowledgment of the socially constructed nature of the concrete and the virtual or online terrains of our daily lives (Burbules, 2004; Soja, 1993, 2004). Thus, while physical boundaries and material objects may shape and constrain our social worlds in certain regards, individual and collective actions may also play an active role in shaping the perceptual as well as the more tangible fields of our social landscape (Freire & Macedo, 1987).

As Soja (2004) points out, the recognition that social structures, such as schools, economic structures/frameworks, and cities, are not fixed or natural "opens up new ways of looking at literacy and learning, building on the interplay of spatial and literary practices as social constructs, real and imagined forms, and dynamic processes" (p. x). Indeed, literacy researchers have applied spatial lenses to their research as a means of understanding the role of language and literacy in the discursive, relational, and dynamic processes of constructing in- and out-of-school spaces (Leander & Sheehy, 2004; Gutiérrez, Rymes, & Larson, 1995). However, save for a few studies (Gee, 2004b; Steinkuehler & Williams, 2006), such lenses have seldom been applied to literacy practices in popular online spaces. Thus, in this chapter, I take an interpretive stance that foregrounds the roles of language, literacy, and social practice, both individual and collective, in the discursive construction and maintenance of FFN. As such, this chapter is descriptive in nature and uses a spatial lens to characterize the many ways that language and literacy are used in the design of online social space as well as to understand the potential for initiating change and various opportunities for creative transformation that are afforded by the site design. Furthermore, the chapter illustrates how such affordances might provide enhanced opportunities for language and literacy learning.

In the past several decades, sociocultural approaches to literacy and language acquisition have documented how the role of social context (Heath, 1983) and specific social practices (Gee, 1996; Street, 1984) can play formative roles, not only in how individuals use language, but also in how different forms of language use are perceived. Macrolevel (Fairclough, 2003) and genre analyses (Cope & Kalantzis, 1993) bring a historical perspective to bear on such work by considering how dominant discourses, orders of discourse, and genres inform and mediate as well as shape and constrain individual language use. Much of this work conceives of context as a backdrop for social exchanges that are mediated through constructs such as genres, language, and discourse. Adding a spatial dimension to such analysis focuses attention not only on the ways in which Discourse mediates and shapes interaction but also on the ways in which language and Discourse can serve to shape and transform social space, thus creating new possibilities for interaction and contexts where potentially new forms of linguistic interaction are recognized and valued.

In addition, a spatial perspective challenges the notion of space as a static entity that has been produced cumulatively and chronologically over time. As Lemke (2004) points out,

> Space is not a Kantian *a priori* category. Spatiality is the product of action, or more generally of material processes, through which we can construe relations we call spatial, as well as those we call temporal, among "moments" of what we take to be the same on-going process. (n.p.)

Such a perspective refocuses attention to how moment-by-moment, individual and collective interactions take place at the "nexus" or intersection of diverse and multiple space-times (Leander, 2004). For example, it has been argued that Bakhtin's notion of chronotopes encompasses not only the semantic aspect of text but also the "cognitive strategies" and/or "schema" that writers and readers bring to texts to both reconcile and conceptualize the divergent temporal and spatial locations of reader, writer, and text (Keunen, 2000). Foucault also attends to sites of temporal and spatial convergence with his characterization of *heterotopias,* or spaces where personal and social interests and experiences, as well as temporal and historical structures, may meet and intermingle in a single location (Foucault 1986, as cited in Hirst, 2004).

Rommetveit (1974) approaches the construction of space from a linguistic perspective, highlighting the importance of the "here-and-now" of communicative context. According to Rommetveit, interaction between writers and readers and/or speakers and listeners takes place in a "temporarily shared social reality"—that is, a social reality constructed through the phenomenological exchange or sharing of semiotic resources, during which interactants try to reach an accord on or understanding of the meaning of each other's texts and/or ut-

terances. Rommetveit (1974) characterizes the nature of human interaction with a notion of mutually constructed interactive spaces that can be applied to understanding how writers and readers have multiple options for mutual negotiation and construction of meaning in online fan fiction spaces.

> Communication takes place in a pluralistic and constantly changing world, only temporarily and partially shared. What constitutes the *here-and-now* at any particular moment of any particular dialogue is hence never an entirely public affair: it cannot be captured in terms of "conceptual realities" imposed upon the situation from the outside, independent of the presuppositions and situationally determined perspectives of the individual participants. Nor can it be adequately described in terms of the private and idiosyncratic experiences of those individual participants. (p. 24, emphasis in original)

Participation in online fan fiction sites is grounded in various "conceptual realities" that are imposed from the outside. For instance, there are the conceptual realities of the original media canons, the genres and conventions of narrative writing, and the constraints of traditional, print-based English. There are also generic and social conventions specific to online fan fiction communities that shape and constrain participation. However, while these preexisting, "public" conceptual realities provide a point of departure for communication, the broader ethos of fan communities and the ever-evolving nature of online interaction also support a great deal of textual innovation.

This textual innovation is often rooted in private, individual discourses and styles; however, it is also formed through patterns of participation that come into being as a result of *here-and-now* negotiation of meaning between participants in communicative acts. Thus, as discussed in Chapter 4, both public and private genres, discourses, and styles provide constraining frameworks. However, they also provide points of departure through which fans are able to connect, communicate, and create novel texts in dialogic or what Rommetveit (1974) calls *intersubjectively established* social realities. From this perspective, utterances cannot be divorced from the "here-and-now" of context, as they were generated to fulfill a specific purpose within a perceived social space at a particular moment. When applied to fan fiction texts in online contexts, Rommetveit's notion highlights how each interaction between writers and readers contributes not only to further understanding of each other's meanings but also to their perceptions and thus constructions of the writing/reading space.

In this period of widespread global migration, new media and ICTs allow products, perspectives, and information to be disseminated across time and space in an instant. Moreover, such ICTs enable individuals not only to traverse but also to occupy multiple social and historical spaces at once. For example, an ELL youth may sit at a computer in her living room writing fan fiction, pre-

tending to do homework, as her mother prepares dinner. She may be developing a fan fiction that merges a modern-day anime series dealing with themes of man versus technology with a historical text evoking ideas about the role of women in ancient Japanese society, while at the same time using this text to explore and represent her own ideas and experiences of growing up as an Asian female in North America. She also may be drawing from her knowledge of academic forms of writing, different media genres, and her knowledge of English, Japanese, and perhaps Mandarin Chinese or Spanish to construct the text. While writing, this ELL youth may be carrying on several conversations at once via Instant Messenger programs, chat rooms, and/or discussion boards, in which participants are located in her former hometown in China, her new hometown in North America, and other such geographically dispersed places. Furthermore, these participants with whom she is interacting may be contributing to the text by offering their own linguistic and cultural inputs, providing ideas about the experience of being female in different countries, and/or directing her to different resources that are distributed across the Web. In turn, she visits these Web-based resources as she simultaneously carries on chat conversations, considers how her readers might react to what she presents in her text, and intermittently talks with her mother about what she did in school today.

This scenario is representative of the sort of activities that many youth today are accustomed to participating in. Such activities "constitute a whole new cultural realm of 'play' and sociality which go beyond the phenomenal world: the materiality of place and the linearity of analogue time" (Luke, 2000, p. 80). Such activities also present new challenges to our standard notions of space, traditional ways of characterizing location, and our usual means of identifying participants in an activity. Fan fiction authors, such as the ones participating in this study, are learning to write in globally networked, pluralistic arenas where the convergence of different modes of representation, media, texts, languages, literacies, and perspectives is commonplace. This can be contrasted with the sort of learning that often takes place in enclosed spaces such as composition classrooms where peer interaction is confined to a largely homogenous group determined by geographic location and socioeconomic status (e.g., districts). In addition, in many classrooms, student activity is structured not only by physical arrangements but also by school and classroom rules as well as the authority of the teacher. Such classroom scenarios seem to offer little room for student innovation and for writing outside the margins. Nor do they offer opportunity for individuals to use language and other mediating systems to selectively position themselves and to construct and enact certain socially and/or spatially situated identities.

Affinity Spaces

Terms and Definitions

In his text *Situated Language and Learning: A Critique of Traditional Schooling,* Gee (2004b) distinguishes between the well-known notion of "communities of practice" (Wenger, 1998) and *affinity spaces* as an alternative construct for looking at learning. Gee points out that although communities of practice have been a useful concept for approaching learning in novel ways, there are certain complications that arise when using the notion of community to conceptualize a space. First, the word "community" implies a certain level of connectedness and belonging that all occupants of a space may not feel (e.g., an ELL student may feel marginalized in a classroom community by linguistic and cultural differences). Second, the notion of community implies a static sort of membership and does not allow for a robust characterization of the ebbs and flows and differing levels of involvement and participation exhibited by occupants of a space (e.g., a student who feels marginalized may choose not to participate in classroom activities or may participate sporadically). Approaching FFN as a *space* rather than a *community,* then, is a way of focusing attention on the interplay among engagement, active participation, a sense of belonging, and the production of social space.

Gee (2004b) uses several specialized terms to concretize a general notion of space, starting with that of *content,* or what the space is "about" (p. 80, emphasis in original). *Generators,* in turn, are the various sources for this content. Generators may include physical objects, individuals, and institutions, as well as signs, signifying systems, and conceptual frameworks. From this viewpoint, space can be explored in terms of the *content organization,* or the objects and signs that make up the design of a space. In addition, space can be explored in terms of the *interactional organization* or the ways in which people interact with the content and with each other. Clearly, the two are not mutually exclusive, as content organization influences people's interactions in and responses to a space, and, if observed or allowed, individual's interactions and reactions in turn may shape the subsequent content organization. In Web sites, both the content and interactional organization of the site is primarily determined by the site designers. However, a main premise of this book is that many online affinity spaces based on fan and popular culture, such as FFN, are designed in ways that avoid a binary distinction between site designers and site users, thus allowing users to create, shape, and reshape the site and its content. Moreover, such a design contributes to users' commitment to the site and its concomitant literacy-related activities.

Content Organization of FanFiction.net

As mentioned previously, according to popular lore, FFN was created by a young software designer/anime fan in 1998 (Wikipedia, FanFiction.net, 2006). In addition to the founder, the site has had many different members of the fan community assisting and fulfilling various administrative roles throughout the years on a voluntary basis. Generators for site content are too numerous to list; however, prominent generators would include the following: creators of the original media, creators of the individual fan texts posted on the site, fans/readers who post reviews of fan fiction texts, and site administrators. Table 1 presents the current content organization of the site.

TABLE 1. Sections of the FanFiction.net Web Site

Section	Contents
Home Page	Messages from site administrators; links to other sections of site
Canons	Anime, Game, Book, Miscellaneous, Cartoon, Movie, Comic, and TV Show. In addition, each canon includes links to all the sub-subsections for the individual media canons (e.g., the anime sub-section has approximately 500 different anime canons, ranging in number of posted fan texts from 1 to 57,000).
Personal Pages	Optional user information and biography; user interface for setting preferences and Alerts (e.g., the site allows for automated Alerts so that members receive e-mails when selected authors post or update stories, or authors can receive e-mails when readers post reviews of their own texts, etc.); links to all stories the member has authored; links to favorite authors and fan fictions; links to any C2s (see below for definition) they belong to; optional links to personal Web sites.
Fan Texts	Individual pages for each fan text (linked to subsequent chapters).
Reader Reviews	Feedback posted for each chapter of a fan text
C2s	Fan-run communities or forums for meta-commentary on elements of writing (e.g., settings, genres, conventions), etiquette of peer review, and fandom (e.g., favored character pairings) and collections of certain types of fan fictions.
Directory	Searchable listing of all registered members of the site.
Dictionary/Thesaurus	Searchable database with links to definition of general as well as fandom-specific terms.
Terms of Service	Copyright information; Help section where registered members may submit requests for help, report bugs, inform abuse of site policies, and submit feedback.
Rating System	Page explaining the FanFiction.net Ratings System: K (Ages 5+), "content suitable for most ages"; K+ (Ages 9+), "some content may not be suitable for young children"; T (Ages 13+), "contains

	content not suitable for children"; M (Ages 16+) "content suitable for mature teens and older"; MA (18+) "contains explicit content for mature adults only" (Fiction Ratings, 2006). (No fictions with explicit violence or sexual content are allowed.)
"Just In" Page	Chronologically lists new fictions from all canons as they are posted to the site to draw attention to them.
Search Page	Members may search for fictions by pen name, genre (e.g., humor, romance, angst), language (i.e., the site is set up to host fictions in approximately forty languages), featured characters, rating, canon, date, and status (i.e., whether it is in process or is complete).

From looking at this list, it is clear that the site is designed not only as an archive for completed fictions but also as a space intended to maximize discussion and socialization among fans. In fact, to this end, the site provides an in-house instant messaging system to facilitate fan fiction–related chat. In addition, the site is constructed in a way that allows for a great deal of interplay between the content organization and the interactional organization. For instance, on the home page, administrators list updates and changes that will affect participants' use of the site. In turn, there is a help page where members may submit comments about how to improve the structure and performance of the site.

Interactional Organization of FanFiction.net

Gee (2004b) posits that online affinity spaces represent the cutting edge of effective learning environments in several respects. This is largely because of a set of crucial defining features of paradigmatic affinity spaces that are exemplified by FFN. To begin, the primary defining feature of affinity spaces is that they are organized around a shared passion or a common endeavor. In my study, members of FFN share a passion for the anime series *CCS* (*Card Captor Sakura*) and for writing fan fiction. As such, affinity spaces are unique in that they provide opportunities for individuals who do not share the connections, bonds, geographic proximity, or other typical hallmarks of community to "gather" and become affiliated in a material or virtual space. In addition, because affinity spaces are organized around a common endeavor or interest rather than around temporal or spatial proximity, they are often able to span differences in gender, race, class, age, ability, and education level. Participants in FFN are clear examples of this sort of heterogeneity, as they come from countries across the globe; post fictions, comments, and reader reviews in many different languages; and range from small children in school to homemakers to university professors.

Experts and Novices

Another defining feature of affinity spaces is that "newbies," or novices, and experts share the activities and participate in the same space. This can be contrasted with communities of practice in which novices are viewed as operating at the periphery of meaningful activity until they are scaffolded into legitimate participation through their interactions with masters (Lave & Wenger, 1991; Wenger, 1998). This can also be contrasted with classrooms in which students are often relegated to skill and drill and remedial tasks if they are not viewed as expert enough to participate in a given activity. However, on FFN, there are no constraints in place to prevent novice and/or ELL writers from posting fictions in the same spaces that advanced writers and native English speakers would. In turn, this affords novice and ELL writers access to the same resources and forms of participation that experienced fan fiction authors and native English speakers have. This shared nature of composition and learning space helps ELLs to take on the identity of writers and to further their language and literacy development through authentic and meaningful rather than remediated writing practices.

Another related feature of affinity spaces is that there is a wide range of expertise and many forms of knowledge that are valued; thus, the roles of "expert" and "novice" are highly variable and contingent on activity and context at any given moment. This is in contrast to the communities of practice formation in which there is a certain target body of knowledge or skill set into which novices are being apprenticed (Lave & Wenger, 1991). This feature of affinity spaces is particularly significant for providing ELLs with access to and many options for meaningful participation in the site. However, before discussing this topic, it is helpful to first address the concept of *portals*. FFN has many different portals, which are defined as "anything that gives access to the content and to ways of interacting with that content" (Gee, 2004b, p. 81), both within and outside of the site. For example, the in-site Dictionary/Thesaurus, the options for posting in different languages, and the writing and reading-related Forums are all portals that scaffold fans' access to the site content. Grammar and composition textbooks, as well as general writing help sites, and fan fiction–specific help Web sites also assist in providing access to the site content. The different forms of media and popular culture that provide information about the various fan fiction canons also are portals. In addition, fans who write collaboratively, both in the C2 writing communities as well as in offsite places such as homes, classrooms, school libraries, and so on, serve as portals for each other. Thus, there are many diverse systems in place for providing users with access to the site.

Portals and Active Participation

An additional paradigmatic feature of affinity spaces that makes them so effective for promoting engagement, affiliation, and learning is that many of the portals serve as strong generators for content on the site. The very genre and nature of fan fiction lends itself to this active production and distribution of content information (Jenkins, 1992). In creating their texts, fans are contributing to or expanding the corpus of knowledge around the original media. For instance, one fan might create an OC or Original Character that does not exist in the primary media canon. Then, with that fan's permission (it is considered good form to request permission from the OC creator; however, this does not always happen) another fan may incorporate that OC into his or her texts. The same can be said for the creation of new settings in AU, or Alternate Universe, fictions and/or in fictions that extend the original plotlines of the media. Such additions to content may then become part of the *fanon*, a play on the word canon denoting "information or characterization that has never been confirmed in canon but is accepted as such by fans" (Fanfiction Glossary, 2006), and/or may become a departure point for other fan texts.

The notion of portals as strong generators also relates to the distributed nature of knowledge and the wide range of expertise that is valued in effective affinity spaces. On FFN, many of the portals that promote access to content and participation are created and maintained by fans. For example, in 2002, the site hosted Columns that were written by members who volunteered to write about their particular fan fiction–related interests, specialties, and/or pet peeves. The columns covered a range of meta-topics aimed at helping fans to improve their writing and reading skills (see discussion of Forums in the Content Organization section of this chapter for more details on Column topics). In this way, fans were able to shape the interactional organization of the site by posting Columns with guidelines for how to effectively write and/or review fictions, how to avoid flaming, and how to provide constructive criticism, to name just a few, which then served as a guide for newbies (newcomers) and other members of the site to shape their participation. Also, these columns then became part of the content and distributed knowledge base of FFN and continued to shape future fan texts and feedback as fans visited the Columns and followed the columnists' advice. Hence, the site provides many options for users to contribute to and shape the site content.

Multiple Routes to Knowledge

Another defining feature of affinity spaces is how knowledge not only is distributed within FFN but also is dispersed across other spaces outside of the

site. Fan fiction authors are encouraged to do research for their texts using various resources, such as textbooks, other Web sites, books, encyclopedias, and such, to investigate historical eras and to find out more about characters, different languages, types of clothing, lifestyles, and mannerisms that are specific to certain temporal and geographic settings. As one example, there is a LiveJournal community devoted to fan fiction–related research (http:// community.livejournal.com/fanfic_research/profile). In this LiveJournal space, fans post requests for information about certain canons, share resources about specific time periods and geographic locations, and engage in general discussions about conducting fan fiction research. For example, in one post, a fan fiction author requests references for information on how people lived in the mid-1300s in England. This author received responses that pointed to a variety of online resources including a university's "e-museum," a private Web site on medieval life, maps, and a Wikipedia entry on medieval times. Another such post includes a fandom-specific request for help with identifying the name of the mystical puzzle boxes appearing both in a Jackie Chan movie and in an anime series. This particular fan received a response that pointed him toward a Web site devoted to information about different television series hosted by the CNET Network, a group that maintains a diverse selection of business-related and consumer information Web sites. From these examples, it is clear that fans act as resources for and share knowledge with each other. They also draw from and help each other to locate knowledge that is distributed across diverse personal, professional, and academic arenas.

Beta-reading and writing help sites are distributed sources of knowledge that also scaffold ELLs' access to successful composition and language learning. Beta-readers, in essence, are proofreaders and/or copyeditors, and they are an integral part of online fan fiction culture (Black, 2005; Karpovich, 2006). There are increasing numbers of Web sites and online LiveJournal communities where authors can officially seek out the advice of beta-readers (Black, 2005; Karpovich, 2006). To submit a fiction to many of these sites for review, authors often fill out a form indicating the genre (e.g., angst, humor, romance) and media canon (e.g., *Harry Potter*, *Sailor Moon*, *X-Men*) for the fiction and specifying which aspects of writing they would like the beta-reader to focus on (e.g., characterization, plot development, adherence to genre, grammar and spelling conventions). This creates a peer-review pairing where the designated beta-reader is qualified to and interested in reading fictions from that particular genre and can also contribute the sort of composition-related feedback that the author has requested (Black, 2005). Writers will sometimes seek out help from skilled and available beta-readers by posting a request in the Author's Notes (A/Ns) at the start of their fictions or by posting "advertisements" on various beta-reading sites and

fan fiction forums. Also, many authors will pair with specific beta-readers who regularly read drafts of their stories and provide pointed feedback on how to improve their fictions before the text is published on the Web site. In addition, readers on FFN also fill the role of peer reviewers by providing feedback on story elements such as plot, characterization, grammar and spelling, and simply whether or not they enjoyed the text and why or why not.

Many fan fiction and help sites also feature a range of meta-discussion on elements of fan fiction–related topics that are relevant to and in many ways mirror school-based composition topics and practices, such as peer review, giving constructive feedback, editing, proofreading, effective plot development, robust characterization, and constructing effective rhetorical structures, to name just a few (Black, 2005, 2007; Jenkins, 2006, 2004). Furthermore, as in paradigmatic affinity spaces, because knowledge on FFN is both *intensive* or specialized, such as ELLs introducing knowledge about their first languages or Asian culture, and *extensive* or broad, such as readers drawing from a general knowledge of fan fiction to post reader feedback, leadership turns out to be "porous" and variable in such spaces, as these many different activities and valued sources of knowledge provide multiple opportunities for *all* members to both teach and learn (Gee, 2004b, p. 87). Moreover, leaders and experts, rather than attempting to restrict participation by acting as authority figures, instead attempt to scaffold participation by acting as resources and as facilitators.

In- and Out-of-School Spaces

Shaping and Transforming Space

In terms of learning, affinity spaces such as FFN can be contrasted with school spaces in countless ways. One of the most striking differences between FFN and many classroom spaces is the extent to which participants are able to play an active role in shaping the interactional and the content organization of the space. As Gee (2004b) points out, in classrooms "portals are rarely strong generators where students both interact with the signs that constitute the content of classroom instruction and are able to modify, transforms, and add to them" (p. 88). Specifically, students have few opportunities to contribute knowledge in meaningful ways that might actually shape the course and type of instruction offered. In contrast, the administrators of FFN are constantly taking member feedback and knowledge into consideration when updating the site. The following message from site administrators illustrates the strong emphasis on interaction between members, administrators, and site structure and content.

Support.Fanfiction.net is now open. The new support area has been created to improve response time to user problems, new category/character list requests, and general bug reports. Please note the support area is only available to registered members. (FanFiction.net, 2005)

The post highlights attentiveness to member concerns on several different levels. First, it shows a desire to fix any problems that may be interfering with users' ability to access the site content. Moreover, this includes a desire to accommodate these needs in a timely fashion, thus decreasing the chances of "losing" users as they become lost in and/or do not have full access to content. In addition, the post mentions "new category/character list requests" that demonstrates a concern not only for access but also for catering to and allowing for the creation of content that users find engaging, can understand, and can affiliate with. Specifically, the administrators want to be able to quickly modify the list of media canon categories available for writing in and the searchable list of characters that a text might feature based on member suggestions. This is important because many fans want to read fictions with certain characters and/or certain romantic character pairings. Thus, to help users find acceptable fictions, when uploading a new text, authors must identify the main characters that are presented in the narrative, and readers can then search for texts according to these criteria. Thus, by submitting requests for the addition of new characters and reporting bugs, users are able to shape the site content organization via the site administrators. Conversely, it is relatively rare to find classroom settings where students are able to give teachers feedback about the effectiveness of their pedagogical practices, and then have this feedback taken into account in subsequent lesson planning.

FFN also differs from school spaces in terms of the potential it offers for fans to contribute to the content of the site. In classrooms, students commonly are positioned as passive recipients of the teacher, textbook, and curricular knowledge and are seldom provided occasions to construct and generate their own perspectives on the information being presented to them. Compositions are generally produced to display facility with a certain genre of writing, an understanding of a specific canonical text, and/or mastery of certain forms and conventions of writing. There are few, if any, opportunities for students to actively contribute to or offer alternate readings of the literary canon of the classroom. Conversely, as Jenkins (1992) points out, "by integrating media content back into their everyday lives… by close engagement with its meanings and materials" fans are able to "fully consume the fiction and make it an active resource" (p. 62). Thus, one of the main purposes of participation on FFN is to actively contribute to the story surrounding a particular media text. Thus, fans

are using language and writing to create and generate meaning that will be read and enjoyed by other members of the site, rather than graded and discarded.

This relates to another notable difference between affinity spaces and schools, which is the opportunity affinity spaces such as FFN afford for *all* fans to take on powerful and meaningful social roles and to shape the content and interactional organization of this space. In classrooms, learners or novice students often remain at the periphery of meaningful activity, relegated to rote memorization, busywork, and/or mimicry, whereas more advanced students engage in lessons that involve authentic and powerful uses of language and literacy. Conversely, in FFN, there are many different "expert" roles for participants to fill. ELLs can help monolingual English speakers incorporate different languages into their texts. Struggling writers who are well versed in certain media canons can act as beta-readers, checking for adherence to the original media text.

Also, because knowledge is distributed and dispersed across different areas, writers, readers, and beta-readers can work in tandem, point each other toward helpful resources, and act as resources for and support each other's efforts. Struggling writers and readers alike can post links to personal Web sites where they display expertise in other areas such as fanart, Web design, and gaming, to name just a few. Moreover, such sites can also serve as sources for fandom-specific information, as other members of the site visit them to find information about certain characters, specific episodes of the series, and so forth (i.e., When composing fan fictions, I visit certain *CCS* fan sites that list detailed information about the characters' likes and dislikes, origins, and/or their role in a particular episode, and many of these sites are hosted by very young fans and nonnative speakers). Thus, novice and expert roles are not fixed, but rather shift between actions and activities. Moreover, there are many routes to gaining status and generating content knowledge that is valued within and outside of the site.

Envisioning New Spaces

Gee (2004b) argues that it is instructive to begin comparing the features of affinity spaces to typical school spaces for several reasons. First, the learning and design features of many schools sites differ considerably from those of affinity spaces. Thus, as many youth have a great deal of positive experiences with out-of-school affinity spaces, they are apt to compare and contrast such experiences with their activities and opportunities (or lack thereof) to learn and interact in schools. Second, affinity spaces are increasingly more prevalent in our modern, highly networked, new capitalist world (Gee, 2004b). Gee (2004b)

provides several examples to illustrate the prevalence of affinity spaces such as companies that organize Web-based affinity spaces for niche-market consumers to gather and discuss certain products. For example, at one time, the Volkswagen Corporation's official site for owners opened with the following quote.

> VW owners are a special breed. That's why we have a place just for you. You'll find everything you need right here: Service & Maintenance schedules, tips on giving your VW the TLC it deserves, accessories, the VW Club and more. (www.vw.com, 2006)

Other examples include businesses that position employees as "partners" working in cross-functional, project-based teams that are disbanded and reformed after the completion of specific projects and social activism groups with members from all over the world that affiliate around common causes such as environmentalism, women's rights, and fair wages, to name just a few. Also, there are temporary or long-term academic committees that are composed of faculty and researchers across various disciplines that affiliate and work together around a common cause or endeavor. Effective participation in such spaces entails *procedural* knowledge (Lankshear & Knobel, 2003) or knowledge of how to go about navigating links and networks between people, between organizations, and between different resources to facilitate further learning. This also involves knowing how to use language to discursively construct identities and position oneself in ways that enable access to resources, affiliation with other members of a space, and, thus, access to further learning. Conversely, most classrooms and schools are rooted in a system that values *propositional* knowledge, or that of memorizing facts and figures and mastering established genres and forms of information.

Essentially, what this means is that many youth are engaging in meaningful forms of participation and meaning-making in leisure-time and out-of-school activities and will most likely be participating in affinity spaces in workplaces and sites of higher education in the future. However, they may not be exposed and/or scaffolded into such spaces and forms of participation in schools— which, in theory, are the median step intended to prepare students for social and economic advancement in the broader society. Should this continue, students with unlimited access to technology, networks, and online learning and affinity spaces will continue to learn and master the procedural knowledge and digital literacy skills that will enable them to excel in higher education and work settings. On the one hand, many students who do not have the financial resources to provide unlimited access at home will fall behind in these skills. On the other, because students are quite resourceful at finding access to computers, the Internet, and thus online affinity spaces, it is possible that the majority of

students will become even less engaged with school than they already are, viewing it as an antiquated, self-contained system with little relevance to personal and professional domains where technological and digital literacy skills are considered fundamental (Luke, 2000).

It is important to note, however, that such spatial perspectives and approaches are not solely applicable to online or "virtual" sites. Classrooms themselves are designed learning spaces composed of unique configurations of teachers, students, institutions, interactions, activities, tools, and technologies that change from day to day and year to year. Language and literacy researchers have used spatial lenses to study and conceptualize effective classroom design in which the teacher is responsible for organizing the context for learning and interaction, much like Web site designers do. Nearly ten years ago Gutiérrez, Baquedano-López, and Turner (1997) put forth the concept of "radical middle" or third space classrooms in which effective pedagogical practices and design are notably consonant with the paradigmatic features of affinity spaces discussed in this chapter. In the radical middle authentic language use is at the center of learning. Students are able to draw on "the linguistic resources and conventions of both the individual student and the repertoires of the larger community" (Gutiérrez et al., p. 372), thus allowing for more equitable forms of participation. Moreover, knowledge is made accessible to all learners via distinct portals, such as connections between students' linguistic and cultural knowledge and classroom literacy practices, small group lessons in which more advanced students can scaffold participation, a variety of strategically employed pedagogical and discourse practices, use of a wide range of texts, and explicit instruction by "experts" such as the teacher. However, in such a design, the teacher is not the only literacy expert or "broker" (Gutiérrez et al., p. 373), as there are multiple opportunities for *all* students to act as both experts and novices, and the roles of teacher and learner are dynamic and shift according to each activity. Such features are in keeping with what we know about effective practices in literacy and language instruction—as such, it is interesting to see similar practices emerging in popular out-of-school spaces such as FFN, where many ELLs practice and improve their writing and English literacy skills voluntarily (Black, 2005, 2006, 2007).

Rather than viewing media, the Internet, and new technologies as threats to traditional forms of knowing and ways of being in the world and/or the classroom, it is possible to envision school spaces where new media and ICTs "have the potential to enhance and expand teacher repertoires by taking tremendous pressure off their shoulders to be the sole source of classroom knowledge and interpretation" (Luke, 2000, p. 90). Teachers might take on the mantle of learner, and explore the potential of learning in both on- and offline affinity

spaces with their students. This might also entail the development of class-rooms that are much like affinity spaces, in which the content and interactional structures mutually inform and transform each other according to individual and group needs. Such an approach also shifts focus away from models where reading and writing are viewed either as subject areas or as vehicles for learning content to a perspective where language, literacy, and text are seen as integral components of how the "temporarily shared social realities" (Rommetveit, 1974) of radical or virtual learning spaces are constructed and maintained through a constant process of interaction and negotiation between teacher and students. In recognition of such widespread changes, perhaps it is time to begin creating learning environments that, rather than reinscribing and relying on tra-ditional structures, conventions, divisions, and notions of literacy, instead make use of the opportunities that online and networked computer environments af-ford. This includes gleaning as much information as possible about informal learning and affinity spaces, such as online journals, blogs, games, fan fiction, and social networking sites, where youth voluntarily engage in sophisticated learning and literacy practices. New media, ICTs, and mindsets afford opportu-nities to expand classroom learning beyond the boundaries of the school walls, into other personal, professional, and academic domains in ways that will facili-tate student knowledge of multiple modes of meaning-making, access, participa-tion, affiliation, learning, and success in a globalized, networked society.

Constructing Narrative and Social Spaces

New Technologies, Literacies, and Identities

Writing and Identity

Contemporary research related to adolescents' digitally mediated practices have focused on the many ways that youth use new media to communicate, develop relationships, access and share information, and author socially situated identities in online spaces. For example, Guzzetti and Gamboa (2005) explore the online journaling practices of Janice and Corgan, two U.S. high school students. Through case study analysis, the authors describe how these young women draw from music, hyperlinks, artistic proficiencies, online quizzes, and hybrid textual forms to represent different aspects of their on- and offline identities. Janice and Corgan also use the site to publicly express their emotions and interests and to display their affiliations with certain social groups that in turn helped them to meet and form relationships with other youth who share similar interests.

Composing online journal entries also helped Janice and Corgan develop their literacy skills in many ways. For example, composing for a broad Web audience spurred careful rhetorical choices, as these young women used text to express their emotions and index their affiliation with certain social groups and/or worldviews. They also put a great deal of thought into reading and re-sponding to the journal entries of their friends, which provided the opportunity for careful reflection on and consideration of their own ideas in relation to the perspectives presented in friends' journals. Thus, like the fan fiction authors who are discussed in this chapter, the online medium provided Janice and Corgan with a means of developing and expressing themselves as individuals. Moreover, these activities also spurred their thinking and furthered their development as purposeful writers and readers.

In a similar vein, Chandler-Olcott and Mahar's (2003a, 2003b) work describes how two adolescents, Rhiannon and Eileen, use various online and fan-related practices, such as e-mailing, creating digital art, developing Web content, and playing online role-playing games, to form, maintain, and strengthen social relationships with both on- and offline friends. Much like Janice and Corgan, these young women used their fan texts to narratively experiment with gender roles, primarily by casting females as protagonists, and to participate in ongoing exchanges related to themes and concerns from their lives, such as "friendship, loyalty, power, and sexuality" (Chandler-Olcott and Mahar, 2003a, p. 583). A common element of these studies is exploration of the ways in which the adolescent focal participants build on preexisting literacy skills and popular cultural knowledge to create texts that allow them to engage in conversations about broad social issues, as they construct and enact different social identities both through and around these issues.

Language and Meaning

Rommetveit (1974) describes linguistically and socially constructed realities that are created and sustained through ongoing communicative exchanges between participants. Rommetveit's work is particularly helpful in this study because it puts forth a notion of *transcendent* forms of language use. These transcendent forms of language allow individuals to represent conceptual realities that are hidden or obscured by *traditional* language use. Such a notion of language as malleable to the "speaker's" communicative purpose is crucial for understanding communication in online contexts—where successful interaction often involves literate practices that extend beyond or transcend print-based writing and reading. For instance, the hybrid forms of English and Cantonese used by chat room participants in Lam's (2004) study are an example of youth transcending the constraints of standard language and constructing new hybrid codes that better suit their communicative needs. Thus, becoming truly literate in such contexts requires navigation of multiple representational resources such as images, color, sound, space, and movement as well as a willingness to negotiate the multiple languages and online registers of globally networked online contexts.

Data for this chapter are drawn primarily from case studies of three focal participants, Grace, Nanako, and Cherry-chan. Data consists of focal participants' texts and textual interactions on FanFiction.net (FFN) including their headers, Author's Notes (A/Ns), excerpts from their narratives, and reader reviews of their narratives. These texts were coded to create a broad typology of meaning-making and information exchange, with themes such as culture, lan-

guage learning, and identity emerging through the process. After developing this broad typology, specific sections of fan fiction narratives, excerpts of interactions, and reader reviews were broken down into *lines* and *stanzas* (see Chapter 2 for an explanation); however, because data were in written format, segments were often determined by the writer's own spacing. These lines and stanzas were then coded to develop a more detailed typology of different kinds of meanings and social functions of these texts, particularly in relation to the *genres, discourses,* and *styles* of textual interactions.

According to Fairclough (2003), genre, discourse, and style are three salient types of meaning that can be used to understand the "relationship of the text to the event, to the wider physical and social world, and to the persons involved in the event" (p. 27). *Genres* are specific ways of acting and interacting in social events. Features of genre include the thematic structure of the text, cohesion devices used (parallel structure, repetition), specific wording, metaphors, politeness conventions, and interactional patterns (Fairclough, 2003; Rogers, 2004). Particular ways of introducing stories, interacting with readers, and providing feedback to authors, as well as ways of acting such as informing, advising, warning, promising, and apologizing, were all coded under the domain of genre. *Discourses* refer to ways of representing self, others, and the world (Fairclough, 2003). Features of discourse include themes, voices and perspectives, ideologies, possible interpretations, and potential audiences for a text (Rogers, 2004). The socially situated (Gee, 1999) ways that writers represented themselves as experts, novices, language learners, adolescents, and fans were coded under the domain of discourse, as well as ideas and beliefs about writing such as "writing as recursive," "writing as exchange," and the like within the fan fiction context. *Style* refers to ways of being or using language as a means of self-identifying (Fairclough, 2003) and aligning oneself within particular discourses and/or genres through linguistic features such as modality, transitivity, active and passive voice, and word choice. Language choice, registers, and paralinguistic features of Internet Relay Chat (IRC) were coded under the domain of style.

Using these lenses, I examine how focal participants constructed texts at the level of genre, discourse, and style to gain access to literacy and language learning, to establish social relationships, and to enact particular socially situated identities. Such an analysis is also useful in understanding the sort of literacy practices these young women are engaging in as they write, read, and respond to fan fiction texts. It also provides a means of exploring the resources fan authors draw from and the purposes that their fan fiction–related activities serve in their lives.

Designing Interactive Writing Spaces

Case Study Participants

The focal participants whose work is discussed in this book, Grace, Nanako, and Cherry-chan, are in three completely different situations as learners of English. Grace is a popular fan fiction writer from the Philippines who has written many multichapter stories on FFN since 2001. It is through reading and reviewing Grace's texts and then following hyperlinks or links to other reviews that the other two focal participants met. Grace, who is nearly ten years older than both Nanako and Cherry-chan, began posting fictions on FFN when she was a teenager. Grace grew up speaking Kapangpangan, which she considers her first language, and started to learn Filipino (a standardized version of Tagalog) shortly thereafter. Grace also began learning English at around age seven at school in the Philippines. English and Filipino are official languages used in the Philippines in media, academic, religious, and business affairs and many residents consider English a second language. Grace primarily uses English to participate in classes, to communicate with people online, and to compose fan fiction. Thus, much of her experience with English has been in written rather than spoken format. This differs from Nanako and Cherry-chan's situations in that they both are living in contexts where English is spoken all around them and both claim to have had greater difficulty mastering written rather than spoken English.

Nanako and Cherry-chan live in the same large Canadian city. Nanako moved to North America from Shanghai with her parents when she was eleven, and Cherry-chan's family moved there from Taiwan before she was born; however, both young women self-identify as English language learners (ELLs) and consider themselves native Mandarin Chinese speakers. Although Nanako and Cherry-chan live in different areas and attend different schools, they met online and developed an on- and offline friendship through their shared interests. They are both avid anime fans and heard about FFN through their online interactions with other anime aficionados. Both young women began writing on the site in junior high, and Nanako has continued to write and post stories on the archive into her high school years. However, Cherry-chan, though still a member of FFN, now has moved the majority of her collaborative fan writing and social interactions to a LiveJournal account and an anime fan forum.

I chose to focus on these three ELLs, Nanako and Cherry-chan in particular, for several reasons. First, because they are friends and have shared interests in the same anime series and their activities in the space are somewhat intertwined through reading and reviewing each other's texts. Next, they became

friends because they gravitated toward the same types of fan fictions and writers in the site; thus, they had very similar textual role models and experiences when they were first learning to navigate participation on FFN. For example, according to Nanako, Grace's fictions served as generic models for constructing her own texts, and analysis demonstrates similarities at the levels of genre, discourse, and style. Moreover, Grace's interactions with readers and presentation of herself as an ELL writer provided both Nanako and Cherry-chan with textual models for representing themselves and for designing their own interactive writing spaces in ways that facilitated their individual language development. In a similar vein, Cherry-chan credits Nanako with scaffolding a great deal of her writing development and participation on the site.

Grace

Grace began composing paper-based fan fictions when she was ten years old; however, because of lack of computer access at her home in the Philippines, posting her fictions online took a bit of negotiation. In an interview, she explains,

> At first I don't have an Internet access or a computer. I started writing by bringing a small notebook with me and wherever I go … I have this notebook. Then when an idea comes … I'll write it. After that … I will rent a computer with Internet access of course … for an hour and type everything and submit on the Internet. (2005)

Grace's enthusiasm for writing and the various anime series provided enough impetus for her to constantly carry around a "plot bunny" notebook. *Plot bunny* is the fan fiction–specific term for story ideas, particularly those that multiply rapidly into other ideas. Her passion for writing within the online fan community also prompted her to engage in the difficult task of composing fictions in her third language of English in order to make them accessible to a broader audience and then paying for computer access to upload them.

The following is an excerpt from the start of Grace's first *Card Captor Sakura* (CCS) fan fiction, published in May of 2001. The excerpt contains two distinct sections. The first section, made up of Segments A–E, is the *header* in which Grace provides readers with information about the text. The second section, Segment F, is the initial portion of the narrative. This particular fiction centers on the romantic relationship between Sakura Kinomoto, the protagonist of the *Card Captor* series, and Syaoran Li, the exchange student from Hong Kong with whom Sakura is commonly paired in CCS fan fictions. Grace's text alludes to the popular couple pairing at the start of the narrative when she flashes back to a "pinky promise" between Sakura and Syaoran.

Segment A

First attempt fanfic of Card Captor Sakura by: Grace all rights reserved on CLAMP

Segment B

First Note from the Author: This is my first attempt fanfic, Enjoy the story and oh, forgive my grammar.. English is just my Second language.

Segment C

oh and sowwy hauuuh... ^.^;; sowwy for the changes.. as you can basically see, that I want to improve not only my story but also on how I present it. ^.^ *nods*

Segment D

This story takes place after Sakura defeated the Clow reed and in this story, there is no movie 2 happened.. and that Syaoran didn't confess he loves Sakura.. he just went back to Hongkong and that, um.. Meiling doesn't know that Syaoran is in love with Sakura. and that- oh what the heck.. just read the story =p

Segment E

Disclaimer: *plays a recorder* remember.. Grace* doesn't own CardCaptor Sakura. she's making the fanfic just for fun.. remember.. Grace doesn't own CardCaptor Sakura.. she's making the fanfic just for fun..remember... *hits the recorder with a mallet* geez.. anyways, the real owner is the CLAMP! goodie good good CLAMP! CHEERS!

Segment F

Affair of the Heart*

Part 1: Yesterday and Today...

Seven Years Ago...

"Sakura! you did it! Congratulations! you finally defeated the Enemy!" Tomoyo said, approaching her
"Your Mission is now finish" Ceberos said, nodding
"Yatta!" Sakura yells as she jumps
Syaoran Li looks down and sighs, he looks at Sakura again, = She's so happy.. = he cleared his throat and said
 "It's time to say Goodbye"
They all look at him
"Pinky Promise?"
 Syaoran nods and they both did the pinky promise..
Seven Years Later...

"Ohayo!"
all the students look and smiles at the girl who entered into the room.

Grace's header is structured in a way that indicates her insider knowledge of the genre of online fan fiction. Specifically, in Segment A the header contains common elements such as title, author information, and a copyright disclaimer acknowledging the derivative nature of the fiction. Segments B and C contain A/Ns that provide readers with information about the authoress—specifically that she is an English learner and that she is trying to improve her composition

skills by posting, revising, and then reposting her texts. Segment D contains a concise summary that provides readers with information about the story—specifically the timeline and information about the state of relationships between characters. Grace's insider knowledge of writing online fan fiction is also clear at the level of style as she draws from IRC register to indicate paralinguistic features such as *nods* and crying ^.^;; (face with tears) or playful =p (side view of face with tongue sticking out) in her writing.

At the levels of genre and discourse, the excerpt discursively positions Grace as a certain kind of fan fiction author in order to establish a particular relationship with readers. For instance, Grace represents herself both as a novice writer within the *CCS* canon in Segments A and B and as a nonnative English speaker in Segment B. In this way, she is able to mitigate critique about potential mistakes. These types of lines have become a standard part of the genre of Grace's headers and/or A/Ns. In addition, in Segment C she is also enacting the role of an author who wants to improve both function and form in her text as she engages in a recursive process of revising and reposting her fictions in response to new insights and audience feedback. As discussed in the analyses throughout this book, one of the benefits of posting fan fictions online is the opportunity for receiving immediate feedback from a broad audience; however, authors respond to this feedback in very different ways. Some writers, like Grace and Nanako, often take their fictions down, revise parts of them according to readers' suggestions about topics such as plot, character relationships, and grammar, and then repost them. Other authors directly acknowledge feedback and thank readers for providing it, but instead of revising and reposting fictions, they choose to incorporate readers' suggestions into subsequent chapters and new texts. Some other fan authors completely ignore audience input.

Grace's willingness to work hard on her fictions and to put substantial effort into writing and revising them is largely related to the role that her fictions and participation in the online community play in her life. For instance, Grace describes how "one time there were group of transferees at school ... when they saw me they put out their notebooks and told me to sign it hehe" (2005). Thus, Grace's fictions had become so popular within a certain circle of *CCS* anime fans that several young women visiting her school requested autographs on their own "plot bunny" notebooks. In addition, Grace explains that "I also write for God through my Christian fanfics" and that "now through some of my fanfics ... I can share the Love of God and show to the whole world what kind of God I have" (2005). Thus, composing and posting online helped Grace develop an identity and receive recognition as a popular and successful fan fiction writer. However, over time Grace's texts also became a conduit for expressing her faith as a Born Again Christian. Both her identity as a writer and

her faith as a Christian provided motivation to work hard, take audience feedback into account, and create texts that would achieve a broad readership.

Nanako

Early Texts

Nanako, who has been an avid anime fan since childhood, was quite excited when, about two years after moving to North America and starting to learn English, she stumbled across the anime fan fiction community. This community presented an opportunity for Nanako to use and practice English while at the same time creating stories about topics that she found highly interesting. In an interview, Nanako explained that it was through reading Grace's creative anime fictions on FFN and interacting with Grace online that she gathered up her courage and decided to start authoring her own texts. When Nanako first joined FFN, she spent a great deal of time reading and reviewing other authors' anime-based fan fictions. In this way, she was able to gain a sense of how fan fictions were structured in this community. She was also able to draw from other texts as generic models when she finally felt confident enough to compose and post her own fictions online. Moreover, from reading Grace's texts, Nanako also had models for incorporating elements of fan fiction–related interaction, such as A/Ns and Thank You Lists, that would help her establish a dialogue with the audience. This in turn would help her to construct an intersubjectively established writing space that facilitated her writing development and led to her subsequent success as a highly popular author in her own right. As the analysis will show, she did this through selectively appropriating resources and by developing a relationship with readers that was based on reciprocal and supportive writing and reviewing.

The following is an excerpt, posted in December of 2002, from the first chapter of one of Nanako's early texts that was updated over a period of two years. The fiction is based on the anime series *Yu-Gi-Oh!* The protagonist of *Yu-Gi-Oh!* is a teenage boy who shares his body with the ancient spirit of an Egyptian Pharaoh, and the series largely centers on male characters battling with Duel Monster playing cards. However, in her fan fictions, Nanako chooses to highlight a potential romantic relationship between the characters Dark Magician and Dark Magician Girl.

> Segment A
>> **Complete**
>> A/N: Bonjour! This is my first Dark Magician and Dark Magician girl romance story, so please go easy on it ^^ Also, please excuse my grammar and spelling mistakes because English is not my first language. I might have some typ-os, so hopefully you guys can look over it ^^ I'm one of the worst class writers in

fanfiction.net, so please don't flame me!First attempt fanfic of Card Captor Sakura
by: Grace all rights reserved on CLAMP

Segment B

**Summary: The dark magician girl was the cruel and heartless dark
magician's apprentice. She always thought that she had hated him, because
he was so cold towards her............. But her life was changed forever, the
moment she saw him cry............for her............**

Segment C

Chapter 1

**I'll always remember
It was late afternoon
It lasted forever
But ended so soon............**

Segment D

I was lying awake on my bed, remembering the last duel I had with the Dark
Magician, my master. Brushed my messy blond hair with my limp fingers from my
emerald green eyes, stared blankly up at the ceiling. The memories of the special
moment flashed in my mind.

(A/N: I'm not very sure about the colour of her eyes..............—;;)

~ Flash Back ~

I was in my uniform, standing nervously on the battlefield, side by side with my master,
The Dark Magician. He was handsome, as always. His violet hair hung low, covered
part of his cold sapphire blue eyes. He has always been Yami's favorite duel monster,
well of course, he was also one of the strongest ones. I envy him, yet I dislike him. He
has always act very cruel and heartless towards me. Never care about anything, except
winning duels for Yami. I guess that's just the way he is.

On comparison, it is clear that this excerpt of Nanako's early writing is similar
to Grace's text in many ways. In terms of generic structure, both excerpts have
distinct headers, A/Ns, and summaries. In addition, the narrative for both
stories begins with a flashback setting up the romantic relationship between
characters. In terms of discourse and function, Nanako has also adopted
Grace's strategy of positioning herself as a novice writer within the *Yu-Gi-Oh!*
canon and as a nonnative English speaker. This positioning allows Nanako to
stave off potential criticism and to enlist readers' help in improving the story.

However, there are also clear differences between Nanako's and Grace's
texts that reflect their different situations as language learners. For example, al-
though the two young women position themselves as novice ELL writers,
Grace has been exposed to English in the Philippines since childhood whereas
Nanako began learning and using English only when she moved to Canada at
age eleven. Moreover, as mentioned previously, Grace has had much more
practice with writing in English. This difference in comfort levels may explain

some of the dissimilarity in the styles of their texts. For example, although Grace asks readers to "forgive my grammar," this statement is introduced with an "oh," almost as if it was an afterthought, and she still assumes that they will "enjoy the story." In addition, her style of address seems to assume an audience that is already supportive and in agreement with and/or malleable to her perspectives and wishes. She expresses this through statements such as "as you can basically see," which presupposes that readers share her viewpoint, and her *nods* of confirmation at the end of the statement. It is also evident in her lighthearted command for readers to "just read the story," punctuated with an emoticon of a tongue sticking out (=p).

On the other hand, Nanako's early style of addressing readers seems a bit less certain and is aimed at establishing a friendly relationship with readers and creating a supportive audience for her texts. This can be seen in her attempts to build connections with readers by referring to them collegially as "you guys," through repeated use of the word *please* and friendly, smiling emoticons (^^), and by expressing hope that the audience can overlook any errors. This relationship-building is also echoed in the last sentence of Segment A when she writes that she is "one of the worst class writers in fanfiction.net." She then uses the conjunction *so* to imply that because of this acknowledgment readers should not flame or offer harsh and hostile reviews of her text. The A/N from Segment D is also a way for Nanako to establish a relationship and/or dialogue with readers, as she points out that she is not sure about the color of the Dark Magician Girl's eyes. Within the fan community, it is safe to assume that many readers will know the correct eye color and send Nanako an e-mail or post it in a review. Thus, this statement is a means of enlisting readers' help in fleshing out the details of her story.

Later Texts
The next example, a *CCS* revision posted in 2003, provides further examples of the similarities between Nanako's and many of Grace's texts. The excerpt also demonstrates Nanako's emerging confidence as a writer and her growing knowledge of the genres and social conventions of online fan fiction writing.

> Segment A
>> **Complexity**
>> By: Tanaka Nanako
>> Genre: Romance/General
>> Pairings: Sakura/Syaoran, Tomoyo/Eriol
>> Rating: PG-13
> Segment B
>> **Summary: Sakura is secretly in love with the most popular guy in school who used to be her childhood best friend, Syaoran. But in his eyes, she's**

just a friend. Then the school dance was coming up, Syaoran's girlfriend suddenly broke up with him, so he asked Sakura to pretend to be his girlfriend cuz he didn't want his friends to laugh at him...But as time passed he began to fall for Sakura...

Segment C

Important note: English is my second language, please excuse my grammar and spelling mistakes. Also, I might have some typos in the story, so hopefully you guys can overlook them.

Segment D

"Talking"

'Thinking'

~*~*~*~ Scene changes

Segment E

Chapter 1 The Pain In My Heart

It was just another ordinary day. Seventeen years old Sakura Kinomoto was sitting in the classroom daydreaming about her special someone. On her notebook, there was a hand drawn heart, and inside the heart, it says the name 'Syaoran Li' in it. Her emerald green eyes were gazed at the boy who was sitting in front of her.

The boy has soft chestnut hair and amber brown eyes. He was the most handsome and popular guy in school. Sakura sighed lightly and continued to stare at Syaoran Li, who used to be her childhood best friend. He has changed a lot over the passed few years. He wasn't the shy and loving boy he used to be. Right now, he acts cool and careless in front of people because all the popular guys act that way.

In the first segment, Nanako presents introductory material much like the material included in the first segment of Grace's excerpt. However, Nanako also includes traditional fan fiction header information such as title, author, canon, genre, character pairings, and rating. In addition, in Segment D she provides further orientation for readers by providing a "key" to help differentiate between character dialogue, thoughts, and scene changes. This key was adopted wholesale from Grace's work, as the symbols exactly match those used in Grace's texts, and Grace includes the same key at the start of many of her fictions.

Over time, Nanako also begins to take a very similar approach as Grace does in terms of responding to reader feedback—meaning that she often revises and reposts her fictions in response to the audience's reactions to her texts. The following A/N from a fan fiction posted in 2003 highlights her efforts in this regard.

Okie dokie... koko wa tanaka nakako sumi-chan desu... n it seems lik ma fic has caused some err controversial problems.. so ermmm I'm gonna revise it n make it a better story (me ish takin in all da criticizes from da reviewers) yesh I kinda rushed on it, screwed up the plot, lotsa grammatical errors.. gomen nasai gomen nasai!!! i'll update

the revised story as soon as possible! And I wanna thank all the people who supported me and who gave me supportive, encouraging comments! Arigatou gozaimasu!! (2003)

The A/N illustrates Nanako's commitment to constructing a writing space that is responsive to readers' expectations. Specifically, because so many readers had taken issue with a particular plot twist, Nanako was taking down and revising the chapter, not only for the plot but also for grammar and conventions. However, it is important to note that this is a relatively balanced process for Nanako. To clarify, readers often provide her with plot and or grammatical suggestions, but as discussed in Chapter 6, they do so in ways that ultimately honor Nanako's authority as the author and that place primacy on the meaning value rather than the correctness of her texts. However, because the audience has such a vested interest in the media canon, Nanako is also willing to honor the audience's wishes when she feels that she has made a significant deviation from the tenor of the original media. Moreover, she is committed to improving her English writing, and thus will revise according to pointed feedback on spelling, grammar, and conventions.

Stylistically, the A/N also illustrates Nanako's increasing knowledge of general online and anime-based fan fiction community registers and discourses. For instance, she incorporates Japanese terms such as *gomen nasai* (I'm sorry) and *arigatou gozaimasu* (thank you very much). In addition to indexing her growing familiarity with the anime fan fiction community, the Japanese also serves as a means of indexing her offline academic activities. During this time, Nanako was taking Japanese classes in school and was quite excited to use her knowledge of the language to enhance the cultural tenor of her narrative.

This excerpt also contains an early version of the "Dedication" and "Thank You List" segments that would become a staple part of the overall generic structure of Nanako's fan fictions. Over time, as Nanako reads more of Grace's texts and posts more of her own stories, she realizes that when readers are acknowledged by name in a Dedication or Thank You List, they feel a sense of connection with the author and have impetus to continue posting feedback. Thus, lengthy Thank You Lists and Dedications became part of the genre of Nanako's headers. As an illustration, in the following A/N, Nanako responds to a reader who "flamed" or posted a hostile complaint about the long Thank You List included at the beginning of her chapters.

> **To THE FLAMER:** I don't know if you read any of Grace's fics, well you know what? She always has long thank you lists in the beginning of her stories, and I think that's perfectly normal. No one ever complained about that, and how many reviewers she has. I mean, the only reason I have a LONG thank you list is because I have a lot of lovely and wonderful reviewers *waves at her AWESOME REVIEWERS!!! ^-^* so

if you don't like that, then I'm very sorry to say that TOO BAD FOR YOU! (no offense). (2003)

As she explains in the preceding post, Nanako used Grace's fictions as a resource model for structuring her own text and for developing a following of readers. However, after using Grace's texts as an initial model, Nanako went on to tailor her use of Thank You Lists and Dedications to further establish a productive writing space for herself.

Cherry-chan

Early Texts

Cherry-chan is a second-generation immigrant to North America who was born in Canada but grew up speaking Mandarin Chinese and Taiwanese at home with her mother and brother. Like Grace and Nanako, Cherry-chan has been an anime fan since childhood and she began writing on FFN in April 2001. Like Grace and Nanako, her fan texts are based on anime series such as *CCS* and *Yu-Gi-Oh!* However, although Cherry-chan's texts are similar to and draw from Grace's and Nanako's stories as generic resources, her participation in the fan fiction community ultimately played a much different role in her life. Specifically, she used her participation in FFN to form initial social relationships and then branch out into other digital forms of composition and communication. The next excerpt shows an early example of Cherry-chan's writing in September 2001.

> Segment A
> **What is Love?**
>
> ***Chapter One:The Marriage***
>
> ~^~^~^~^~
>
> Ohayo/Konnichiwa/Kongbongwa (Depend when you are reading this little fanfiction).First of All! Could Everyone pray for the people who died in USA?Please?* On Her Knees* Please?Is it enough or no?If it's Not Then I'll Give you an Chapter of a fanfiction and After that will you????* Looking For Her Disk....* Now Where is that Stupid Disk?Aww.......Well Heres Why I started to Make another Story Because I Can't Find My Disk....AND heres the plot,It's a Bit weird ok...NeverMind the whole thing is weird,Sakura&Tomoyo knew each other.Tomoyo went to China forever maybe.Over in China Syaoran met Only Tomoyo-Chan and he began to fell in love with her.When Tomoyo-Chan left on that same day,A Handsome boy named Eriol came to live in Japan.He saw Sakura,when he was entering the classroom and fell in with her.17 years has passed now there 27 years old all of them(No One has Magic in this story).Now you are probably wondering why is this a S&S and T&E fanfic?hmmmm?Am I right?O Well I'll tell you..In the

next Chapter...hehehe!Or.........In the next 3 Chapters..............
R&R!Plz?

Segment B

I Don't Own CardCaptorSakura or CardCaptors and I'll never will,Happy?

Segment C

Ok So Let's Begin(If someone is reading this....?)

Segment D

(Warning:First Three Chapter are S&E (Sakura&Eriol) and T&S (Tomoyo&Syaoran) is That ok? With Everyone?Guess not And Please don't Throw Tomaoto or anything at Me or Else I won't Finish this Story!)

Segment E

O Yeah Did I also Meantion This Story is for My Dear Friend ~***Angel Of Light***~ It's Her Birthday and I'm 2 lazy(Gomen Nasai[So Sorry]) to buy her a Present for her So I'm Going to give Her My Fanfic!Enjoy ~***Angel Of Light***~ (Please Check Out Her Fanfic and please R&R Her fanfic as Well as Mine please?????)

Segment F

Key Translation:
{}=Chinese
[]=Japanese
()=Wo Da{My} Notes!ehhehe
~^~^~^~^~

Segment G

"I Do",the young pretty lady answered with a Wonderful Smile on her Face.

"..........You Made Kissed The Bride" The Priest answer happily.

The woman and The Man Kissed Softly.After that People were standing up and clapping their Hand Happily.

"That Brat Better Take Care of My Sister!" Someone Whispered and Mutter.

The Young Woman who had nice honey brown Hair that was up to her Shoulder a bit that was now Tied up in like a Princess Hair.Her Light Innocent Green Eyes.Her Beautiful White Dress she was Wearing now.And She Growen alittle taller than Grade 4th.She was Walking out of the Church holding a Mans Soft Gentle Hand(Ehhhh.....You Know who's the Guy don't you...It's Not Syaoran and I Told you in the Beginnning who it was in the way top) and on the other hand she was holding was a bunch of Flowers in her Hand.She Had Thrown the Flowers and one of her Friends caught.The Woman Giggle because her Friend was Blushing Furiously.

When viewed through the lenses of genre, discourse, and style, Cherry-chan's text is similar to Grace's and Nanako's texts in several respects. For example, she includes a copyright disclaimer, a "warning" for readers, and a key with corresponding symbols that are similar to those found in Grace's and Nanako's

fan fiction headers. Nonetheless, this early text differs from Nanako's and Grace's writing in significant ways.

For example, in terms of genre, in spite of the chapter headings in Segment A, this fiction did not have a title posted on FFN, which is an indication of her novice status as an online fan fiction writer. Another significant generic and stylistic difference is her A/N, which reads much like a stream of consciousness rather than an organized orientation to the text. For example, Cherry-chan begins with Japanese greetings for three different times of day: Good morning, good afternoon, and good evening. Then, she shifts immediately to a plea delivered *on her knees* that readers pray for the victims of 9/11. She goes on to offer a bribe of another updated fan fiction chapter, but also implies that this is an empty promise because she is *Looking for her disk* and is unable to find it. Immediately moving on to the introduction of the story, her language resembles staccato bursts of speech as she curtly lists off features of the plot. Also, the frequent ellipses, fragmentary clauses, and word choice give the passage the tone of a face-to-face rather than writer-to-reader exchange.

This, and some of Cherry-chan's other notes, are filled with representations of paralinguistic and physical cues that are hallmarks of online registers, such as those used for Instant Messaging and chat. For instance, she writes in all caps to indicate a RAISED TONE OF VOICE, uses smiley ^_^ or crying ^_^;;; or surprised @.@ faces to convey emotions, and uses emotes such as *sniffs*, *shrugs*, and *sweatdrops* to depict physical actions. Her extensive use of these elements contributes to the conversational tone of her notes and encourages readers to respond to her on a personal and social level. According to Rommetveit (1974), it is through this sort of "creative transcendence" of traditional language that speakers are able to "make the reader experience aspects of life which somehow appear to be blurred or even concealed in conventional language use" (p. 21). Thus, the sort of transcendent language structure used by Cherry-chan—a hybridization of written and spoken features—can be viewed as a means of conveying the shared social reality of globally networked online spaces that allow for synchronous or nearly synchronous communication via representational resources with characteristics of both speech and written text.

Another aspect of Cherry-chan's texts that sets her apart from both Grace and Nanako as an author is that in them she makes numerous direct references to issues and events from her own life as well as from the broader community and world news. For instance, at the level of discourse, she often positions herself as a student under a great deal of academic pressure. She also represents herself as a sibling who competes with family members for time on the computer. She also broaches topical world news (this text was posted on September 22, 2001) when she offers her own sentiments and requests that readers pray

along with her for the victims of September 11. Thus, rather than using her A/N in the traditional sense of providing readers with information about the fan fiction text, she is instead referencing larger social and political discourses.

Later Texts

Over the next couple of years as Cherry-chan spent more time developing her English skills, reading other texts, and interacting on FFN, her writing and the presentation of her stories changed significantly. For example, the excerpt shown below was posted in 2003, nearly two years after the first text was written and after she began corresponding and sharing fictions with Nanako on a regular basis. Changes in the structural, organizational, and grammatical aspects of the text are evident.

Segment A
HiyahHiyah!! First Time Doing a Shounen-ai Fanfiction Go Gentle Onegaii....^^;
Segment B
Disclaimer - I do not own the Manga/Card Game/Anime Yuugiou/Yu-gi-oh + the Christmas Lyrics

Kiyoshi Kono Yoru/Silent Night - Araki Kae & Natsuki Rio Minna no Christmas/Everyone's Christmas - Wada Kouji
Segment C
Warnings - Spelling and Grammar Mistakes can be found | FIRST SHOUNEN-AI FANFICTION | OOC Characters | Mild Cursing | AU |
Segment D
Fanfiction Dedication - Double Authoress -- rancor (1234567) + sweets (1234567) [//Doushiite// I feel VERY happy when I see their Reviews ^^' Always so long @.@ Which I like ^^; plus make me feel more welcome into Shounen-ai] + Reviewers
Segment E
Main Pairing - Yami x Yuugi
Segment F
Summary - [PG-13] Yami had met an angel right in front of his doorstep, he admired the boy so very much, and had taken great interested into the boy and wanted to know more about him. Yami wasn't very aware there was an unexpected assignment for the winter holidays, an assignment that has to do with orphanages and the university. The angel Yami had saw last time was from the orphanage, was there some kind of connection to all of this or just snowflakes of destiny sparkling in the air.
Segment G
Read and Review Onegaii
Segment F
01 – Angels Falling
It was a snowy cool evening, snowflakes waved through the abnormal wind, stars were shimmering up in the blanket of navy darkness. It was such a magical night. The sweet scent of fate was in the evening.

"Essays, essays what's with these essays these days! It's almost the winter holiday and I have to work all this pack of crap." teenage boy, with tri hair colour yellow, red and black, blended into his spiked up hair. Having the most deepest crimson eyes. At times he could be cold and serious about everything, but other times he has a soft sides just like everyone else. He threw the papers into the air, "This is BULLSHIT!!" he cursed as rest his head down on the table.

An annoying telephone rang underneath a slope valley of papers.

The teen jump, at the sudden sound, as he erased most of his papers off the desk. Finding a cordless phone that rang for countless seconds. "Argh...Messy-ness." Growling as he slap some textbooks off his oak desk, "Oh! here it is."

"Moshi, moshi." He greet tiredly.

In this later writing, Cherry-chan garnered many ideas for structuring her fictions from reading Nanako's texts. At the level of genre, the changes in Cherry-chan's presentation and organization of the fan fiction are clear. The different sections of the header are clearly marked with labels, and she includes a short Dedication section, much like the one in Nanako's early texts. Also, the story narrative is introduced with a clear chapter heading. This can be contrasted with the earlier example of her writing that distinguished sections through spacing alone and indicated the start and finish of the A/N with a divider made up of arbitrary keyboard symbols (~-~-~-~-~-~).

Cherry-chan's texts demonstrate changes at the level of discourse and style as well as at the level of genre. Her A/Ns to readers now contain elements that are reminiscent of both Grace's and Nanako's notes. For example, in Segment A, she explains that this is her first attempt at a *shounen-ai* (boy love) fiction and asks readers to "go gentle" with their reviews. She also includes "Warnings" in Segment C to further position herself as a novice within the shounen-ai community and to acknowledge readers as potential experts who might notice errors in timeline and/or grammar or spelling. She also includes a clearly marked summary that is now very similar to Nanako's summaries. Specifically, information about the text is presented in a concise chronicle and ends with creative imagery to generate audience interest in the fiction.

In terms of narrative structure, this later story text begins much like many of Grace's and Nanako's fictions do. Specifically, she uses descriptive language and imagery to establish the setting. She then introduces the main character through a description of his thoughts and activities. In addition, Cherry-chan's increased facility with English writing is clear as she artfully uses metaphor, action, and internal dialogue to draw readers into the story.

Divergent Forms of Participation

Communication Contracts

According to Rommetveit (1974) there is a reciprocal "contract" established between participants in a dialogue or communicative act that allows them to construct a common conversational ground of sorts for the exchange of perspectives. To understand the intersubjectively established social reality of a communicative space, it is necessary to determine what sort of "contract" has been established between interlocutors.

> In order to find out what is made known when something is read or heard we have therefore to inquire into what kind of contract has been established between the two participants in that particular act of communication. This implies, in turn, an exploration of which aspects of a multifaceted and pluralistic world constitute their temporarily shared social reality. Their dialogue may, for instance, by mutual and tacit agreement, be oriented towards aspects of social life such as temporary employment or choice of job, or they may tacitly have endorsed a contract concerning a topic committing both of them to a temporary concern with profit and loss in business transactions. (Rommetveit, 1974, p. 25)

As discussed in Chapter 3, the nature of the FFN site presupposes writing, reading, and discussing of fan fiction as a topic. However, after more than three years of observation, it became clear that Grace, Nanako, and Cherry-chan were establishing different sorts of "contracts" with their audience according to their identities as writers, as language learners, and as individuals. In turn, these contracts, realized at the level of genre, discourse, and style, focused on different topics, involved drawing from distinct resources, and required unique and often innovative uses of language and text.

Grace

Grace, for instance, viewed fan fiction writing as a means of contributing to the broader fanon and possibly righting injustices or plot twists that she viewed as mistakes in the original media. In an interview, she explains that she writes in certain canons, "because I love those series, and I know some of the readers wants to read some of um ... let's see *alternative* story?" (2006, emphasis in original). She goes on to say, "thank God for Fanfics. Even though Seiya and Usagi (*Sailor Moon*) did not end together in series, there are some fanfics that put them together ... and its making us their fans ... satisfied" (2006). Thus, one of Grace's main purposes in her early writing was to make meaningful contributions to the broader fanon narrative surrounding certain anime series. Grace and her readers established a contract based on Grace's adherence to

specific couple pairings and her attempts to write plausible, engaging stories within the canon to the best of her abilities as an ELL. Readers participated in this contract by offering constructive, supportive feedback on both her story text and her composition skills.

In addition, Grace's later writing served as a vehicle for sharing her Christian faith with readers. On finding renewed faith as a Born Again Christian, she started infusing her anime fan fictions with themes related to salvation and drew from religion as a writing resource. Grace took this writing very seriously; however, many of her readers were not willing to accept the religious topics and themes as parts of their ongoing "contract" as reviewers. Grace describes how her choice to write religious fictions cost her a large percentage of her reader base. She explains, "before I have a community of fans ... it reaches thousands of members but after becoming a Christian, I lost it (hehe)" (2006). Although Grace treats this topic with humor, her readers' responses to her Christian-fics caused a great deal of turmoil in Grace's writing space. This situation provides a clear illustration of the importance of intersubjectively established contexts for interaction—specifically, Grace began composing from a faith-based perspective, but her readers were unable to reconcile the Western religious themes with the Eastern origins of the anime. Thus, Grace and her readers were unable to reach a mutually acceptable contract for ongoing communication, and Grace lost much of her audience.

In spite of this upheaval in her FFN writing space, Grace's participation in the fan fiction community played (and still plays) a very important role in her life. Through writing in this context, she gained confidence in her abilities to "speak American" and to communicate her ideas and reach out to a broad audience. She also made many contacts with other fans who helped her develop her art, Web design, and anime music video (AMV) making skills. In time, these abilities contributed to the development of an online ministry that Grace now runs, and she derives a great deal of personal and spiritual satisfaction from this.

Nanako

Nanako, in her early writing, seemed to be interested in establishing a "contract" with readers that is centered on the topic of fan fiction composition and/or themes related to romance and gender. For instance, Nanako's introductory A/Ns explicitly state that she is writing to improve her English composition skills.

> A/N: Konnichiwa minna-san! This is my new story ^^. Please excuse my grammar and spelling mistakes. Because English is my second language. Also, I'm still trying to improve my writing skills..........so this story might be really sucks.........--;; (2002)

Such a statement is also a way of eliciting writing-related feedback from readers, thus establishing a contract that is based on supportive feedback. Another area that highlights Nanako's focus on improving her writing and on the fan fiction texts themselves is her Thank You Lists for readers. Nanako uses her Thank You Lists strategically to elicit further support and feedback on her writing from readers (Black, 2007). Moreover, she specifically comments on their feedback and goes back to make corrections to her writing based on the feedback. For instance, in one excerpt she writes, "Thank you! I will correct my mistakes!^___^ *Hugs Fire Light*" (2002). And, in a selection from the start of a chapter she writes, "IMPORTANT NOTICE: If you read the first version of chapter 8, PLEASE RE-READ IT!!! I revised it and the plot changed a lot!! Thank you!!" (2003). Thus, Nanako is agreeing to a contract based on writing fictions, having her fictions reviewed, and then revising and reposting her fictions in accordance with reader feedback.

In addition, as can be seen in the first chapter of "Complexity," the second sample of her fan fiction writing, Nanako's narratives are firmly grounded in lifeworlds that are familiar and of interest to her and the audience. Like many of Nanako's fictions, "Complexity" is set in a school and takes up topics such as popularity, crushes, unrequited love, bullying, and academic pressures. However, as Nanako explains in the following excerpt from an interview, her fan fiction writing also serves as an escape from these topics.

> I love being Tanaka Nanako, an anonymous online fanfic writer, because it offers me an escape from the stressful reality. I can express myself, my opinions, and feelings more openly because my true identity isn't given. Fanfiction.net is another realm where passionate love, forbidden tales, beautiful angst thrive, where like-minded people can share their ideas and their views on life without feeling restrained. (2005)

Nanako's readers seem to accept this contract and share her vision of the "realm" of fan fiction. They indicate this by avidly following and posting positive feedback on her texts. They also express this by commiserating and using the review space to share their own tales related to bullying, negative encounters with "the popular kids," and the pressure they feel to do well in school. Moreover, Nanako responds to these reviews and offers her readers support in return.

Cherry-chan

As mentioned earlier in the chapter, in looking at Cherry-chan's A/Ns, her reviews of other writers' texts, and her fan fictions themselves, it is clear that composition has not always been Cherry-chan's focal topic. In fact, she seems more interested in using her texts and interactions on FFN to establish a social contract with other fans. For instance, many of her A/Ns contain a "Fanfiction

Dedication" in which she provides a social motivation for creating the text. This can be seen in the following excerpt where she explains why she is composing a shounen-ai fiction that features a *bishounen* or "beautiful boy" character pairing that she does not particularly care for.

> Fanfiction Dedication - Uno Gakkou Tomodaichi--Demon Galik* (123456*) [//Doushiite// Known her for along time; I do Mean LONG ^^; and this is probably the only fanfiction I'll rite her favourite pairing --;; with her bishounen(s)..that I just..dislike alot...stuffs...haha..] + Reviewers (2003)

And, in this excerpt she points out that the fiction is a present for a friend.

> O Yeah Did I also Meantion This Story is for My Dear Friend ~*Seraphim*~ It's Her Birthday and I'm 2 lazy(Gomen Nasai[So Sorry]) to buy her a Present for her So I'm Going to give Her My Fanfic!Enjoy ~*Seraphim*~ (Please Check Out Her Fanfic and please R&R Her fanfic as Well as Mine please?????). (2001)

Thus, Cherry-chan is not writing about her own preferred romantic pairings or necessarily composing the fictions because she has a "plot bunny" or a driving need to express issues related to her life. She is not using her texts to share religious ideology with readers as Grace does. She is not using the FFN space to improve her composing skills as Nanako does. Instead, Cherry-chan has a social and relational impetus for composing these texts. Specifically, she is composing them as gifts or at the behest of friends as a means of strengthening her social connections with these youth.

The form and relative infrequency of Cherry-chan's writing also indicate that she is not highly invested in authoring fictions to receive feedback on her composition or language skills per se. For example, according to many young writers on the site, one of the benefits of FFN is that it provides an opportunity to receive almost instantaneous feedback from a broad readership. One way that authors can attract a broad readership over a long period of time is to post fan fictions as a series, updating one chapter at a time as Nanako and Grace do. Ending chapters with "cliffhangers" or "cliffies" is another way that fan fiction writers draw readers into the lives of the fictional characters and encourage them to continue following a series to see what will happen next. Cherry-chan, like Nanako, frequently ends chapters with cliffhangers that intrigue her audience and leave them asking for more in their reviews. Also, many of her texts are written as series with multiple chapters that are meant to be updated over time. Nonetheless, in spite of knowing how to employ these strategies to garner interest in her stories, she does not update the chapters often enough for many of her readers to remain immersed in the worlds and scenarios created in her fictions. Moreover, as she points out herself in an interview, she has yet to finish any of the numerous fan fiction series that she has started. Cherry-chan's

failure to update or complete her texts, her socially grounded topics, and the conversational tone of her posts suggest that she is interested in constructing an intersubjectively established context with other youth that is based on personal rather than writing-related topics.

When asked about her writing on FFN, Cherry-chan explains, "I'm not really a pro-active author like Nanako, because I sort of lost interest in making my own [fictions] and decided to write with other friends (kinda like a collaboration)" (2006). Cherry-chan also began to read and post a great deal of reviews to other writers' texts. Her reviews, much like her A/Ns, are a unique mixture of conversation and text. Take, for example, the following review that she posted in response to one of Nanako's stories. The excerpt has not been divided into segments and lines in order to preserve the stream of consciousness quality of the passage.

> YAMII IIIIIIIIIIIIIIIIIIIIIIIIIII ::stops to take a breathe :: YAMIII IIIIIIIII OUTTA ALLLLLLLLLLLLLLLL THOSE CHAPTERS I READ FORM YOU THISS ISSS THE MOST....EVILEST ONE OF ALLL YOU BETTER CONTINUE OR Or..erm..I haven't thought of a threat yet....cuz..well ::Coughs:: dats not the point -- YAMI ONEGAIII CONTINUEEEEEEEEEEEEEEEEEEEEEEEE EEEEEE HEHE ooo and Good Luckie..on More Examz! haha hehe Happy Chinese New Year..[[Even thou it was just yesterday -- but ya...]] hehe blahhh me not in the mood to type a long review gomen ne --;; I'll do it later...need to search for borin French Geography Piccy blahhhhhhh JaJa Stupid Music Pratice Logs --;; JaJa continue or umm Cherry-chan will do something.....umm..ya something blah --;. (2003)

This review, like the previous A/N, is like an excited stream of consciousness in which Cherry-chan incorporates many different "moves" that emulate speech. For example, she incorporates laughter "hehe," expressions of disgust "blahh," excitement "ooo," and uncertainty "er..." and "…..umm.." She also uses emotes such as "::stops to take a breathe::" and "::coughs::" and meanders from topic to topic, much like speakers do in conversations. Moreover, although she states that she is not "in the mood" to type anything lengthy, this review was a paragraph long. This discrepancy indicates that it was not the typing or the writing that Cherry-chan was *not* in the mood for, but rather, she was not inspired to give lengthy, composition-related feedback on Nanako's narrative text. She was, however, inspired to express her appreciation of the story and to write about issues from their daily lives such as exams and trying school assignments.

Cherry-chan's desire for socially grounded forms of participation can be illustrated by her collaboratively composing fictions and extending her relationships from FFN into other online forums and social networking sites. The forums she frequented support a great deal of synchronous or near synchro-

nous communication between members. Thus, she was able to engage in "here and now" (Rommetveit, 1974) interactions with other fans, in which their shared social context is "established and continuously updated by their acts of communication" (p. 23). In these new sites, she also was able to use a wider range of multimodal forms of representation, such as music, images, mood-indicating avatars, and color, to enhance the conversational aspects of the interactions in ways that FFN does not easily support. Also, her participation in anime forums and in the LiveJournal community does not require her to compose an extensive narrative text. Instead, she could "log on" and engage in a number of brief but intense conversations about a range of topics, such as her life, anime, art, school, love, friends, family, and learning English, and then log off an hour or so later.

Over time, Cherry-chan also began working closely with a fellow fan to collaboratively author RPF, or Real Person Fictions, based on the romantic lives of Japanese or J-Pop musicians. These fictions are posted on her LiveJournal site, as FFN permits texts based only on fictional characters. In writing these texts, Cherry-chan collaborates with another adolescent of Chinese descent who grew up speaking English. Through this collaborative writing activity, Cherry-chan is able to engage in pointed composition-related interactions, develop metacognitive strategies for monitoring her own language use, and gain insight into the social nature of writing. Daiute (2000) argues that collaborating with a partner provides writers with a means of "experiencing the role of writer and reader as they respond to a partner's suggestions of specific text sequences and listen to a partner's reactions" (p. 35). Thus, networked technologies provide an extracurricular context for Cherry-chan's writing, language development, and socialization as well as a means for her to engage in "functional interactions" that bypass both the boundaries and at times the textual conventions of offline spaces (Daiute, 2000).

Transcendent Uses of Language

Grace, Nanako, and Cherry-chan are all using language in what Rommetveit calls "transcendent" ways. Their uses of text go beyond the limitations of traditional print-based, standard language to represent the realities of living and communicating in globalized and networked on- and offline spaces. Grace, for example, uses her texts to fuse the Asian anime texts with Western religious themes to convey her religious beliefs to a broad online audience. Nanako, however, creates many culturally hybrid texts with themes drawn from her new life in North America as well as from her life growing up in China. Moreover, as discussed in the next chapter, as her confidence level increased, Nanako also

began composing hybrid texts that combined the Japanese of the anime series, her first language of Mandarin, and her second language of English. This linguistic hybridity enabled her to represent the experience of being a bilingual and/or multilingual speaker to her readers (Black, 2006; Lam, 2004) and to share the social reality of multilingualism in ways that the traditional, monolingual texts of a classroom would not.

Cherry-chan also uses transcendent forms of language in her writing and online communications. These forms of participation and communication can be contrasted with those of writing classrooms in which emphasis is often placed on developing organized texts that tell a linear story and represent a unified voice (Hammerberg, 2001). However, this style of writing clearly did not suit the sort of communicative social context that Cherry-chan was trying to create. Specifically, many of her texts represent a hybrid of written and conversational forms of text that is common in online discourse. Moreover, Cherry-chan was seeking an interactive, social connection with other fans, and this led her to visit other Web sites. In particular, she chose fan-based forums that allowed for synchronous interaction and for posting and interacting via shorter, multimodal texts. Her collaborative fictions are also transcendent in the sense that they represent the fusion of two authorial voices, that of Cherry-chan and her co-author.

As an ELL, these sites and multimodal forms of writing may have appealed to Cherry-chan because she was able to augment her written text with images and sound to further convey meaning, whereas Grace and Nanako preferred to focus on composition or developing written English skills in a somewhat more traditional print format. This may also be related to the different needs and learning styles of these young women. As Daiute (2004) points out, in composition classrooms "the more explicit the social interaction context, the more support there is for beginning writers to choose appropriate composing strategies, rhetorical forms, and specific words" (p. 11). In this regard, Cherry-chan may have been seeking a more explicit interactional context in which she was able to enhance and augment her messages with other features such as image and sound, and also the more synchronous communication and the shorter text of the forums provided her with almost instantaneous feedback and support for constructing her next utterance. Moreover, many of the forum interactions were grounded in immediate social topics and events (e.g., school activities, new anime releases), issues (e.g., struggles with different languages), and concerns (e.g., grades). Conversely, Grace and Nanako were comfortable with less explicit contexts in which their rhetorical choices and language use were informed by sometimes lengthy exchanges with readers and centered on the narrative text of their fan fictions rather than on social matters.

Thus, rather than using language and text solely to reproduce existing genres and participate in concretized social patterns, these adolescent fans are creatively making use of a range of representational resources to design new, hybrid genres of fan fiction that allow them to enact specific socially situated identities. These options for creating alternative forms of text and social realities can be contrasted with the more formal pedagogical and composition-related constraints in place in most Language Arts classrooms. Specifically, there is a marked disconnect between the univocal, print-based, and conventional forms of writing required of students in schools, and the sort of hybrid, multimodal, multilingual, and interactive texts that students are engaging with in online spaces.

Language, Culture, and Identity in Fan Fiction

Observers of the twentieth and the onset of the twenty-first century will note how these times are distinguished by a peculiar passion for identity: identities made around nation, community, ethnicity, race, religion, gender, sexuality, and age; identities premised on popular culture and its shifting sets of representational practices; identities attached to fashion and new imagined lifestyles, to leisure and work, and to the mundane and the exotic; identities made in relation to place and displacement, to community and to a sense of dispersal, to "roots" as well as "routes."

—Yon (2000, p. 1)

Language, Identity, and Discourse

Much of current research on second language (L2) and literacy acquisition has centered on the contextual nature of language development and has highlighted the role of identity in English language learners' (ELLs') literacy practices. In addition, as new information and communication technologies (ICTs) facilitate the formation of "virtual spaces" that cross traditional cultural, linguistic, and geographic borders, scholarship in Teaching English to Speakers of Other Languages (TESOL) has turned its attention to such online spaces as new transnational contexts for identity development and language socialization (Cope & Kalantzis, 2000; Warschauer & Kern, 2000). Save for a few studies (Lam, 2000, 2004, 2006; Yi, 2005), there has been little inquiry into the roles of popular and fan culture in the online literacy and social practices of ELL youth. Moreover, with the fast-paced propagation of new media and technologies, novel fan practices and "virtual" communities based on popular culture seem to spring up on a daily basis. The popularity of such communities generates many questions related to how youth from across the globe are affiliating around popular culture in online spaces. How do adolescents with limited English proficiency construct identities in online English and text-dominated spaces? How do these identities change and develop over time? What resources do these adolescents draw on

for their interactions and presentations of self in online spaces? What role does popular culture play in their identity development and literate and social practices?

In this chapter, I draw from constructs in Second Language Acquisition (SLA), literacy, cultural, and media studies as theoretical bases for examining how networked ICTs and fan culture provide an English language learning youth with a site for developing her English language and writing skills. During this process, she also develops an online identity as a popular multiliterate writer. To understand how this happens, I explore the notion of *identity* as a fluid construct that shifts over time with this ELL's long-term participation in a fan community. I also explore popular culture as a point of affiliation and as a *dialogic resource* that she appropriates both in her writing and in her interactions with other fans. In so doing, I show how popular culture and technology converge to provide a context in which this adolescent ELL is able to develop a powerful transcultural identity that is discursively constructed through the different cultural perspectives and literacies that she and other fans from across the globe bring to this space.

Research on SLA has often focused on individual learners' psycholinguistic processes as they learn to read, write, and speak in the target language. Some of this work conceives of identity, if at all, as a stable construct that exists outside of and/or that can be set in opposition to social context (see Harklau, 2007, for a review of research on L2 writing and identity). For example, many theories of acculturation posit standard stages that learners go through as they come into contact with, assimilate to, and/or resist the host culture (Atkinson, Morten, & Sue, 1983; Gay, 1985). The research perspective has expanded to consider the development of *ethnic identity* as a fluid, dynamic, and often recursive process (Jeffres, 1983; Phinney, 1990) that is closely tied to learners' interactions in various social contexts. This focus on the social is mirrored by the aforementioned work being done within sociocultural or New Literacy Studies (New London Group, 1996) that conceives of literacy and language development as socially situated practices (Street, 1984) that are intimately tied to cultural, historical, and institutional contexts as well as to identity (Gee, 1996; Lankshear & Knobel, 2003).

Gee's (1999) notion of little-d/big-D Discourse bridges literacy, identity, and context in that it conceives of little-d discourse as everyday language use and big-D Discourse as various resources that act as an "identity kit" of sorts. Thus, big-D Discourse encompasses the wide range of representational resources such as clothing, text, language, and gesture that individuals use to be recognized as certain kinds of people within a given context. Such a construct is useful in looking at interaction in online spaces for several reasons. This con-

struct recognizes the different semiotic and material resources, not only including but also exceeding traditional print-based language, such as images, avatars, icons, shape, sound, and space, that individuals use to convey meaning via computers. In addition, big-D Discourse highlights the ways in which individuals use language and text to index certain facets of their identities in online spaces where many traditional markers of identity are unavailable (Merchant, 2006). Thus, from this perspective, ELLs may have multiple fluid identities that are connected, not to some fixed stage of acculturation or some internal state of being, but rather to more flexible patterns of participation and self-representation in social events that change over time and according to the context and activity (Gee, 2001).

In our modern, information-oriented society, computer-mediated communication (CMC) and the Internet provide new opportunities for using discourse and text to discursively construct and enact achieved identities in online environments (Gee, 2004b; Thomas, 2004). In this spirit, researchers have started to explore how immigrants across the globe are using online spaces to aid in the formulation and/or continuation of their various ethnic identities and affiliations across geographic borders. As an example, Mitra (1997) explores how Indian expatriates use text to construct their identities and signal certain allegiances by selectively inserting themselves into the discourse of an online newsgroup community. Members of the newsgroup live in different parts of the Western hemisphere and would typically be isolated by spatial constraints; however, CMC and the newsgroup provide a common space for this population to gather and discuss "the identity crisis that the Indians negotiate every day in their everyday life in the new land" (p. 67). Thus, this online space provides a forum not only for the sharing of individual experiences but also for collective debate, commiseration, and reaffirmation of an immigrant Indian identity that takes on many different forms and carries across national borders.

Fan Culture, L2 Literacy, and Identity

Although the role of popular culture in ELL youths' practices of linguistic and cultural identification remains largely unexplored, recent scholarship has started to address the function of such technology-mediated fan practices in ELLs' literacy and/or identity development. As an example, Lam's (2000) innovative work includes an in-depth case study of a Chinese immigrant who created and maintained a Web site devoted to a popular Japanese singer. Through authoring the Web site and interacting with fans who visited his site, this youth was able to develop a "textual identity" that bolstered his confidence as he learned and

practiced English with a transnational group of peers. More recently, Lam (2006) explored how an ELL high school senior's Web page enabled him to gain status as a respected anime fan and webmaster. Moreover, the connections he established via the site also allowed him to develop fluency in multiple social languages, including online and anime-related discourses, as well as in the global forms of English spoken by the many ELL anime fans he interacted with. Through such studies, Lam's work illustrates how these online, pop cultural spaces provide opportunities for youth to fashion linguistic and cultural identities for themselves—in essence, multiliterate and transcultural identities—that extend beyond traditional geographic borders such as the nation-state.

In a similar vein, Yi's (in press, 2007) work explores the multiliterate practices of generation 1.5 Korean-American youth participating in an online community called Welcome to Buckeye City (WTBC). Drawing from ethnographic and case study data, Yi describes how youth in WTBC use their first language (L1) of Korean and L2 of English to relax, socialize, write, and confer about problems from their everyday lives. Thus, Yi explains how this community was a "safe house" (Canagarajah, 1997, as cited in Yi, 2007) of sorts, where these bilingual youth felt comfortable conveying different aspects of their identities in multiple languages. In addition, Yi's case study analysis explores how Joan, a generation 1.5 Korean-American high school student living in the United States, drew from a wide range of multiliterate composing practices to develop a multi-faceted "writerly" identity in the WTBC community (Yi, 2007, personal communication). Joan composed distinct poems, short stories, cards, notes, relay novels, e-mails, and instant messages, and each of these texts provided her with the opportunity to take on subtly different identity roles according to the social context. Moreover, much like authors on fan fiction sites, Joan also received feedback on her publicly posted texts. This feedback provided Joan with opportunities to discuss her "adolescent thoughts and feelings" with other immigrant youth. Constructive feedback also helped her to improve her composing skills and positive comments helped to affirm her identity as an accomplished writer and poet (Yi, 2007).

Anime-based fan fiction is also an example of the highly participatory, agentive, and global nature of online popular and fan culture. In the anime section of FanFiction.net (FFN), the majority of fictions are written in English; however, analyses will demonstrate how many members of the site seem to display a global disposition in that they value and express interest in learning about the different cultural and linguistic backgrounds of other youth in the space. Hence, the emphasis of anime fan fiction writing does not center on English-only or print-based forms and conventions of writing and North American cultural values. Instead, interactions between writers and readers illustrate a cos-

mopolitan, shared appreciation for multiple languages, different cultural perspectives, and alternative forms of text. Texts from the Web site also illustrate fans' strong allegiance to popular culture and emphasize the value of communication, social interaction, and pluralism in this online space.

In *Textual Poachers: Television Fans and Participatory Culture,* Jenkins (1992) challenges prevalent stereotypes of fans as "passive dupes" who uncritically ingest the messages of mainstream media. He instead argues that fan culture is based on the introduction, discussion, and dissemination of a multiplicity of perspectives.

> [Fans'] activities pose important questions about the ability of media producers to constrain the creation and circulation of meanings. Fans construct their cultural and social identity through borrowing and inflecting mass culture images, articulating concerns which often go unvoiced within the dominant media. (1992, p. 23)

The fan fiction texts presented in this chapter are a clear illustration of Jenkins' point, as through writing, reading, and peer-reviewing fan fiction, these youth are engaging in a *dialogic* process (Bakhtin, 1981; Dyson, 1997; Nystrand, 1997) of appropriating Japanese media characters and narratives and making them their own. As such, these youth refashion the preexisting media tales by infusing them with social and cultural themes, multiple literacies, various forms of expertise, and concerns from their lives. Moreover, these mass-produced media become resources for and are integrated into fans' day-to-day interactions and activities, and the cultures of online fandoms. In addition, through such appropriation, many youth in this space are able to take on identities, not as immigrants, or as struggling writers or readers of English, or as native or nonnative speakers of one language or another, but rather as learners and users of multiple social languages and discourses.

Building an Online Identity

Nanako

As mentioned in the previous chapter, Nanako and her family moved from Shanghai, China, to a large Canadian city in the summer of 2000. When they moved, Nanako, a native Mandarin Chinese speaker, was eleven years old and did not speak any English. According to Nanako, at school in Canada, she struggled with all of her courses except for math and found it difficult to make friends since she is "a rather quiet person" and "couldn't even speak a sentence in English without thinking about [her] grammar and all" (2006). The winter after she moved, however, she was surfing the Web for anime and happened

upon some personal Web sites that featured anime-based fan fictions. She became an avid fan fiction reader, and because many of the texts were posted in English, her interest in this form of Japanese popular culture also became a conduit for her language learning.

Two years later, Nanako joined FFN and created a personal page that offered her many different means of forging social connections and also for presenting certain aspects of herself to the online community (Black, 2005). Two months after joining FFN, and only two and a half years after moving to Canada and beginning to learn a new language, Nanako began writing and publicly posting her own fan fictions on the site in English. Over the years, Nanako has been able to achieve the identity of a successful and wildly popular author in this space. Moreover, as this chapter demonstrates, the relationships she has built with readers and the dialogic nature of writing and participation have played a large part in her success and popularity on the site.

Research Questions

In the analysis for this chapter, I focus primarily on thematic topics that were related to identity, language, and culture. To this end, I present texts that are representative of how Nanako actively constructed and enacted her identity in this space (and how this identity changed over time). I also chose salient types of reader reviews or feedback in which the reader responds or in some way contributes to Nanako's online presentation of self. I then conducted a closer discourse analytic examination of such texts with the following questions in mind:

- What sort of linguistic "work" are these texts doing?
- How and in what ways are the texts indexing Nanako's identity as a successful writer?
- How and in what ways are the texts indexing the readers' identities as knowledgeable participants in this space?
- How and in what ways do the texts reference and/or draw from language, culture, and popular culture?

In answering these questions, I coded data on multiple levels. First, I looked at separate lines to identify the main topic or thematic structure of each clause (Gee, 1999; Halliday & Matthiessen, 2004). Next, I returned and looked at each line in terms of the sort of *socially situated* identities that were being enacted, referenced, and/or were relevant to meaningful participation in the site (Gee, 1999). For example, in certain contexts, Nanako would present herself in the

broader category of Asian, whereas in others she would self-identify as Chinese. She would also represent herself as a bad writer, a lazy writer, or an English learner depending on her particular goals at the time. I then compared across reviews, Nanako's interactions with readers, and interviews to identify potential thematic and/or structural patterns in these various texts and forms of self-representation.

Dialogic Resources

In Bakhtin's (1981) dialogic conception of language, to become literate in a certain social language entails more than solely learning the discrete, linguistic aspects of reading, writing, and speaking. Similar to Gee's (1999) notion of language as part of Discourses or "identity kits" that enable individuals to be recognized as certain kinds of people, Bakhtin conceives of language learning as coming to know, either consciously or implicitly, how to participate successfully in certain social situations and to enact the social values and ideological dispositions of certain cultural, linguistic, and/or social groups. This heteroglossic or multivocal (Bakhtin, 1981) vision of language also encompasses the ways in which individuals appropriate an array of available dialogic resources, such as media, texts, other utterances, and social voices, to assist them in constructing meaning and in projecting certain identities and social affiliations that may depart from and/or challenge what is standard or established.

In the following analyses, I discuss how Nanako's facility with different forms of literacy and popular culture, and the online fan fiction community provided her with many diverse resources that helped her to construct and en-act the identity of a successful fan fiction writer in English. However, this iden-tity was negotiated not only through English but also through Nanako's pan-Asian linguistic and cultural knowledge and affiliations. In addition, for Nanako's writing on FFN, she draws on a range of pop cultural resources from different countries, such as Japanese animation, music from the United King-dom, and novels and motion pictures from the United States, to assist her in composing in English. I also discuss how these dialogic resources shifted over time as Nanako's facility with English and her comfort level in the online com-munity increased. To conclude, I posit that Nanako's participation in this online space not only helped her to develop confidence and motivation for continued writing and language learning in English but it also provided her with a sense of pride and a renewed emphasis on her linguistic background and ethnic iden-tity as an Asian.

From *Beyblade* to *Card Captor Sakura*

Nanako's initial fan fictions were based on two anime series, *Beyblade* and *Yu-Gi-Oh!*, that, like many media "mixes" (Ito, 2001) or "franchises" (Lemke, 2005), have corresponding toys, television shows, movies, and manga (comic books) and were wildly popular at the time. The plots of both series revolve around competitors battling or dueling either using Beyblades, which are spinning tops, or in the case of *Yu-Gi-Oh!*, using Duel Monster playing cards. While both shows have female characters and competitors, the action centers mainly on male protagonists and their skirmishes. In drawing from these media for her writing, Nanako appropriates only certain aspects of these texts and then uses them to create her own plotlines. For instance, in her first *Beyblade* fiction, Nanako develops her story around the characters from the White Tigers, a Chinese *Beyblade* team. In particular, the narrative events focus primarily on a romantic relationship between the characters Ray and Mariah. Thus, her choice of plot provides means for fusing elements of popular culture with the emerging interest in sexuality and/or romance that she and many adolescents on the site share.

The narrative of the story text itself is written entirely in English, aside from one spot where, interestingly enough, Nanako portrays one of the Chinese characters using a Japanese term as she is thinking to herself. The use of Japanese rather than her first language of Chinese here could be attributed to several factors. First, as discussed in subsequent analyses, Japanese language is often viewed as a badge of membership in anime fan communities. Also, while Nanako knows a great deal about the *Beyblade* show, she freely admits that she does not know details about some of the characters; hence, she may not have realized that this particular character was in fact Chinese.

Nanako's *Beyblade* fiction is what is known within the fan community as a "songfiction" or songfic, which is a "story based entirely around the lyrics of a song" (Fanfiction Glossary, 2006). This hybrid story structure can be seen in the following excerpt from Chapter 1 of *Complete*.

Chapter 1 The Pain

It was a cozy night, I was lying awake on my bed, I just couldn't help but thinking about Ray. His bedroom was just a few blocks away from mine. I wanted to go and see how he was doing, but I would probably get kicked off the team if Lee or Kevin see me wondering around Ray and his teammates' rooms. *Oh Ray, I wish you could come back to me, then we can be together just like the old times.*

~ Flash back of yesterday ~

If you see me walking down the street

Staring at the sky and dragging my two feet

I was walking down the street with my teammates, and then we saw you and your team, the bladebreakers. I was so glad to see you again, you were as handsome as per usual, I wanted ran up to you and gave you a warm hug, but I know Lee won't allow me to so. I really missed you Ray.

Thus, the text is dialogic in the sense that she mixes both the Asian elements of the Japanese Animation with more Western pop cultural elements by using a song from an all-female pop band from the United Kingdom. Moreover, for a writer who was just learning English, the mixture of generic resources from both the song and the narrative story format provides an intertextual framework to scaffold Nanako's writing. Specifically, she was able to separate and use each stanza of the popular song, as well as readers' knowledge of the tone of the song, to augment and support the romantic nature of the narrative story she was crafting. Moreover, she did not have to construct the entire narrative from scratch.

Author's Notes and Self-Identifying as an ELL

Nanako introduces the first chapter of *Complete* with Author's Note (A/N). As mentioned previously, on FFN, A/Ns are used by writers to address readers before, during, or after their stories. However, there is a fair amount of controversy surrounding A/Ns in the broader fan fiction community. The debate hinges on the fact that many "serious" fan writers do not approve of such notes, arguing that they are jarring and/or detract from the readers' enjoyment of a text. Nonetheless, as evidenced by the copious amount of A/Ns, readers' positive responses to such notes and general support for their continued presence in the community (e.g., online petitions), A/Ns are an integral and, I would argue, valuable part of writing and participation in this space. On the Fanfic Symposium, a site devoted to meta-discussion of fan fiction, Gilliam (2002) writes about this very topic and argues that "fanfiction.net is less an archive in which finished stories are housed than a community in which the participatory process of constructing the story is as important if not more so than the finished product" (n.p.). Nanako's extensive use of A/Ns supports this vision of FFN as a social and interactive writing space rather than a depository for text. She uses A/Ns for a variety of notable purposes: to establish certain aspects of her identity, to introduce and help orient readers to her texts, and also to thank reviews for their feedback and support of her writing, to name just a few. Moreover, as discussed in the next section, Nanako uses her A/Ns to elicit both social- and writing-related

responses from readers in such a way that the readers and their feedback also become resources that support and inspire her participation on the site.

For instance, the following A/N serves several different functions. First, the note is a way for Nanako to begin establishing her identity as an anime fan. Second, it provides a guide to her text for readers to follow. And finally, it serves as a means for Nanako to negotiate her writing space with readers. In Segment A, Nanako begins not in her native language of Mandarin, but in Japanese. She greets readers (*Konnichiwa*) and tells them that "[She's] back" (*Tadaima*) from a few weeks of not writing or updating her stories. As mentioned previously, the Japanese terms are a means of indexing her identity and insider status in the realm of anime fan fiction, as many fans try to learn and/or integrate Japanese into their anime-based texts.

Segment A
L1 A/N: Konnichiwa!
L2 Tadaima!
L3 This is my first Beyblade song fic,
L4 so please go easy on it.

Segment B
L5 I just love Ray/Mariah fics,
L6 they are so kawaii together! ^_^

Segment C
L7 Read and Review!
L8 And no flames!
L9 Thank you!

Segment D
L10 By the way, this is in Mariah's POV
L11 on the night when Ray lost his bit beast. (2002)

In Segment B, Nanako is indexing another aspect of her identity, while at the same time eliciting a different sort of interaction from readers. Specifically, in Line 5 she identifies the couple that will be paired romantically in the story, and then in Line 6, in Japanese, says what a *kawaii* or cute couple she thinks they are. In this way, Nanako is establishing herself as a supporter of the romantic pairing of a certain anime couple. Interestingly enough, this is often a huge point of contention, as many fans are deeply invested in *shipper* or relationship-based texts and prefer to read stories that feature pairings that they are interested in and/or approve of. In this sense, Nanako is establishing a point of contact with her readers and is identifying herself as a Ray + Mariah fan. She is also eliciting responses that are not based on her writing per se, but are more

related to other fans' interpretations of the anime itself and is in a sense engaging in the debate surrounding which characters make the best romantic fit.

Nanako also uses this A/N to negotiate her writing space with readers in a way that indexes the sort of online writer that she is, specifically, one that appreciates and encourages the participatory and social nature of FFN. For example, in Lines 3 and 4, she asks readers to be gentle with their comments as this is her first attempt at writing a *Beyblade* songfic. Then, Segment C is a clear example of Nanako's attempts to negotiate with readers as she elicits feedback by asking for "reviews" in Line 7; moreover, she specifies the type of feedback she wants in Line 8. In online register, "flames" are antagonistic, derisive comments. Thus, by writing "no flames," Nanako is parleying for gentle, constructive forms of feedback and making it known that harsh criticism is unacceptable. Nanako concludes, in Segment D, Line 10, by providing further orientation for readers by specifying the character point of view the story is told from, and in Line 11 establishes a specific timeline for the text.

One month later when Nanako posted the second chapter of this fiction, she introduced a new element of self-disclosure into the A/Ns. Specifically, she chose to foreground the fact that she is learning English, and, thereafter, this disclosure played a formative role in many readers' responses to her texts. She writes:

L1 Important note: English is my second language,
L2 so please ignore my grammar mistakes and spelling errors.
L3 I might have some typo
L4 since I wrote this story in a hurry. (2002)

In self-identifying as an ELL, Nanako is again engaging in a sort of dialogic negotiation with readers. First, she explicitly requests that readers overlook conventions in her writing, which implicitly directs their focus to other aspects of composition such as content and meaning value. Also, at this point in time (one month after the initial chapter was posted), many readers were pleading with her to update the story. So in Line 4, she is also able to use haste as a disclaimer of sorts to mitigate any potentially negative responses to errors and typos in the text. In addition, as shown in the following examples of reader reviews, this new introduction to her A/Ns generates interest in and questions about Nanako's linguistic and cultural background. As such, she is able to use the A/N in such a way that continues helping her to construct her identity as an accomplished fan writer. Moreover, this addition sets the stage for establishing her expert knowledge and insider status as an Asian writing anime-based fan fictions.

Card Captor Sakura and Linguistic and Cultural Identity

Three months after posting the *Beyblade* fiction, Nanako moved on to another anime canon, specifically, to *Card Captor Sakura* (*CCS*). As discussed in Chapter 2, *CCS* is what is known as a *magical girl* series, a popular subgenre of *sh jo* or anime for young women. In this series, the protagonist is a young Japanese girl named Sakura Kinomoto, who uses her magical powers to capture an enchanted deck of cards. Though the plot does feature many of Sakura's battles with the magical cards, it differs from the *Beyblade* and *Yu-Gi-Oh!* series in that it also places a great deal of emphasis on friendship, family, and implied romantic relationships between characters. Thus, when Nanako began writing *CCS* fictions that featured relationships between certain popular couples, her stories generated a great deal of interest in the community. One such fiction, her fourteen-chapter story *Crazy Love Letters,* became very popular in the *CCS* section of FFN and received more than 1,700 reviews from readers (as of 5/21/2005).

As a dialogic resource, *CCS* provided Nanako with new opportunities for creating texts that were linguistically and culturally hybrid. For example, although the series takes place in Japan, two of the main characters are exchange students from Hong Kong, and one of them, Syaoran Li, becomes Sakura's primary love interest. Unlike the *Beyblade* fiction that was written primarily in English with some Japanese interspersed, Nanako used these Chinese characters as an entrée for bringing her first language of Mandarin into her writing. At the same time, she continued to improve her English and also attempted to integrate more Japanese, which she is learning in school, into her texts. When I asked about her use of multiple languages in fan texts, Nanako explained that she used the languages to add to the realism of the story.

> I find add words of another language into a piece can be very effective in a way. For example, on FF.N, Sakura and Syaoran speak Japanese and Syaoran speaks Chinese as well. To give the story more realism, Japanese and Chinese should be added into the dialogues to give the reader the impression that the story is actually happening in some place in Japan or China. Using different languages is sometimes like attracting the readers into the writer's own made up world and make things seem more realistic than it actually appears. (2006)

In addition, as she begins revealing more about her cultural and linguistic background in her biographical statements, self-identifying as an ELL in all her A/Ns, and using different languages in her fan fiction texts, the multilingual nature of her texts becomes another crux of interaction and dialogic negotiation for her and a transnational group of fans. In the next section, I focus only peripherally on Nanako's text (see Chapter 6 for further discussion of this fan

fiction), and instead highlight how Nanako's selective appropriation of resources and reader reviews of this text enabled both Nanako and her readers to discursively position themselves within a diverse, pop cultural milieu made up of youth from across the globe.

Reader Reviews

According to Bakhtin, dialogism is a mode of meaning-making characterized by the meeting and interaction of diverse and often dissenting social voices and perspectives (1981). As I discuss further in Chapter 6, FFN provides a space for such dialogism in the provisions it makes for reader feedback. Specifically, each chapter of a posted story has an easily accessible link for submitting reviews. This allows readers to respond to each section of a text as they finish reading it. This is significant for Nanako as an ELL writer because she received immediate, contextualized feedback on the effects that her rhetorical choices and uses of language have on different readers (Black, 2005). Then, this dialogism continues, as, through A/Ns, e-mail, and subsequent texts, Nanako is in turn able to respond to readers' responses. However, as Nystrand (1997) points out, "discourse is dialogic not because the speakers take turns, but because it is continually structured by tension, even conflict, between the conversants, between self and other, as one voice 'refracts' the other" (p. 8). Thus, Nanako is not simply composing her stories for some silent, anonymous audience. Instead, she is learning to write and to make language choices as part of authentic participation in what Nystrand calls a "dynamic, sociocognitive process" (p. 8) or event as writers and readers co-construct the "temporarily shared social reality" surrounding her text (Rommetveit, 1974). Readers in this space, as avid anime fans, feel a sense of ownership over the characters and media that Nanako is representing in her texts. Moreover, as members of this fan fiction site, they also have a proprietary attitude toward the writing environment and feel justified in putting forth their own ideas and perspectives in terms of how it should be shaped. Thus, in terms of content, reader reviews are not only resources for and responses to Nanako's writing but are also conduits for readers' distinct identities and cultural perspectives, which at times may differ or conflict with each other. Jenkins (1992) points out that "for most fans, meaning-production is not a solitary and private process but rather a social and public one" (p. 75). As such, FFN provides a meeting place for what Newkirk (2000) calls "the dialogic relations of multiple worlds" (p. 124) stemming from popular culture, school and academic practices, fans' home and friendship groups, online communities, as well as fans' varied ethnic and

cultural affiliations, to name just a few. Moreover, these multiple worlds play significant roles in how youth construct, enact, and portray their identities.

In the following reviews, both reviewers respond to Nanako's fan fiction text as well as to her use of her first language of Mandarin. In addition to providing simple feedback on Nanako's writing, which supports her identity as a fan fiction author, these reviews also enable readers to demonstrate allegiance with Nanako and to index their own identities as Mandarin Chinese speakers. For example, the first reviewer begins by making this association in the first segment and holds off commenting on the text itself until Segment B.

Segment A
L1 so u speak manderin?
L2 cool!!
L3 me too ^^

Segment B
L4 i luv this story!
L5 keep up the good work!! (2003)

Similarly, in the next example, the reviewer begins by complimenting Nanako on her facility with Romanized Mandarin, indexing their shared knowledge in this area, and also relegates story commentary to the final segment.

Segment A
L1 Congratulations! I deem you another Han Yu Ping Ying champion! :D
L2 It's rare to find many people who understand how to use this phonetic spelling of the Chinese language correctly,
L3 but you have proven that you can through the Mei-Lin/Syaoran conversation!
L4 Great job on that aspect your fic!

Segment B
L5 Overall, of course, your fanfic is wonderful!
L6 I've been meaning to review but kept forgetting ^^;;
L7 Please update soon!: D (2003)

In deeming Nanako "another" Hanyu Pinyin champion in Line 1, the second reviewer is implicitly positioning herself as accomplished in this area as well. Moreover, the reviewer's feedback on this aspect of Nanako's writing sends a clear message that knowledge of and skill with multiple languages, not solely English, is valued in this space. Both the structure and the content of these reviews illustrate the social and participatory nature of writing in this space. Structurally, both readers foreground their shared linguistic background and appreciation for Mandarin, which immediately creates, albeit at the surface level, a social connection with Nanako. Both readers also end with segments of

strong support and enthusiasm for Nanako's general abilities as a writer. In addition, the emoticons (smiling and crying faces), truncated spelling (u, luv, fanfic), and repeated exclamation points index the readers' knowledge of online social registers and display their affiliation with the participatory and interactive nature of writing and reading on FFN as they show strong support for the author.

Hanyu Pinyin itself is a hybrid form in that it represents Chinese phonetics with characters from the Roman alphabet. This system of translation is particularly useful in CMC because keyboards are not set up to display the many thousands of traditional Chinese logographic characters (Wikipedia, Hanyu Pinyin, 2005). Moreover, Romanized forms of language are increasingly more prevalent as a medium for online communication between youth who are bilingual in English and Chinese. For example, Lam's (2006) work explores how a "mixed code" variety of Romanized Chinese and English was used by bilingual Cantonese/English speakers in a chatroom.

> This language variety served to create a collective ethnic identity for these young people and specifically allowed the two girls in this study to assume a new identity through language. This new identity follows neither the social categories of English-speaking Americans nor those of Cantonese-speaking Chinese. (p. 45)

Thus, online spaces are fertile grounds for observing the fluid nature of identity and language in use. Lam's study presents one of the many shifts taking place as ELLs adopt and adapt language varieties to communicate in global forms of English in online spaces. Moreover, it highlights how language and new ICTs are playing a new role in the ethnic and social affiliations of immigrant youth across many different parts of the world.

In addition, Nanako's extensive use of Romanized Chinese and even her minimal use of Japanese were means for positioning herself both as an insider in the Asian realm of anime and as an effective user of several different languages. Many of her readers contributed to this discursive construction of self with reviews that expressed enthusiasm and admiration for Nanako's knowledge of different languages, including but not limited to English. For example, in Segment B, the following reviewer claims to be learning Chinese and Japanese from reading Nanako's fan fictions.

Segment B
L4 This is really interesting,
L5 the plot is thickening every minute!
L6 I'm learning so much chinese and japanese every time I read! (2003)

Moreover, in terms of integrating her first language in her fictions, Nanako writes in a manner that positions her as an expert and makes the Mandarin

accessible to speakers of other languages. For instance, she provides clear translations of all Mandarin Chinese text, essentially juxtaposing the English and Mandarin languages, as in the following example of a conversation between Meiling and Syaoran.

> Meiling turned to face Syaoran and grumbled in Chinese. "Dan shi, Xiaolang, wo xiang he ta shuo ji ju hua. (But, Xiaolang, I just wanna talk to her.)"

> "Ni bu yao fan ta, ren jia you shi gan. (You shouldn't bother her, people have things to do you know.)" Syaoran frowned and responded in Chinese as well. Sakura just looked at the two of them with a big question mark on her head. (A/N: Aww so kawaii!! Lol!) (2003)

Nanako, at times, inserts A/Ns into the fiction to explain different aspects of language, such as explaining that there are many different ways of saying "I'm sorry" in Mandarin. In a similar example, the next reviewer, a native English speaker, expresses her admiration for Nanako's skill with English, Chinese, and Japanese.

> Segment B
> L3 By the way, you are on my fave authors list!
> L4 And your english is great!
> L5 You should hear my japanese... ;^^
> L6 I don't know any chinese either,
> L7 so you are very smart to know so much about these languages! ^_^ (2003-07-08)

In Line 4, the reviewer explicitly comments on Nanako's status as an ELL. The reviewer then goes on to affiliate with Nanako as a fellow language learner by implying in Line 5 that her own Japanese is terrible. Then in Line 6, by conveying her ignorance of Chinese, the reader acknowledges not only the breadth of Nanako's linguistic abilities but also how "very smart" Nanako must be to use these different languages effectively in her texts. Moreover, the reader's point in Line 7 can be contrasted with how language learners are often positioned in the majority of English-speaking contexts, such as schools. In particular, bilingual speakers are often viewed from a deficit perspective in which their first languages are seen as something detrimental that interferes with acquisition of English. However, this reviewer positions Nanako as a smart, accomplished user of multiple languages.

In a different example, the review presents a somewhat dissenting voice as the reader asserts both her knowledge of the *CCS* series and her identity as a Cantonese speaker. However, it is important to note that even in presenting a critique of Nanako's writing, this reader still mitigates this dissent by finding other points of affiliation around Chinese popular culture and with Nanako's story itself. For instance, in Segment A, the reader begins with a humorous

threat that implicitly expresses her appreciation for Nanako's story as she threatens to strangle her if she does not continue updating with new chapters. Then in Segment B the reviewer makes a further point of affiliating with Nanako over a popular Chinese film that they both like.

Segment A
L1 Meiling is so evil! Ha!
L2 Don't stop,
L3 if you do I'll strangle you! Haha!

Segment B
L4 I love Huan Gu Gak Gak as well.
L5 It's a great story huh?
L6 bu i watch it in Cantonese.
L7 My favourite character is Siw Yin Ge,
L8 The one Vicki Zhoa Wei plays.
L9 it's awesome.

Segment C
L10 Let me point out that Li and Leing are from hong Kong, not China
L11 and since they're from hong Kong they should be speaking
 cantonese
L12 but nevertheless i love it! (2003)

It is not until Segment C that the reader points out that, according to regional language differences, the Chinese characters from the *CCS* anime should be speaking Cantonese rather than Mandarin. However, it seems significant that the reader then mitigates this critique in Line 12 by using the coordinating conjunction "but" and then the conjunctive adverb "nevertheless" successively in a way that essentially renders the critique doubly unimportant. This is one example of how the site serves as a space where members can negotiate linguistic and cultural difference, but do so in a way that emphasizes connection and affiliation across potential barriers. Readers also, for the most part, express social and ideological differences in ways that still provide support and respect for the authors' creativity and artistic license.

Flames

It is important, however, not to reify FFN and other online communities as unproblematic socially and culturally harmonious spaces. To this end, I would like to discuss reviews that run somewhat counter to the previous samples. In the eighth chapter of *Crazy Love Letters*, Nanako introduced a plot twist that involved an arranged marriage between Sakura's love interest Syaoran and his

cousin Meiling from China. Out of 137 reviews for that chapter, the reviews of only two readers questioned the propriety of marriage between cousins. One reviewer simply expressed confusion that a cousin could also be a fiancé; however, the other reader posted a flame that does not merit reprinting. Interestingly enough, neither Nanako nor any other members of the community directly responded to these reviews. However, within the story text itself, Nanako indirectly explains that Syaoran must marry his cousin to fulfill his obligation to his family. Also, about a year after the *Crazy Love Letters* series was completed, Nanako began a new fan fiction that focused explicitly on the role of arranged marriage in Asian society. Thus, rather than directly addressing the question and/or confronting the hostile flamer, Nanako addressed the topic through her writing.

Also in the same batch of feedback, another reader posted a flame complaining about a long list in which Nanako thanks many of her regular reviewers. (This Thank You List was discussed in Chapter 4 and is discussed again in Chapter 6) Though it is unclear to which flame Nanako is referring, in the Chapter 9 A/Ns she revealed that she had been considering retiring from FFN because of flames that she received, but that a good friend convinced her to reconsider. Following this mention of her possible retirement, Nanako received an outpouring of support from her readers. The ensuing anti-flame sentiments ranged from thoughtful, nearly page-long discussions of how best to deal with flamers, to threats and name-calling, all the way to general expressions of appreciation from readers coupled with recommendations to simply ignore hostile reviewers because "hey if they dont like the story then they shouldnt read it right? ^-^" (SakiGurl, 7-11-2003).

Shifts in Identity over Time

Daily Life Resources

McCarthey and Moje (2002) in their article posit that one of the many ways identity is implicated in literacy and language learning is in how "readers and writers can come to understand themselves in particular ways as a result of a literate engagement" (p. 229). The shifts in Nanako's writing and participation in the fan fiction site over time reveal how her literate engagement in this space allowed her to draw on an array of dialogic resources to scaffold her writing and also provided her with a supportive social context for foregrounding and backgrounding different aspects of her identity according to her comfort level and the situation. During the years when Nanako was writing her first stories,

she was just beginning to adjust to life and school in a new country. Her texts represented many different themes and issues from her life as an adolescent. Her early fictions have settings such as concerts, sleepovers, parties at houses where the parents are out of town, and school classrooms. In addition, the texts deal with concerns that would be familiar for many youth, such as popularity, friendship, first love, and the pressure to succeed academically. These early narratives also are filled with what are most likely references to and resources from Nanako's daily life in North America (e.g., she mentions certain products such as Tylenol; she inserts the book jacket text from a Nicholas Sparks novel written in English; she draws from many television shows set in the United States). However, as more time passed and as Nanako grew more comfortable in this space, there were some notable shifts, not only in her writing and language use, but also in the narrative resources she draws from and in the themes she works through in her texts. These changes can be related to Nanako's changing patterns of participation and self-representation over time.

According to Nanako, in her early attempts at writing on the site, she not only wanted to participate in the anime and fan fiction culture, but also was hoping to improve her writing ability. Her first fictions were written almost entirely in English, and the A/Ns at the beginning of each text clearly indexed her identity as a new learner of the language and asked that reviewers overlook her grammar and spelling errors. These A/Ns in turn shaped readers' responses to her texts in many ways. For instance, many readers gave her pointed but gentle feedback on how to improve certain aspects of her writing (Black, 2005). Readers also focused a great deal on the content rather than the conventions of her stories. In this way, FFN provided a safe space where Nanako as a learner could experiment and practice with different genres and forms of writing in English. At the same time, she was able to use her developing language skills to participate in a social environment that was meaningful for her and her fellow anime fans as they affiliated around different elements of adolescent pop culture. She was also able to develop both skill and confidence in her identity as a writer and to make lasting social connections with youth from many different countries.

Over time, the aspects of self that Nanako foregrounded through both her texts and A/Ns began to shift. For instance, it was not until she had been writing on the site for about seven months and had received hundreds of encouraging reviews from readers that she began incorporating her first language of Mandarin and a small amount of Japanese into her narrative texts. Then, as readers, such as those who affiliated with Nanako as fellow Chinese speakers and/or the many readers from other countries who expressed interest in learning about Asian languages and cultures, began responding positively to this integration of multiple languages, she began to present more of this aspect of her

self to readers. For instance, her use of both Japanese and Chinese became more or less standard in her texts. Also, her A/Ns and her biographical statements on the site began to foreground a continued affiliation with her Asian heritage, as she devoted space to lists of new Chinese movies that she was watching or to discussions of popular Chinese actors, in addition to listing her favorite anime and manga series. Moreover, Nanako's fan fiction texts themselves began to turn toward themes and topics that she viewed as more closely related to aspects of her identity as an Asian female.

For instance, in an interview, Nanako explained that after attending school in Canada for several years, she began to realize that her schoolmates were largely unaware of either Chinese or Japanese history. Thus, she assumed that many fan fiction readers might also be unaware in this regard and decided to write stories that were grounded in the rich histories of these two countries. Specifically, she is referring to two recent fictions. In one, the popular novel/motion picture *Memoirs of a Geisha* serves as a dialogic resource for another crossover fiction in which she presents the anime character Sakura as a Geisha. The other, set in 1910 Kyoto, Japan, centers on Sakura's struggles with an arranged marriage. In addition, she has plans to compose a historical fiction based on the second Sino-Japanese war, or the war fought between China and Japan from 1937 to 1945. In reference to these shifts, Nanako points out that her writing has changed "dramatically" as she has matured, moving from the "utterly unrealistic high school happy, fluffy fanfics to something with more meanings" (2006). She goes on to explain that her desire to share her cultural heritage with others is in part the impetus for writing more stories about China and Japan.

> I guess you can say it's my Asian pride that urged me into writing more stories about China and Japan. At school, I realized that very few people knew the history of the far east. So I kinda thought, maybe not a lot of people on fanfic.net knew about it too. So I have decided to lead my readers into the world they didn't know existed and fascinate them with its rich history and culture, but at the same time, for myself to learn more about my own culture and history, since I often must go research for my fanfics. Lolz my knowledge is very limited too. (2006)

Thus, by writing these historical texts, Nanako has an opportunity to learn more about her own culture and history because she often conducts research to effectively represent the social and historical details in her fictions.

Achieved and Ascribed Identities

Gee (2001) posits that in many institutions (e.g., schools) those in power often draw from rules, laws, and traditions to authorize certain social roles in ways

that also "author" a certain kind of identity for the occupants of these roles. Such authorized or ascribed social positions are clearly present in classrooms where teachers are placed in the role of expert, and students are often assigned roles as certain kinds of learners. Moreover, many students, including ELLs, are often ascribed roles based on deficit models of cultural and linguistic difference. These roles, in turn, connote certain types of identities and set up certain expectations for student ability and behavior, without sufficient attention to the part that school, classroom, curricular, and societal contexts play in our assessments of and ways of categorizing students. Ascribed social positions can be contrasted with the notion of *achieved* identities, which are identities that individuals actively construct and negotiate in their moment to moment interactions with others. From this perspective, individuals may be positioned in certain ways by categories that have been authored for them; however, they also may engage in dialogic negotiation with these ascribed roles, as they choose to discursively represent and situate themselves in ways that may challenge or subvert standard expectations.

Unfortunately, in many North American educational settings, ELLs are viewed from a deficit perspective, and abilities in their first language are viewed as a hindrance to learning English and/or are not taken into serious consideration as an additive element for participation and meaning-making in classroom activities. In addition, in many schools, youth are cordoned off into spaces delineated by official and unofficial lines drawn along race, ethnicity, social class, gender, and ability. These lines can be quite pronounced for ELL youth who are isolated by linguistic and cultural barriers and/or who are completely relegated to classrooms that are separate from the mainstream school population. On the contrary, the online environment of FFN provides multiple routes that offer potential for traversing some of these real and imagined barriers.

On FFN, Nanako's writing was not constrained by an ascribed ELL role and/or specific expectations and requirements for her texts. Neither was she expected to adhere to the identity of an immigrant, a Canadian, or a native Mandarin Chinese speaker nor was she forced to choose between the languages in her linguistic repertoire. Instead, Nanako's process of fan fiction writing enabled her to portray different aspects of her identity in different ways over the years. Moreover, who, what, and how she chose to represent was in many ways contingent on the feedback and positive interactions she had with readers. Through her self-identification as an ELL, she was able to garner language-related support as well as social support from readers, which in turn provided her with the impetus to continue learning and writing in English. In addition, by drawing from a range of dialogic resources that were pertinent to her life at the time, she was able to establish her membership in a realm of adolescent popular

culture. Then gradually as she grew more comfortable and received more sup-
portive feedback from readers, Nanako was able to use her writing to demon-
strate and also to explore aspects of her Asian heritage, as she moved into
developing texts that center on the role of women in Chinese and Japanese so-
ciety, and this sets her thinking about creating texts based on the tumultuous
history between China and Japan. Rather than being constrained by the expecta-
tions of a monolingual, uniform group of readers, Nanako's process of self-
representation and meaning-making was instead supported by a linguistically
and culturally diverse group of youth from across the globe. Moreover, at the
same time that she was learning English, she was also developing new skills re-
lated to Romanized writing in her heritage language of Mandarin.

As broad shifts along the lines of globalization, CMC, and "virtual" spaces
compel us to reconsider the notions of culture and community (Jones, 1997;
Yon, 2000), it also becomes necessary to consider differences between how
ELLs, and adolescents more broadly, are positioned in schools versus how they
choose to position themselves in out-of-school spaces. Perhaps there are les-
sons to be learned from sites such as FFN, where the absence of imposed or
ascribed social roles enables adolescents from a range of different backgrounds
to act both as teachers and as learners. Through their online interactions, both
native and nonnative English speakers alike are learning to use multiple lan-
guages, social discourses, school-based forms of writing, as well as knowledge
of popular culture, in socially and linguistically appropriate ways. Also, they are
able to discursively position and represent themselves as articulate members in a
pluralistic space that fosters a positive sense of self. Moreover, the site also pro-
vides a safe, supportive, and meaningful venue not only for language learning
and literacy development but also for affiliating and commiserating with other
youth around social and cultural issues that are central to their lives. Finally, in
this site, language learning and identity development are not characterized as
movement toward some fixed, monocultural standard. Instead, literate and so-
cial engagement in this space involves a great deal of communication, and a
fluid and ongoing process of meaning-making and identity negotiation that
traverses national, linguistic, and cultural borders.

Reader Reviews and Fan Fiction

The afternoon's sun was still shinning bright in the clear blue sky. The clouds were dancing in circles as the wind blew gently at them. Sighed Sakura dreamily as she looked up at the clear sky and felt her heart filled with happiness. This was how her new life should've been, filled with joy. Everything looked wonderful and fantastic to Sakura. The flowers smelled lovely. The trees waved their branches as if they were welcoming Sakura's presence. The grasses beside the sidewalk were lash and green. Even the fresh air tasted a little sweet. Sakura was in such good mood and she didn't even care if the people were staring at her oddly. Her heart danced in joy as she continued to walk. She never actually noticed the beauty of Tokyo until now.

—Nanako (2002)

Identities, Affinity Spaces, and Networks

Scholarship within the New Literacy Studies (Cope & Kalantzis, 2000; Gee, 2004b; New London Group, 1996) has dealt with shifts from what is valued within the Old Capitalist/Industrial *mindset* that centers on the production of material goods to what is valued within social and work spaces rooted in a *mindset* that is "forged in cyberspace" (Lankshear & Knobel, 2003). Such shifts have come in tandem with the fast-paced development of new information and communication technologies (ICTs) and a New Capitalist focus on the production and exchange of information rather than commodities (Castells, 1996; Gee, 2004b). Gee (2004b) posits that facility with *design* has in large part replaced manufacturing skills within the value system of New Capitalism. In his text *Situated Language and Learning: A Critique of Traditional Schooling*, Gee (2004b) draws on the notion of *design* to shed light on some forms of pop-culture inspired learning and interaction through his exploration of a video game fan site. According to Gee, "three types of design that reap large rewards in the New Capitalism: the ability to design new *identities, affinity spaces,* and *networks*" (p. 97, emphasis in original). In this chapter, I use these three interrelated aspects of design as lenses to view the interactions between writers and readers on FanFiction.net (FFN).

Affinity Spaces

In the aforementioned work, Gee draws from the paradigmatic features of an affinity space devoted to the video game *Age of Mythology* to contrast "communities of practice," in which novices learn through apprenticeship and scaffolding into legitimate participation (Lave & Wenger, 1991), with the forms of learning and participation that are commonly found in *affinity spaces*. In Chapter 3, I explored the paradigmatic features of affinity spaces in relation to the specific social and communication features of FFN. In this chapter, I revisit some of the general characteristics of affinity spaces, particularly the co-construction or design of space between fan writers and readers.

In affinity spaces, people interact and relate to each other because they have a shared passion, goal, or interest. For instance in Gee's study, members of the affinity space relate to each other through their shared passion in the video game *Age of Mythology,* whereas in my work, members of the online fan fiction site share a passion for *Card Captor Sakura* (*CCS*). Gee posits that defining the point of affiliation in this way emphasizes how variables such as race, class, gender, sexuality, ability, and education level, though certainly not eliminated, are often backgrounded to this common taste or endeavor. Thus, affinity spaces are unique because they provide opportunity for individuals who ordinarily might not have a great deal of contact with each other or have the opportunity to meet or gather in an online common ground. Moreover, on such common ground, there are multiple opportunities for *all* members of the affinity space to share their knowledge and in turn learn from others.

Networks

Developing *networks* is another key aspect of design in the New Capitalism (Kelly, 1998, as cited in Gee, 2004b) and our information-oriented society (Castells, 1996). As a research context, FFN provides clear examples of youth learning to use new ICTs to develop "communicational links between people and organizations" as well as between "people and various sorts of tools and technologies" (Gee, 2004b, p. 99) in ways that traverse traditional boundaries of time, space, and linguistic differences. For example, in examining interactions between writers and readers on the site, it is clear that participants must be able to navigate "the multiple linguistic, audio, and symbolic visual graphics of hypertext" (Luke, 2000, p. 73) to participate successfully in the social network of this online affinity space. The site and its members use an array of text and symbol-based signs to indicate hyperlinked connections within FFN and across other pertinent sites. These might include sites promoting fan fiction writing contests and awards that allow members to nominate and vote for their favorite

fan fiction stories; fandom-specific sites containing detailed information on media canons; academic sites containing historical or linguistic information about specific countries and eras; and corporate or fan sites that provide information on copyright laws, to name just a few. These connections allow members to draw from knowledge distributed across different locations. This distribution of resources not only is a defining feature of networked affinity spaces (Gee, 2004b) but also is related to the sort of skills that are increasingly valuable in modern work, academic, and leisure settings. For example, information available across Internet-accessible spaces is increasing daily—for example, information such as guidelines for operating computers, software, and other tools and technologies; materials related to admissions, enrollment, programs, and classes for various colleges and universities; rules, instruction manuals, and product guidelines related to sports, games, and hobbies. Youth not adept at accessing and navigating these sites are and will continue to be at a distinct disadvantage to those who have had ample experience locating, interpreting, and using such networked resources and distributed forms of knowledge.

In terms of the design-related skills of leveraging new technologies and learning to communicate within global networks, it is also clear that fans "draw on a range of knowledge about traditional and newly blended genres or representational conventions, cultural and symbolic codes, as well as linguistically coded and software-driven meanings" (Luke, 2000, p. 73) to participate successfully in the fan community. For example, there are the linguistically and culturally "blended" or hybrid texts discussed in Chapter 5 (e.g., texts that are composed primarily in English and represent scenarios from the lives of adolescents living in North America but also incorporate Japanese and Chinese language and cultural symbols). Hybrid textual forms also are created by blending various media and textual genres (e.g., songfics, moviefics, chatfics, poetryfics) as discussed in Chapter 1. There is also the hybridity of Internet Relay Chat (IRC) discourse, which blends elements of conversation and writing, and multimodal texts to incorporate image, space, sound, color, movement, and print to convey meaning. Thus, readers must understand such "newly blended genres and representational codes" (Luke, 2000, p. 73) not only to compose texts but also to successfully read and provide feedback.

Another key component of designing and successfully participating in global networks is the ability to recognize, value, and accommodate for the range of culturally and linguistically diverse perspectives that participants bring to such spaces. The themes and topics often raised in fan fiction texts, such as love, relationships, marriage, sexuality, family, friendship, fairness, loyalty, and responsibility, provide an indication of differing cultural perspectives on such

topics. Thus, online fan fiction spaces provide opportunities for youth to encounter, engage with, and learn about and understand models of life that are different from their own. The importance of negotiating cultural difference in navigating links between people, institutions, and diverse tools and technologies is discussed in detail in the final chapter of this book.

Identity and Discourse

The notion of identity is crucial not only to design but also to participation in schools and in fandoms. As outlined in Chapter 5, identity is not necessarily a fixed, stable construct, but can be flexible and context-dependent. From this perspective, individuals have multiple identities that are connected, not to some fixed, internal state of being, but to patterns of participation in social events (Gee, 2001). Moreover, in certain contexts, individuals are often expected to occupy particular roles that have been ascribed to or authored for them by society (Gee, 2001). As explicated in Chapter 5, such ascribed identities are often visible in classrooms where teachers are vested with the role of expert, and students, by virtue of tracking, Individualized Education Plans, and sometimes general supposition about culture, and/or social class, are assigned roles as certain kinds of learners. This sort of ascription of identity becomes problematic when students from nonmainstream backgrounds are expected to occupy roles based on deficit models of cultural and linguistic diversity and differences in learning styles. Moreover, such cultural and cognitive-deficit models connote certain types of identities, behaviors, and abilities, without sufficient consideration of the role that the classroom and curricular contexts play in our assessments of student actions or in our rubrics for categorizing student identities. On the contrary, an interesting aspect of fan fiction sites and many other affinity spaces is the absence of imposed social roles or obligatory knowledge for participants. Thus, FFN is a learning environment where new ICTs and the absence of authorized roles for experts and novices afford individuals greater freedom in designing or discursively constructing achieved rather than ascribed identities.

According to Gee (2001), in the New Capitalist or "modern" value system of the information age, discourse and dialogue play an important role both in designing identities and in having others recognize such achieved identities within affinity spaces and online environments. FFN is a clear example of a site where traditional print-based language and post-typographic forms of text play crucial roles in defining the affinity space, creating and sustaining social networks, and enacting achieved identities within the site.

Nanako and Design

Data for this chapter primarily stem from Nanako's fourteen-chapter fan fiction *Crazy Love Letters*. Nanako is an exceptional case because she has become an expert in design—more specifically, over time she has become very adept at networking in this space and has developed a considerable group of readers and avid followers to the extent that she now has more than 6,000 reviews of her fifty plus publicly posted fan fiction texts. Thus, her interactions on the site demonstrate her facility with designing aspects of the FFN affinity space and various social networks that suit her needs as an individual as well as with designing a positive identity for herself as a popular fan fiction writer.

For the purposes of this chapter, I use texts that are representative of salient types of reader reviews. I also focus on reviews that Nanako explicitly responds to in her Author's Notes (A/Ns), in her fictions, and in her Thank You Lists for Reviewers that she updates for each chapter in order to gain a greater sense of the negotiation between writer and readers. After revisiting the initial thematic patterns from the typology, I then present a closer discourse analytic examination of such texts with the following questions in mind:

- What sort of linguistic "work" are Nanako's texts and the reader reviews doing?
- How and in what ways are these texts representative of successful design of affinity spaces, networks, and identity?
- How and in what ways might Nanako's texts and reader feedback be indexing the author's identity as a successful writer and the readers' identities as knowledgeable participants, thus helping them all accrue forms of social and intellectual capital in this space?

In answering these questions, I analyze each line and stanza in terms of the sort of socially situated identities (Gee, 1999) that are being enacted or referenced in the social network of this affinity space. I then return to Nanako's texts to see her responses to each of these reviews. This portion of the analysis includes explicit responses made through her communications with readers as well as implicit responses made through revisions to her fan fiction stories. I also code for explicit and implicit references to the development of social networks and/or to interactions that indicate a negotiation of the writing/reading space. It seems important to emphasize, however, that the focus of this chapter is not on minute discourse analysis of individual texts. Instead, analysis is aimed at identifying general "types" of reviews and patterns of interaction between Nanako and her readers to better understand the learning, social, and interactive

aspects and nature of design in this space. Such an approach also highlights how Nanako uses her mastery of design to discursively construct and sustain an achieved identity as a highly popular author in this space, rather than taking on an ascribed identity as an English language learner (ELL) who struggles with writing in English. Such an approach also facilitates understanding of how this author and her readers, through interaction and negotiation, are able to co-design a social and learning-based space where native and nonnative English speakers alike are able to display expertise and build on their different forms of personal, cultural, and linguistic capital.

Designing a Fan Fiction Writing Space

This section uses some of Nanako's introductory and concluding A/Ns to illustrate her facility with design. Specifically, Nanako is quite skilled at using language and discourse to shape her own interactional and learning space in such a way that maximizes opportunities for constructive feedback on her language and writing. She also uses these A/Ns for establishing her social and writing-related resource network by cultivating strong relationships with readers. For instance, Nanako begins and ends each of her chapters with A/Ns that demonstrate implicit and explicit attempts to influence readers' responses to her texts as well as to demonstrate her responsiveness to readers' wishes and desires. Her pattern of using these types of A/Ns can also be seen in the text excerpts from her fourth and fifth chapters.

Opening Author's Note

> Segment A
> L1 Important note: English is my second language
> L2 and I only spoken it for 2.5 years.
> L3 So please excuse my grammar and spelling mistakes.
> L4 I might have some typos in the story,
> L5 so hopefully you guys can look over them.
>
> Segment B
> L6 A/N: Konnichiwa minna-san!!
> L7 I'm back! ^^
> L8 Okie, I am trying my best to finish up this story,
> L9 but I also have to have time to study for my exams. ><;;;;
>
>
> Segment C
> L10 Anyway, since I did good school,
> L11 and remembered everything the teacher asked me to,

L12 I will be able to have more time for updating my crappy stories!
 ^_____^;;;;

Segment D
L13 Thank you all who reviewed this story,
L14 and this chapter is dedicated to **Sakura Blossomz01, wild-gurl, Sweet^-^Rose,**
DZ pals, Fire Light and **Lily-Chan.**
L15 Thank you for adding me to your favorite author list! ^//.//^
L16 THANKS FOR THE GREAT SUPPORT YOU ARE GIVING ME!
 ^_____^

L17 *Hugs her reviewers*

Segment E
L18 By the way, please pay close attentions to the e-mails in this chapter,
L19 because they are some really important clues.

Segment F
L20 ^_____^ MERRY CHRISTMAS EVERYONE!!
L21 THIS ISH MY PRESENT FOR YOU!!
L22 I HOPE YOU'LL LIKE IT!!! ^_____^. (2002)

Nanako begins the chapter by identifying herself as an ELL in Line 1 and then, in Lines 3–5, asks the readers to overlook her typos and grammatical and spelling errors. In Segment B, she goes on to announce "I'm back!" thus acknowledging that it has been a long time since her last update and that she is now "trying her best to finish up this story." These lines demonstrate Nanako's responsiveness to the audience's repeated requests for her to "plz update" or add additional chapters to the story, as she somewhat apologetically explains that she has not been able to do so because she needs "to have time to study for [her] exams," punctuating her own preference for writing fan fiction over studying with a crying emoticon (><;;;;) at the end of Line 9.

Nanako's skill at creating and sustaining social networks is also evidenced by this opening A/N. For instance, in Segment D, Lines 13 and 14, she thanks "all who reviewed this story" and then goes on to dedicate the chapter to reviewers who provide what she considers to be continuous and/or especially supportive or helpful feedback. In this way she provides appreciation for the time they have taken to review her stories, and by dedicating the chapter to certain reviewers, she is also providing continued impetus for them to read and post supportive feedback for her texts. In addition, by publicly posting the names of those particular reviewers (who are also authors) at the start of her popular text, she increases the chances that some of her many readers will seek out the reviewers' fictions and read them, thus creating a mutually supportive, hyperlinked network of writers and readers.

In a similar vein, in Line 15, she thanks readers for adding her to their "favorites list," which is a function of the site by which members can create hyperlinked lists of preferred stories and authors. Such links make it easier for members with shared interests to find each other and for like-minded readers to find Nanako's fan fictions. Another relatively unique aspect of Nanako's A/Ns is the continuously updated Thank You List (which is separate from the dedications in Segment D) and a Favorite Reviewers from the Last Chapter List that she includes with each chapter. In the lists, she writes personal responses and acknowledgments to certain reader reviews, thereby giving explicit encouragement for the sort of feedback she finds helpful, and by omission, she implicitly discourages feedback that she finds offensive or trivial. Furthermore, acknowledgment in the chapter dedications or the lists appears to be a status symbol among Nanako's network of readers, and they openly discuss "making it" to the Thank You or Favorite Reviewer lists. Also, as in the following example, many reviewers thank Nanako for acknowledging them in their reviews.

> Thank you for putting my name on the "Thank You" list!! (sob) This chapter is really SAD!! (keep sobbing and grab a bunch of tissues.) Please update next chapter soon. And don't tell me Sakura is going to leave "little wolf" forever?!?!?! (blow nose)(sigh) Enough crying for now. Remember, update it soon!! ^,-; (2003)

While in the following example another reader discusses being mentioned in the Dedications.

> ah thank you for dedicating me for this chapter!! omg NO!! SAKURA .. is... LEAVING !! ... leaving Syoaran ... DAMMIT MEILIN! she didn't have to be harsh on her... but i can see why she has done it. Now, Syoaran has to get Sakura back and tell her the truth. can't wait!! (2003)

However, as mentioned in Chapters 4 and 5, some readers (primarily those that are not mentioned in the list) took issue with Nanako's extensive Thank You List and posted negative comments about it in their reviews. Conversely, other reviewers are clearly of the opinion that readers who loyally follow her stories and post constructive and supportive feedback merit such personal acknowledgment. This can be seen in the following review.

> Anyway, don't mind whoever gave you the flame about writing a LONG thank you list... what can he do? you. are. loved. and he's not [hehe!]. I do prefer when authors reply personally to their reviewrs, it's giving them the gartitude they deserve... so don't stress yourself about making shorter thank you lists and keep giving your reviewers what they deserve. =) (2003)

Thus, many fans view the Thank You Lists and Dedications as providing loyal readers with well-deserved gratitude. Moreover, this ongoing process of writing,

reading, reviewing, and acknowledging is an integral part of how Nanako develops and sustains an interactive network of friends within this fandom.

In Segment E, Nanako directs the readers' attention to certain aspects of the story, in this case the e-mails between characters. Specifically, she wants them to attend to these e-mails as they contain important clues for understanding her text as well as a bit of foreshadowing of the chapters to come. Such communication is a way for Nanako to play at least a small formative role in determining how readers approach the text, what aspects of the narrative they attend to and comment on, and what sort of feedback they provide.

Segment F, the final segment of the opening A/N, is primarily aimed at doing social and identity work. For example, Nanako is sustaining her social networks by wishing all her readers a "Merry Christmas." Moreover, she is also indexing her developing confidence and identity as a successful author as she presents her fanfic as a gift for the audience. This sense of confidence was constructed through a mutual negotiation between Nanako and her readers. For instance, in Line 3, she writes that because she is doing well in school, she "will be able to have more time to update her crappy stories!" This reference to her stories as crappy is not overlooked by readers, and they respond with repeated assertions that her stories are wonderful rather than crappy and admonish her to be more positive.

In addition, as mentioned in Chapter 4, Nanako ends many of her chapters with "cliffhangers" or "cliffies" as a means of creating and maintaining a high level of reader interest in the story narrative. In turn, readers respond by posting repeated requests for her to update her texts so that they can find out what happens next in the story. Thus, Nanako, at least in part, is skilled in creating some of the positive feedback and high demand for her stories, while the readers respond in positive ways, and their encouragement pushes her to continue writing. It is worth noting here that although Nanako is skilled at eliciting responses from her audience, the quality and creative nature of her texts is a major contributing factor to the large numbers of readers and reviews she has garnered over the years.

Nanako uses similar networking and identity-building strategies in the closing A/Ns she includes in nearly all her stories. Take the following closing A/N from the same fanfic chapter as an example.

Closing Author's Note

Segment A
L1 A/N: ><;;; bad writing.........I'm not a good writer.........><;;;
L2 please review, and tell me what you thinks of this story.
L3 Because if you guys don't like it,

L4 I won't write more........
L5 I always say that^^;;

Segment B
L6 Review!
L7 And no flames!
L8 Au revoir! (2002)

Nanako opens Segment A with a self-deprecating remark and crying emoticons to demonstrate her uncertainty about the quality of this particular chapter. Then in Line 2 she openly solicits reader reviews and in Lines 3 and 4 implicitly solicits positive feedback by saying that she will not write any more if the audience does not "like it." Interestingly enough, in Line 5, Nanako more or less acknowledges this as a rhetorical move that she uses frequently to elicit encouraging audience feedback when she admits that she "always says that" and then punctuates it with what might be mock tears of shame (^^;;).

In Segment B Nanako emphatically demands reviews in Line 6, and then clearly states "no flames!" in Line 7. In this way, she is setting up a supportive writing environment for herself in which readers respond to the content or meaning-value of her fictions rather than discrete linguistic conventions. In addition, through the conversational tone of both the opening and closing A/Ns and the emoticons, Nanako is establishing a backdrop for dialogue about social and writing-related interaction. In such a space, readers can feel comfortable expressing their reactions to her fan fiction stories, as well as contributing their ideas and suggestions for improvement.

It is also worth noting that Nanako introduces yet another language in Line 8 of this A/N, as she bids readers "Au revoir!" or farewell in French. English, French, and Spanish are the three most commonly used languages for composing texts on FFN, and as of 2007, site administrators were searching for French and Spanish speakers to translate site content into these languages. Nanako has a significant number of readers who self-identify as native French and Spanish speakers. Because she speaks some French, she is able to reach out to this audience. And, through her interactions on FFN, she is able to form online relationships with native French speakers who are now translating her English fan fiction texts into French and posting them on the site. This is further evidence of the value placed on skill with multiple languages on FFN.

Reader Reviews

In looking at posted feedback, it is clear that readers take Nanako's A/Ns and personal comments into consideration when reviewing. Moreover, close

analysis reveals that readers' appreciation for a story, their criteria for what counts as "good writing," and the community's notion of what makes a good fan do not appear to hinge solely on school-based literacy and grammatical conventions. Instead, appreciation for a text seems to be contingent on other elements such as a particular pop cultural aesthetic, readers' affiliation with the anime characters, the author's ability to create engaging story lines, as well as the author's ability and willingness to network and interact with other fans. In this section, I discuss four review types that emerged during coding of structural and thematic patterns in audience feedback that are responsive and/or contribute to Nanako's design of her writing space. They include (1) the *OMG Standard*, which is a simple form of positive feedback; (2) *Gentle Critique*, which incorporates positive feedback with general suggestions for improvement; (3) *Focused Critique*, which incorporates positive feedback with specific suggestions for improvement; and (4) *Editorialized Gossip*, which focuses on the anime characters as if they were real life personages. Analysis reveals how each of these review formats is in dialogue with some aspect of Nanako's online presentation of self. On the one hand, these reviews contribute to Nanako's achieved identity as an anime expert and as an accomplished fan fiction author, as well as to the design of a supportive, interactive, and highly networked writing space. While on the other, they also provide readers with an opportunity to display valued forms of social and intellectual capital for their online peers, thus contributing positively to their identities as fans on FFN.

The OMG Standard

In an e-mail detailing her perspective on reader reviews, Nanako explains that "the really sweet ones are actually the ones that inspire me the most. Everytime i read them, i feel all fuzzy and happy inside. It gives me a purpose, a reason for my writing (other than for my own enjoyment XD)" (2005). She goes on to explain that "I find the technical-wise suggestions really useful, because it helps me to improve my writing and keep in mind not to make the same mistakes again" (2005). Interestingly enough, the most prevalent review structure, one that I call the *OMG Standard*, is a clear example of readers' "sweet" responsiveness to Nanako's stated needs as a writer. OMG is an acronym for the exclamation "Oh My God!" that is fairly common in IRC and online discourse. Basically, this type of review consists of enthusiastic statements of appreciation for the fiction such as "OMG! I love this chapter!" Of the 200 coded review structures, 62 were categorized as OMG Standard.

While the structure and surface content of OMG Standard reviews may appear simple, when viewed in light of the notion of design and socially situated

identities, it is clear that there is a notable measure of social networking and affiliatory work being done simultaneously as readers display forms of pop cultural, personal, and social knowledge through such reviews. Moreover, the prevalence of OMG Standard reviews for Nanako's writing is also in keeping with her request that readers overlook her grammatical and spelling errors, as such reviews do not include criticism, but instead provide positive feedback and often some brief encouraging words about features such as plot and character development. Take the following review as an example.

Segment A
L1 OMG
L2 this is so kawaii!!
L3 lol

Segment B
L4 i guess I should get to the next chapter then!
L5 Lil' Keko (2003)

In Lines 1 and 2, the reader, Lil' Keko, demonstrates her knowledge of IRC/Online discourse through her use of the common acronyms OMG and lol (laugh out loud) and enacts the identity of a tech-savvy member of online networks. In Line 2, she uses the word *kawaii*, a Japanese term for "cute," which serves to mark her insider status as an anime fan. Moreover, as Nanako uses this term regularly in her personal communications with readers, it marks the reader's membership in this fan fiction circle as well. In Line 4, Lil' Keko uses the modal verb *should* and an exclamation to express a strong sense of obligation to continue reading, as she is aware that "being a fan" in this space involves enthusiastically following Nanako's chapters and providing reviews throughout a series. This in turn provides impetus for the author to keep writing. In addition, this "short but sweet" review format allows Lil' Keko and other readers to comply with Nanako's end-of-chapter requests that they provide many reviews as motivation for her to continue the series.

Gentle Critique

As a former ESL teacher, I was particularly interested in how fan fiction readers introduced critique in ways that were accepted by Nanako as an English learning writer. Thus, in this section I focus on reviews that include forms of critique providing feedback on different aspects of Nanako's writing in structurally similar ways. Through the analysis and comparison across reviews, I found that reviews including critique often followed a similar structural format. They included: (1) an introduction, personal greeting, or response to the A/N;

(2) a positive comment on some aspect of the text; (3) critique; (4) a disclaimer or mitigating statement; (5) a positive comment or encouragement to continue writing; and (6) a closing. For example, in the first review type, that of Gentle Critique, the reader begins by explicitly responding to the A/N in which Nanako claims that her writing "sucks." The reviewer writes,

Segment A
L1 I THINK YOUR WRITING IS GREAT!!!!
L2 don't put yourself down ;_;
L3 PLZ CONTINUE!!!!!!

Segment B
L4 there was just a few convention (grammar, spelling, stuff like that.) mistakes,
L5 but you had your reasons.

Segment C
L6 REMEMBER YOU *ARE* A GREAT WRITER OK?
L7 AND CONTINUE!!! (2002)

While the reviewer comments on grammatical and spelling errors in Segment B, she also relegates such conventions to the realm of unimportant "stuff" by giving the topic only two lines that are sandwiched between segments that thematically focus on positive comments and encouragement for the author. Moreover, she uses caps, the online equivalent of yelling or raising your voice, and exclamation points to highlight the importance of the segments and lines containing positive feedback and encouragement. In contrast, Line 4, the line containing critique, is not even capitalized at the start of the sentence. Moreover, in the concluding clause of Line 5, the conjunction "but" is a cohesive device that indicates how the second clause is to be related to the first in Line 4 (Gee, 1999). Specifically, Line 5 renders the "conventions" mentioned in Line 4 unimportant with a mitigating statement acknowledging that Nanako "had [her] reasons" for making errors. Presumably the reader is referring to Nanako's self-identification as an ELL in the A/Ns.

This sort of thematic structure—positive comment; reference to grammatical and spelling errors with an acknowledgment of the author as an ELL; and then encouragement to continue writing—is quite common in reviews of Nanako's work, as well as within subsections of FFN that are frequented by young writers and readers. In addition, this type of review often includes specific comments on how much the reader enjoyed elements of the story such as interesting plotlines or characterizations that are congruent either with common fan expectations, such as pairing popular couples, or with the anime canon, such as adhering to the original character traits. This type of review demon-

strates the level of affiliation readers have with the pop cultural subject matter. It also highlights how, in this space, writing is deemed valuable not only by virtue of grammatical and conventional correctness, but also by a shared pop cultural aesthetic related to this anime series.

Focused Critique

Another common type of review, Focused Critique, is one that follows the same structural format as Gentle Critique and includes "sweetness" as well as specific critique and/or "technical-wise suggestions." The review begins with introductory segments aimed at affiliation with and/or encouragement for the author, followed by specific critique in the middle, which is followed by a disclaimer and/or a conclusion that reaffirms the reader's status as a fan of that particular author.

> Segment A
> L1 lol.
> L2 Happy early birthday
> L3 *gives her sugar*
>
> Segment B
> L4 I really love your fic.
> L5 It's so…sugary
> L6 lol
> L7 I like sugar…
>
> Segment C
> L8 I have a couple of suggestions though.
> L9 One is this: the past and present tense (sp).
> L10 Like "I had this to do still".
> L11 Two is the spelling every here and there.
> L12 and Three, like the wording of some things
> L13 like "And thanks again for cheering me up when I'm losing hopes and upset" in the fic.
>
> Segment D
> L14 Okay. That's all.
> L15 Sorry for wasting your time.
>
> Segment E
> L16 Ja ne (2002)

In Segment A the reviewer Chas begins by explicitly answering one of Nanako's A/Ns that stated that it was almost her birthday. Assuming an interactive stance, Chas responds by wishing Nanako a happy birthday and displaying her

knowledge of the IRC/online discourse by using the acronym lol and an *emote* (expression of emotion, action, gesture enclosed in asterisks) in which she "*offers her some sugar*". In Segment B she goes on to provide positive feedback and to engage in playful textual banter that draws from the multiple meanings of the word sugar. This playful performative aspect of her review is another common element in online fan fiction feedback. Though not as pronounced in this particular post, many readers respond to the online, networked nature of the site by providing feedback as if they were interacting with and performing for an audience.

After these positive and socially oriented introductory segments, Chas introduces her critiques of the chapter in Segment C. The critiques each begin with a general statement and then narrow to a specific excerpt taken from Nanako's writing. For instance, in Line 9 the reader makes a general statement about Nanako needing to work on past and present tense. Then, in Line 10 she provides specific example from Nanako's writing that should have been written in the present tense (i.e., "I still have to do this.") to be consistent with the rest of the paragraph. In these critiques, the reader draws on and displays knowledge of a school-based form of feedback as she comments on specific conventions and traits of writing such as grammar, spelling, and word choice. However, what I find particularly interesting here is the disclaimer in Segment D, Line 15. Such disclaimers are a common feature of how readers structure critique in this space. Specifically, most critique is prefaced by positive input and then followed by a disclaimer or mitigating statement of some sort. In this case, it is interesting that the reviewer seems to apologize for taking up the author's time with the only feedback rooted in a school-based discourse, when she does not add a similar disclaimer/apology after the social and performative lines in Segments A and B.

The next review is also an example of Focused Critique in which a reader recasts one of Nanako's paragraphs. Like the other reviewers, Fire Light structures her critique with positive feedback, gentle criticism, a disclaimer, and encouragement to continue. She chooses to recast a paragraph containing two grammatical errors that appear often in Nanako's work, null subjects and comma splices, both of which would be permissible in some instances in Nanako's L1 of Mandarin.

Segment A
L1 Hey!
L2 Great story!
L3 I hope you keep going!

Segment B
L4 I just have a little advice for you.

L5 In this paragraph you put:

A few minutes passed., Sakura walked out of the bathroom with a towel wrapped tightly around her body. Hummed a tune as she walked into her room. Her school uniform was placed on her bed neatly. She then got dressed quickly and made her way towards the kitchen. There, she saw her worst enemy eating a bowl of cereals. She glared at him murderously and went to check the fridge, to get some eggs, to make herself some pancakes for breakfast.

L6 You need to change some things.
L7 Instead, for it to make some sense, you could have put:

A few minutes had passed and Sakura walked out of the bathroom with a towel wrapped tightly around her body. Humming a tune, she walked into her room where her school uniform was placed neatly on her bed. She got dressed quickly and then exited and made her way to the kitchen. There, she saw her worst enemy eating a bowl of cereal. She glared at him murderously and went to check the fridge, to get some eggs, to make herself some pancakes for breakfast.

Segment C
L8 That is just an idea!
L9 But this story is really great,
L10 so continue onegai?!!!
L11 Fire Light (2002)

It seems important to note here that in spite of Nanako's request that readers "overlook" her grammatical and spelling errors, her readers still introduce constructive criticism if they deem it necessary. However, in their critiques, readers seem to choose errors that are quite salient in Nanako's work and/or that interfere with their understanding or enjoyment of the text. Most readers are careful to avoid flaming the writer and instead work to temper constructive critique with appreciation for other aspects of the writing and encouragement for the author. Moreover, the fact that most Gentle and Focused Critique reviews contain a disclaimer, such as "That is just an idea!" in Line 8, and end with a signal of affiliation and encouragement, such as the Japanese term "onegai" in Line 10 meaning "please" or "I beg of you" to continue, seems to indicate that even when making suggestions, readers honor the author's expertise and authority over the writing.

Along these lines, in the following interview excerpt, Nanako explains some of her viewpoints on the author's authority over her texts.

I often tend to ignore the reviews that are a bit too...bossy, and the ones that are too childish. Such as, kill off that character, i dun like him or her. Or, update that right now cuz I havent got all day to sit here and wait for ur next update. Something along those lines.. I personally think the readers should respect the writer for what they wrote in the

story because they probably have a good reason for writing it, its either they want to prove a point or get a message across to the audience. (2005)

Even so, there have been instances where Nanako went back and revised a chapter according to readers' suggestions about the story line. For example, she revised one of her chapters from *Crazy Love Letters* at least twice in response to audience feedback. This suggests a negotiation between the author's authority over her own writing and the readers' enjoyment of the text in this space. It seems important for such a balance to exist when all members of the site are so invested in and affiliate around the subject matter.

In spite of her earlier request for readers to overlook errors, in a later A/N from her twelfth chapter, Nanako writes that "nice criticizes, comments, compliments, and suggestions are welcome" (2003). Moreover, she explicitly expresses appreciation for this pointed sort of "technical" feedback in her Thank You List when she responds to Fire Light's review and writes, "Thank you! I will correct my mistakes!^___^ *Hugs Fire Light* And thanks for adding me to your favorite list! ^___^." She also returns to her story and corrects the paragraph as per Fire Light's suggestions. In addition, in subsequent chapters, she omits subjects less and less frequently, which could indicate that Fire Light's recasting as well as other reviewers' references to this particular feature made Nanako more aware of it in her writing and enabled her to gain a greater command of that aspect of English sentence structure.

It is difficult to untangle what grammatical, syntactical, and pragmatic aspects of Nanako's texts might have changed as a result of focused reader feedback versus those that are a result of her in-school English learning. However, several common errors from her earlier texts that readers frequently commented on and pointed out in her writing are seldom present in her later texts. Some of these errors include null subjects and comma splices in instances that would have been permissible in her first language of Mandarin. Another such aspect is quotation marks in the representation of dialogue. In fact, one reader explicitly thanks Nanako for correcting her quotation marks in response to audience feedback:

THANK YOU SO MUCH FOR SWITCHING BACK TO THE REGULAR QUATION MARKS AND STUFF! it means a lot to me that u would take time to rewrite the whole thing! THANK YOU THANK YOU THANK You! (i know i should be saying arigato, but it just doesn't sound rite). (2003)

Other features that changed, although they were not often commented on by readers, include singular/plural errors, subject/verb agreement, and the use of definite versus indefinite articles. So, while I am unwilling to make any causal claims in terms of writing improvement, it does seem reasonable that receiving

a great deal of feedback, engaging in written communication with many native English speakers, and practicing writing on a frequent basis may have contributed significantly to Nanako's language development.

Editorialized Gossip

The last common review type, Editorialized Gossip, is one in which the reader discusses anime characters and their exploits as if they were independent of the fan fiction author's pen. For example, the following reviewer is reacting to a plot twist in which the anime character Meiling comes between the popular couple Sakura and Syaoran. Though the review contains several lines referencing Nanako's writing, the primary thematic topics in Segments A, B, D, and E are anime characters as active, independent participants in the story. For instance, in Line 11, the reviewer threatens to "hop into the story and shake some sense" into the character Meiling.

Segment A
L1 OHMYGOD
L2 Meiling is such an evil evil evil person!
L3 Not evil, evil's cool, but CREUL!

Segment B
L4 She really hates Sakura doesn't she!
L5 And if she DID love Syaoran,
L6 she wouldn't put him through so much torture by torturing Sakura like that!
L7 Ugh!

Segment C
L8 But the part where Sakura reads the e-mail from "Little Wolf" is so sad!!

Segment D
L9 Meiling better figure out what IS the right thing,
L10 because if she doesn't,
L11 I'm gonna hop into that story and shake some sense into that girl!!
L12 lol...

Segment E
L13 And it's a very good thing that Sakura took note of Syaoran's format to write e-mails,
L14 because otherwise she wouldn't pick up the fact
L15 the [that] MEILING IS AN CRUEL PERSON!

Segment F
L16 You use different languages in just the right places...

L17 it makes the story quite complete.

Segment G
L18 But I didn't really like the part where Meiling confesses
L19 because it hinted that Syaoran might have FEELINGS for Meiling...
L20 I HOPE NOT!

Segment H
L21 And I hope Syaoran gets Sakura back
L22 because this chapter is really sad,
L23 and I want the last chapter to be happy-go-lucky!!

Segment I
L24 Will the season finale be followed up by a sequel?
L25 I hope! (2003)

This sort of "willing suspension of disbelief" is a common feature in this space and further demonstrates the high level of commitment these writers and readers have to the pop cultural subject matter. Moreover, this review provides additional evidence of reader's attempts to negotiate with Nanako about her writing. For example, in Segments G and H, the reviewer explicitly comments on plot action and concludes each with a line stating her own wishes for the direction of the next chapter. Then, in Segment I, the reviewer expresses the wish that Nanako follow the "season finale" with a "sequel" and in each of these three segments and ends by punctuating her wishes with caps and/or exclamation points.

Another interesting aspect of this review that is quite common with Nanako's readers is how the reviewer expresses appreciation for the multilingual nature of her writing. As discussed in Chapter 5, Nanako's texts often incorporate Japanese, which she is learning at school in Canada, Mandarin Chinese, which is her first language, and some French. In this particular instance, the reader is responding to a scene in which Nanako has used Mandarin Chinese, also the L1 of Meiling and Syaoran, to convey intimacy between the two characters in an emotionally charged portion of the story. However, Sakura and Syaoran rather than Meiling and Syaoran are the preferred couple pairing; thus, the reader responds emotionally to the effect that Nanako's use of Chinese has in this particular scene. Specifically, it causes the reader to worry that the preferred couple might be in jeopardy. In this instance, rather than being viewed as a deficit or hindrance that interferes with her ability to compose in English, Nanako's L1 is recognized as an additive element that creates suspense for readers and contributes positively to her writing and to her achieved identity as a popular anime fan fiction author.

Implications for Literacy and Language Education

Digital Literacies

A common thread across work in academic and professional domains is the "new division of labor" between people and computers and the imminent divide between "those who can and those who cannot do valued work in an economy filled with computers" (Levy & Murnane, 2004, p. 2). Another commonality is the growing recognition that traditional forms of literacy, such as print-based reading and writing, are necessary but not sufficient for effective work (Levy & Murnane, 2004), leisure (Gee, 2004b), or academic (Labbo, Reinking, & McKenna, 1998) participation in an information society (Castells, 1996) that depends on meaning-making through an array of "texts" including conventional print documents, as well as graphic arts, spoken and embodied language, video, audio, and other forms of online and post-typographic communication (Lankshear & Knobel, 2003).

This poses a special problem for ELLs and struggling writers and readers in classrooms when they already are ascribed roles as learners who need to focus *primarily* on learning discrete technical aspects of print-based reading, writing, and the English language and are not provided with opportunities to "engage in processes of digital composing and reading that will allow them to discover their ideas, to realize communicative goals, and to develop digital fluency" (Labbo, Reinking, & McKenna, 1998). It seems reasonable then to look at the initiatives school-age ELL writers and readers are already taking in out-of-school spaces, such as FFN, in terms of how they might be developing the crucial design (Gee, 2004b) and key digital literacy skills (Labbo, Reinking, & McKenna, 1998) required for full social, civic, and economic participation in New Capitalist workplaces and an information-focused society. To conclude this chapter, I would like to return to the three interrelated aspects of design—affinity spaces, networks, and identities—to discuss what implications research in fan fiction sites might have for literacy and language education in the future.

Affinity Spaces, Networks, and Learning How to Learn

Labbo, Reinking, and McKenna (1998) argue that educators need to view the computer as a tool that can augment thought and "create opportunities for students to digitally encounter, discover, and articulate their thoughts through digital composing and problem solving" (p. 278) even while engaging in the pursuit of other goals. FFN provides a clear example of an affinity space in which members are using digital literacy skills to discover, discuss, and solve

writing- and reading-related problems, while pursuing the goals of developing social networks and affiliating with other fans. This is evident in how Nanako learns to leverage the networked technology and the computer-mediated forms of communication available on FFN to design an effective learning environment that meets her needs as an ELL and enables her to achieve the online identity of a successful writer. The affordances of online communication allow her to publicly present her writing as a means of discovering and problem solving English language–related issues, while at the same time displaying her expert knowledge as a multilingual speaker and as a fan.

Moreover, the immediacy of reader response via online channels provides ELLs with "just in time" information (Gee, 2004b) or on-the-spot mini-lessons on specific "troublesources" (Nystrand, 1986), or elements of their composition that impede comprehension or need development. Such focused and dialogic forms of feedback have been shown to be effective in scaffolding L2 (Guerrero & Villamil, 2000) and L1 (Nystrand, 1986) writing. Moreover, the way that critique in reviews generally is tempered by positive input still enables the author to maintain confidence and motivation to write and helps to create a strong sense of an eager audience, waiting for the story to continue. All these elements of FFN help ELLs to construct and maintain identities as accomplished writers or designers of fan fiction.

Because there is an array of skills and abilities that are valued in affinity spaces, and because there is an absence of authorized roles and imposed forms of knowledge, Nanako and her readers are able to maintain confidence while at the same time acting as learners in varying capacities. Writers and readers in this space are also able to draw from various networks of information that are dispersed across people (reviewers, co-writers, fan fiction consultants), tools (spellcheckers, thesauruses), other media, and Web sites (writing help sites, fan sites). This distributed type of knowledge is also a defining feature of affinity spaces. Thus, in terms of literacy education, FFN could provide one exemplar for a classroom learning environment where the emphasis, rather than being focused on *propositional* knowledge that primarily involves the learning of content area facts and figures, is instead moving toward *procedural* knowledge that involves the acquisition of skills and strategies for how to learn and continue learning (Lankshear & Knobel, 2003) via networks, distributed funds of knowledge, and computers. This procedural knowledge—also described as "expert thinking" and "complex communication" (Levy & Murnane, 2004); the "ability to be a lifelong learner" and "learning in social contexts" (Labbo, Reinking, & McKenna, 1998); and "progressive, communal knowledge building" (Scardamalia & Bereiter, 1994)—is also identified as a key aspect of being digitally

literate in a society where resources are increasingly dispersed across computer and Internet networks.

Popular Culture, Identity, and Critical Media Literacy

Another set of implications for literacy education relates to the pop cultural subject matter that provides a nexus of affiliation for FFN. Work within language and literacy studies has begun to emphasize the import of popular culture for students in providing metaphors for the construction of cultural models (Tobin, 2000; Zuengler, 2003), narratives for interpreting and structuring experience (Alvermann, Moon, & Hagood, 1999), and semiotic resources for developing social identities through writing (Black, 2005; Dyson, 1997; Jenkins, 2004; Lam, 2000, 2006; Newkirk, 2000, 2002). In addition, the preceding analyses reveal how popular culture is an integral component of social affiliations and a springboard for meaningful interactions around language, writing, and literacy on FFN. Nanako is able to leverage her knowledge of anime culture to practice conventional and pragmatic aspects of English, experiment with different genres of writing, and gain a great deal of discourse or communicative competence in the fan fiction register through her written exchanges with other fans. Readers are able to draw from their knowledge of grammatical and syntactical aspects of English and school-based forms of peer feedback, as well as from their knowledge of anime, to display forms of expertise and to practice and share specialist forms of language (Gee, 2004b) with Nanako. Such activities also enable readers to build on their achieved identities as knowledgeable and articulate anime fans.

The essential implication here is that substantive literacy instruction does not need to focus on learning as an elite and solitary enterprise centered on authorized interpretations of canonical texts (Newkirk, 2000). Instead, print literacy can be made "more attractive and possible by being imbedded in systems that are, at least initially, more attractive to the learner" (Newkirk, 2000, p. 297). Such systems might include social scaffolds such as collaborative writing through networks or multimodal writing through digital literacy and online authoring software. Or, such systems might include a range of student-selected pop cultural and current event-related topics in which all students, including ELLs, have a frame of reference and/or a measure of expertise. Choosing such topics can provide a point of departure for authentic communication as students use and develop literacy skills to discuss and debate topics and display various forms of expertise in areas that are meaningful and relevant to their achieved identities and social worlds.

I am not suggesting that educators adopt popular culture and fan fiction in a wholesale manner into their curriculum, as this would certainly diminish its popularity with students. Nonetheless, I do think there is a vital need for educators to critically engage with and develop activities around media and popular culture that are central to students' lives. Research in fan fiction sites has the potential to expand our understandings of how new generations of learners are using digital and print-based literacies to play agentive roles in designing and negotiating learning spaces; creating and sustaining social networks; and enacting achieved identities as engaged, competent, and literate members of a writing community. Moreover, as Lankshear and Knobel (2003) point out, with the advent of new ICTs and the widespread movement toward globalization, there perhaps have been profound changes, not only in the world of literacies *to be known* but also in *how to know* the literacies of world. Thus, as literacy educators and researchers, we ought at minimum to take note of these changes, and optimally, to learn from these changes and integrate them into our understandings of literacy instruction in schools.

Fan Fiction and Literacy in the Twenty-First Century

Education and Twenty-First Century Skills

Throughout history, schools have been both touted and perceived as egalitarian means of achieving social and economic advancement. However, a great deal of research also has examined how schools can serve in an exclusionary capacity. For instance, work within the New Literacy Studies (Gee, 1999, 1996; Heath, 1983; New London Group, 1996) has explored how the lifeworlds and literate backgrounds of many students differ significantly from those that are valued in classrooms and by many classroom teachers. This position is supported by work in other disciplines that has revealed that the U.S. teaching force consists primarily of Caucasian, middle-class, heterosexual, able-bodied females (Howey & Zimpher, 1989; Swartz, 2003; U.S. Department of Education, 2001). One outcome of this largely homogeneous teacher population has been that nonmainstream students are often marginalized in the social, academic, and assessment practices of classrooms (Heath, 1983; Hicks, 2002).

In addition, many U.S. public schools are still rooted in a "mindset" that prepares students for participation in an industrial society (Lankshear & Knobel, 2003). For example, Kalantzis and Cope (2000) argue that many classrooms essentially have been "mock workplace[s]" that mirror the assembly-line sensibility of Fordism in which "the teacher took the systematically divided-up component parts of the curriculum, transmitted them to students bit by bit, and then assessed knowledge as 'discipline'" (Kalantzis & Cope, 1993a, as cited in Kalantzis & Cope, 2000, p. 127). Schools have also mirrored the "'multiskilling', worker 'empowerment', and cultural assimilation" sensibility of the total quality control and self-management emphases of post-Fordism (Kalantzis & Cope, 2000, p. 128) as they have "moved toward progressivist forms of pedagogy" focused on building student motivation, student-centered activities, and empowerment within structured classroom and curricular settings (Kalantzis &

Cope, 2000, p. 129). Such mindsets and classroom approaches, however well intentioned they may or may not be, can still serve in an exclusionary capacity in the respect that they may often reflect and be rooted in mainstream, middle-class lifeworlds and literacies (Moje, Willes, & Fassio, 2001).

As we move forward into the twenty-first century, it is likely that our existing pedagogical practices will not be sufficient for preparing students for effective and meaningful participation in a more globalized, networked, and information-oriented society. To be more specific, in the United States, workplace as well as leisure-time activities increasingly center on the production of textual goods (e.g., Web sites, forums, blogs), "virtual" goods (e.g., Second Life products and World of Warcraft characters and gear for sale on Ebay), and information (e.g., Wikipedia, online help sites) via the computer, rather than on the production and distribution of material products (Lankshear & Knobel, 2002, 2003, 2006). Moreover, this is occurring as new media, information and communication technologies (ICTs), and networked technologies are changing the nature of communication and are facilitating interaction across different languages, cultures, and traditional geographic borders. As mentioned in the previous chapter, a familiar theme across research being conducted in such areas is the growing recognition of a divide between those who can and cannot do valued work with computers and in globally networked spaces (Levy & Murnane, 2004; Warschauer, 2003). Another commonality across such work is recognition of the fact that traditional forms of literacy, such as print-based reading and writing, are necessary but not sufficient for effective participation in a network society, as facility with digital forms of literacy become fundamental for participation and communication (Luke, 2000).

Rapid technological advances and ongoing processes of globalization have given rise to serious consideration and reconsideration of the goals and responsibilities for institutions of formal learning in the twenty-first century. For instance, the 21st Century Workforce Commission (2000) suggests that "the current and future health of America's 21st century economy depends directly on how broadly and deeply Americans reach a new level of literacy—'21st Century Literacy'" (p. 4). Such discussions have spurred the development of educational frameworks for twenty-first century literacy and skills (International Reading Association [IRA], 2001; Northwest Central Regional Educational Laboratory [NCREL], 2003). Members of research, education, and business communities have formed partnerships to create these frameworks, working in tandem to identify proficiencies that currently are or will be extremely valuable in future work and academic environments. These consortiums aim to create "a unified, collective vision for twenty-first century learning that can be used to strengthen American education" (Partnership for 21st Century Skills, 2004, n.p.)

and to ensure the United States' competitiveness in a global, technology-mediated market.

The NCREL describes the need for digital literacy skills on their *enGauge 21st Century Skills* Web site (http://www.ncrel.org/engauge/skills/skills.htm), underscoring the point that traditional literacy skills are now only a starting point for engaging in other forms of literate interaction.

> As society changes, the skills needed to negotiate the complexities of life also change. In the early 1900s, a person who had acquired simple reading, writing, and calculating skills was considered literate. Only in recent years has the public education system expected all students to build on those basics, developing a broader range of literacies. (International ICT Literacy Panel, 2002, as cited in NCREL, 2003, n.p.)

The digital literacy skills identified by various twenty-first century consortiums include proficiencies such as basic, scientific, economic, technological, visual, information, and multicultural literacies and global awareness (NCREL, 2003). These skills resonate with research across disciplines exploring the potential impact of technological advances (Gee, 2004b), global connectedness (Suarez-Orozco & Qin-Hilliard, 2004), the economics of attention (Lankshear & Knobel, 2006), and participatory culture (Jenkins, 2006) on youths' learning and literacy practices.

In this spirit, I conclude with an exploration of the sort of twenty-first century literacy skills that youth are engaging with in online fan fiction spaces. However, it is important to note that this is only a preliminary inquiry into this topic. I hope to explore this topic further in future work as the knowledge base surrounding twenty-first century skills grows. In addition, it is important to note that this discussion is framed as a point-by-point comparison between popular approaches to teaching writing in formal classroom learning environments and the informal learning of affinity spaces. Through such a comparison, I hope to provide insight into the points of convergence and divergence between learning in these spaces and to stimulate thinking about how our understandings of these types of learning in informal affinity spaces might be leveraged in the development of new pedagogical approaches in the teaching of language and literacy in more formal learning environments.

Writing in Classroom Spaces

Of late, a great deal of contemporary writing instruction has taken a turn toward expressivist and process-centered pedagogies (Atwell, 1998; Tomkins, 1990) (e.g., Writer's Workshop), with the belief that these student-centered approaches are effective for improving struggling writers' abilities and

increasing their engagement with writing (Moje, Willes, & Fassio, 2001). Such approaches are designed to give students "ownership" of their learning by creating a literate environment and classroom community in which students have the time and freedom to explore self-selected topics, write from their own experience, question conventions and strategies before adapting them to their own purposes, and engage in authentic discourse with peers and expert others about writing (Atwell, 1998). These approaches are also designed to be responsive to student experiences and are based on empirical explorations and theories of writing as an expressive, socially situated, and recursive process (Atwell, 1998; Calkins, 1994). Nevertheless, it has been suggested that when introduced in classroom spaces, such pedagogies can serve as normalizing practices that privilege certain texts, literacies, and mainstream experiences (Moje, Willes, & Fassio, 2001) over those of individual students.

The typical instructional components of process-based writing activities include planning or pre-writing, drafting, peer review, revising, editing, and publishing or sharing. Though the components are aimed at scaffolding students into participation in all stages of the writing process, such activities do have an end goal—production of student texts with the underlying objective of scaffolding students into officially sanctioned forms of writing. The production of these texts is mediated through artifacts such as academically valued genres of writing; grammatical, orthographic, and print-based conventions; as well as more tangible tools such as writing and drawing utensils, paper, and sometimes the computer. A result of this mediation is that texts produced in the classroom are artifacts of a print-based culture and reflect the conventions of print as well as the constraints of academic genres and writing.

Process and expressivist writing activities, though intended to build on individual student's abilities and life experiences, are constrained by sets of formal and informal rules that can act as normalizing measures in classrooms. For example, though formal orthographic and grammatical conventions are not the main emphases of approaches such as Writer's Workshops, they are threaded through all activities, and mastery is an underlying curricular focus in classrooms. For example, teachers conduct mini-lessons at the beginning of Workshops to introduce the strategies and/or conventions that are to be emphasized in the day's activities. In these approaches, process-related rules also shape students' possibilities for participation. There are guidelines for peer-review sessions, rules for helping other students to revise and/or edit their papers, as well as official rules and unofficial norms that shape what are considered valuable and acceptable topics to write about.

In classroom spaces, text production is also mediated through the expertise and knowledge of the teacher. For example, in process-based approaches such

as Writer's Workshops the teacher's role is meant to be that of facilitator, mentor, and co-writer (Atwell, 1998). The teacher writes, shares his or her own writing process with the class, and helps students to identify strategies they could use to solve problems they are struggling with. The teacher also acts as a listener and observer, identifying areas where the class needs help, and then conducting mini-lessons in these areas. This means that as artifacts, the texts both reflect and reproduce an array of sociohistorical composition practices that are rooted in a print-based rather than a digital "mindset" (Lankshear & Knobel, 2003, 2006) and are mediated both through human and nonhuman means. Moreover, many teachers assign writing topics or use prompts to further curricular goals and/or encourage students to write. Thus, although the teacher's role in expressivist approaches is intended to be that of a co-writer and facilitator, by virtue of his/her role as an evaluator, the teacher remains an authority figure who both enforces the classroom rules and influences the sort of abilities, literacy practices, and forms of participation that are recognized, valued, and allowed in the classroom space.

Although longtime proponents of expressivist, process-based approaches (Atwell, 1998; Calkins, 1994) and experts on adolescent literacy instruction (Alvermann & Phelps, 2002) foreground the importance of building on student experience and the social aspects of students' lives when teaching young adults, within the institution of school there are official rules and unofficial norms shaping the extent to which student interests and the social may come into play in learning activities. Nancy Atwell (1998), a middle-school teacher and a strong proponent of Writer's Workshop, points out that in many middle schools, activities are structured to avoid the "messiness" of adolescence by regimenting student behavior through "academic tracking, busywork and seat work, tests and grades, tight deadlines, tons of homework, arcane systems of discipline, few opportunities for students to work together, and fewer opportunities for any demonstration of affect" (p. 54). She posits that through this structure, schools essentially "tell junior high kids that their active participation is too risky an enterprise" (p. 54).

Atwell (1998) advocates incorporating the social and affect into Writing Workshop at every opportunity by means of peer-to-peer and peer-to-teacher conferences where topics often are chosen by students, through peer-to-peer scaffolding during composition, and by illustrating how certain genres of writing, such as poetry, are "made for adolescents' feelings" and their expression (p. 54). However, in the current climate of accountability, teachers' schedules and curricula are largely determined by the need to help students achieve high scores on standardized tests. Writing assignments, formats, and topics are often chosen by the teacher to meet specific curricular goals. This leaves little time for

students to explore their thoughts, ideas, identities, and relationships through writing.

Writing in Fan Fiction Spaces

Self-Direction

One obvious difference between online fan fiction sites and school spaces is that these sites are not constrained by the same institutional rules and curricular demands as schools. Nonetheless, participation as a fan fiction writer does come with particular goals and responsibilities. Take, for example, the responsibility that authors with a wide following of readers, such as Nanako and Grace, have to update their stories so that readers do not feel as if they have been left hanging on a "cliffie," or the responsibility that many English language learners (ELL) authors, such as Cherry-chan, feel to locate a beta-reader to edit their stories in order to make them accessible to readers. Fan authors often feel compelled to compose texts that are acceptable to and engaging for their readership, conduct research to ensure the accuracy of material in their texts, conform to certain canonical constraints, and adhere to site rating and posting rules, to name just a few. However, one fundamental difference between fan fiction sites and school sites is that fans have much more choice and freedom in terms of how they meet these various goals and fulfill responsibilities.

Self-direction, defined as "the ability to set goals related to learning, plan for the achievement of those goals, independently manage time and effort, and independently assess the quality of learning and any products that result from the learning experience" (NCREL, 2003, n.p.), is one of the skills identified as crucial to success in the twenty-first century workplace. While the notion of self-directed learning is certainly not new to classrooms, the ways in which self-direction in fan fiction sites is tied to choice or self-selection of resources, tools, and technologies is what sets it apart from self-directed learning in many school spaces.

For instance, as analyses from this book have demonstrated, fan fiction authors have a great deal of choice in terms of resources that they draw from in their writing. FanFiction.net (FFN) promotes learning via resources that are dialogic or interactive in nature, such as the writing communities, forums, and peer-review systems that all provide social scaffolds for collaborative writing, reading, and knowledge sharing. In addition, resources are not only distributed within the site, but they also extend outside of the site into academic funds of knowledge, community knowledge, media sources as well as personal and cor-

porate Web sites. This can be contrasted with the sort of resources that are generally available in classroom spaces. Many resources promoted in schools are bound to a view of literacy as an individual enterprise that involves reading and answering questions about a standard canon of literature with a concomitant standard interpretation. In addition, classroom resources often serve to teach and/or reinforce standard print-based forms of communication. Such resources are generally static and enclosed like textbooks, dictionaries, and thesauruses, and activity related to these resources is often confined to schools, libraries, and classroom spaces.

Authentic Uses of Technology

Another important feature of fan fiction spaces is that language and technology are used as *means* rather than as *ends*. To be more specific, resources on the site are distributed across networks of people and different technologies. Thus, instead of using different language forms or computer programs for the sake of using and mastering them to fulfill some curricular goals, fans choose the most effective media, tools, language, and resources to accomplish specific, communicative purposes. Essentially, they are learning to use language and literacy as well as different technologies and modes of representation to leverage different resources, navigate different networks, and to continue learning how to learn. This notion of flexible, lifelong learning is another valuable skill in the twenty-first century as quicksilver technological change requires constant adaptability and a willingness to take up and learn new tools (IRA, 2001; NCREL, 2003).

Furthermore, FFN is a prime example of technology supporting the sort of meaningful uses of language and literacy that are crucial, not only for ELLs, but also for *all* students in their academic endeavors. Though the idea of incorporating authentic composition activities into the curriculum is not new, the possibilities that networked computer environments offer for developing authentic interactive writing activities in the classroom are novel in many ways. My own participation posting and reviewing fictions, coupled with my observations in various online fan fiction sites, has helped me to understand how the immediacy of reader response via computer networks does a great deal to develop a sense of audience and to help the writer think about honing his/her rhetorical purpose. Moreover, the strong sense of audience and community afforded by the technology of FFN influences the sort of peer reviewing, teaching, and learning practices that take place. The peer-review practices show a strong tendency toward maintaining community relationships by tempering critique of form with genuine enthusiasm for content or rhetorical effect, which strongly

discourages hostile feedback, and by attending to the expressed needs of the author through Author's Notes (A/Ns) or communication between writers and reviewers. Thus, the potential for immediate discussion and review offered by such a networked space helps to emphasize the highly social nature of writing and serves to highlight the importance of feedback from peers, colleagues, and expert others in the composition process.

Too often students, especially those struggling with language and composition-related tasks, are introduced to the computer only for the purposes of practicing common elements of print-based writing, such as editing, spell-checking, and reordering their work (Daiute, 2000; Warschauer, 2000). However, in fan fiction sites, students actively participate in sophisticated composition activities in which they draw on and synthesize input from a global audience of peer reviewers, engage in dialogic interaction with readers and other fan authors, and draw on the meta-resources available in the community as they revise, edit, and redesign their texts. Moreover, the online environment provides opportunity not only for developing writing skills in new ways but also for developing twenty-first century interactive communication skills.

Interactive Communication Skills

Interactive communication skills (NCREL, 2003) entail choosing the appropriate medium and register for communication as well as knowing the norms and etiquette of specific online communicative contexts that cut across cultures. The growing demand for such skills underscores the importance of developing computer-mediated literacy activities in which students have the freedom to draw on the multiple resources available via online, networked, and digital media to publish, communicate, and convey meaning in ways that are rhetorically appropriate for the context. With scaffolding, such activities can help provide students with access to and practice with the sort of academic writing skills they will need, such as genre-specific composing and addressing specific audiences. Such activities also can provide students with access to the sort of digital literacy skills that are becoming an integral part of successful participation in many social, academic, and professional tasks (Lankshear & Knobel, 2003) as projects and collaborations increasingly take place online.

Creativity and Innovation

In their examination of twenty-first century skills, the NCREL (2003) points out that "human social, emotional, and intellectual development has been driven by creativity. Perhaps more than any other human quality, creativity has left permanent and lasting marks on cultures worldwide—and it is at the very

heart of the knowledge-based age" (n.p.). Creativity and innovation are twenty-first century skills that are very much in evidence in fan fiction writing spaces. Ironically, at the same time that forward-thinking workplaces are calling for creative skills, the imposition of standardized testing seems to be shutting down options for innovation in classrooms. U.S. public schools are being forced to eliminate electives such as art and music, and many teachers are forced to curtail in-depth exploration and inquiry into content area material in order to allow enough time for memorizing and preparing for tests.

Considering the terrific pressure that many teachers are under to help students pass standardized tests, it is easy to see how even activities such as writing, which have traditionally afforded students at least some measure of creativity and expression in the classroom, are increasingly constrained by curricular demands. Fan fiction sites, however, offer youth multiple opportunities for conveying thoughts and ideas through writing. In an interview, Nanako offers her thoughts on the differences between in- and out-of-school writing.

> I definitely express more of my so called philosophical views more often online than in real life, since at school, I have to write what the teacher wants me to write. My freedom of speech and expression is greatly limited, despite the fact that the teachers encourage us to write whatever we want. But we get marked on it and I don't think any of us would risk our grades just to express something we feel strongly about and would, potentially, insult or offend the teacher who is marking our paper. (2005)

Student choice in topics is advocated through student-centered writing pedagogies such as Writer's Workshop. However, it has been argued that when these sorts of pedagogies are implemented in classrooms and are guided by teachers under curricular pressures, in spite of educators' best intentions, these activities often end up focusing on standard texts, canonical themes, and promoting mainstream views that do not necessarily coincide with students' literate backgrounds and experiences in the world.

Conversely, the engagement and enthusiasm that young fans bring to their writing and reading on fan fiction sites reinforces the importance of allowing students to go through the process of learning to write from their literate backgrounds and choosing topics based on what they know and are interested in. Allowing students this sort of freedom of choice also affords them opportunity to draw from familiar resources and textual genres, such as how fan fiction writers use movies, books, poetry, and songs in their composition. Such an approach also allows struggling writers to display expertise and to develop social and intellectual capital in certain areas, and at the same time uses these familiar texts and dialogic resources as existing frameworks to support and scaffold their writing. This in turn gives them the freedom to work on other aspects of their craft.

Activism

Social Support

The freedom of expression in online fan fiction also affords youth much-needed opportunities to express themselves and their identities through writing. Many texts on FFN depict media characters dealing with issues that are never raised in the original series, such as teen pregnancy, school violence, and suicide. Through these texts, authors are able to use writing to articulate and publicly enact concerns from their daily lived experiences. For instance, Thomas (2007) describes how two adolescent writers use online writing to "fashion new and emerging identities for themselves" (p. 160) through role-play writing with fictional characters.

> The characters allow the girls a freedom and power to author an identity (Bakhtin, 1998) which plays out their fantasies and desires: of their physical bodies, their hopes and dreams for the future, and their ideas of romance. Their characters are a rehearsal of who they want to become, and in role-playing that ideal self, they can grow closer to becoming that ideal. (Thomas, 2007, p. 160)

As another example, during the pilot study for this project, I came across a "suicide fic" in which the adolescent author created a fiction that featured a detailed and poignant description of an anime character's suicide. He then ended the fiction with an A/N explaining that this would be his "final" posting because he did not have the strength to go on, thus implying that he was contemplating suicide himself. Jenkins (1992) suggests that fans often choose particular media in part for the potential they offer for addressing life issues:

> Many times, fans are drawn to particular programs because they provide the materials most appropriate for talking about topics of more direct concern, because they continually raise issues the fans want to discuss; such discussions offer insights not only into the fictional characters but also into different strategies for resolving personal problems. (p. 83)

Thus, the text and the plight of the anime character served as a means for this youth to convey his personal struggles and immediate concerns to an audience of engaged readers.

It is also significant to note that if authors openly convey distress through their fictions, such as through intimating suicide, then they, through reviews, e-mail, and instant messenger services, often receive an outpouring of support from the community. This is evidenced by one of the many responses to the aforementioned author's "suicide fic":

Dear Atlas,

i know how you feel. i know that sounds like a really bakana thing to say but i understand your pain. I myself live a life such as yours. I know what you feel like and how much your life must suck at the moment. Atlas-san, i hope you overcome your pain. I haven't yet and bakumono still surrond me. I hope you also keep posting your wonderful stories. It'll keep you sane.

From Someone Who's Been There,

Hito
PS- send me an e-mail if you wanna talk about it. Maybe,just maybe, I can help. (hito@aol.com). (2004)

In this way, these hybrid fan fiction texts represent communicative events, situated in specific contexts, intended for an audience of peer readers who have similar interests and share many of the same concerns. They also illustrate the interactive and supportive nature of a space in which writers and readers use language and textual skills to engage in meaningful, authentic literacy practices and to provide social and emotional support for each other. It also seems important to mention here that although audience members are not usually trained as counselors (although some may be), the advice and support that they offer still has value in several respects. First, they may be providing support that might otherwise not exist at all. By this I mean that a relatively anonymous fan fiction community might be a safer space for reticent youth to reach out for help or advice. Moreover, the fan community provides shared points of interest (e.g., fan fiction, media, music) with an audience of peers that may facilitate and pave the way for social connections. Also, because fan communities are persistent online environments, they provide the option for ongoing contact and communication about matters of social and emotional import.

In addition, the online medium encourages fan authors to design fictions that are intended to enact multiple aspects of their identities for a broad and diverse audience, as the Web audience is not bounded in the same ways that an offline space such as a classroom is. In contrast, though many student-centered writing pedagogies emphasize giving students choices in the topics they write about, because the classroom is part of the broader institution of school, it still is constrained by the rules of that institution. In addition, it is probable that in classroom environments there are unofficial norms about what topics are acceptable to write about for a face-to-face audience, especially one that includes an adult authority figure such as a teacher as well as peers who may offer ridicule or criticism that is more difficult to negotiate in a face-to-face situation.

Petitions

The next example also illustrates the importance of identity and freedom of expression in online fan fiction, to the extent that fans are willing to leave a certain writing space and/or make large-scale efforts to challenge and change the rules if they feel that their freedom of expression is being threatened. As mentioned previously, *CCS* is a young-adult genre that only alludes to relationships and sexuality. This creates a tension for many adolescent fans who are struggling with issues related to sex and sexuality. As a response, many authors will write *slash* fan fictions, which depict same sex-male characters in a relationship when those characters are not paired and may be heterosexual in the original media, for example, Harry Potter and Draco. The female counterpart of slash, *femmeslash*, in the anime community is known as *shoujo ai* or translated "girl love." Though FFN has no restrictions on slash or *shoujo ai*, it does have a restriction on the extent to which sex and sexuality can be brought into the fictions housed in the archive. Moreover, as discussed in this final section, as this rule came into being, it created a clear tension between the identities and meaning-making practices of adolescent authors, other fans, and the site administrators.

First, it is important to note that FFN initially allowed a great deal of freedom in terms of explicit content in fictions. Then, in 2002, site administrators began instituting a ban on fictions with explicit sexual content and/or violence. However, at that point, there already were many fictions posted on the site that did not comply with the new rules. Moreover, the sheer volume of text on the site prevented administrators from enforcing such rules. Thus, site administrators enlisted the help of the fan fiction community.

> June 22nd, 2004—Please note that Fanfiction.net has a zero tolerance policy against mis-rating of stories. Accounts will be closed upon abuse confirmation. Abuse reports are submitted by readers and writers of Fanfiction.net which are then reviewed and confirmed by administrative staff. When abuse of site guidelines has been confirmed, the staff will take necessary action. We encourage everyone to assist in the care of this community by reporting entries when warranted. Those that have no respect for our policies cannot escape the watchful eyes of their peers. (FanFiction.net, 2004)

In 2004, a group of fans began reading and reporting fictions on the site containing explicit content, and site administrators deleted many of the reported fictions. The deletion of these texts incited a great deal of conflict over artistic freedom that continues on the site to date. However, an illustration of the way that this sort of tension has the potential to lead to change within the site is a petition that I received in my fan fiction e-mail account. This particular petition protests the removal of "lemon" fan fictions, or those that depict graphic sex

scenes, as well as sanctions that were being considered against fictions with a great deal of A/Ns. The following is an excerpt from one of the fans who signed the petition protesting the removal and banning of such fictions.

> I have decided no longer to contine stories on ff.net though I remain a member so I can review those who are patient enough to sustain ff.nets stupid rules. I suggest mediaminer instead because it doesn't seem so horrible. I like interactive stories to! There's nothing wrong with them and theres nothing wrong with having a chapter thats just an authors note. What if the author needs o tell us reviewers something. Please sign the petition! (2004)

This excerpt illustrates two important aspects of the nature of the online fan fiction community. First, it reflects the tension between the goals and interests of individual authors and readers and the "stupid" official and peer-enforced rules of the site. This tension has already changed the site in the sense that many of the authors who write with ratings above G have moved their fictions to other archives. Second, it illustrates the sense of empowerment and freedom fans feel in this space—as they are comfortable enough to write a petition protesting unfair rules and/or moving their fictions to another space if they are denied artistic freedom. This sort of initiative is an initial step toward the sort of civic engagement that is another crucial twenty-first century skill (NCREL, 2003). In addition, the petition seems to have effected some change in the system, as there seems to be at least a temporary hold on deleting existing fictions on the site. This is also a point of divergence from most Language Arts classrooms, as I have yet to hear of a class petitioning the school to allow profanity, violence, and/or sex in their Language Arts writing assignments or the school literary magazine. Moreover, students do not have the freedom to refuse to write within confines that violate their artistic and/or personal sensibilities, at least not without penalty.

Another less obvious element of online fan fiction that this post illustrates is the reader's appreciation of the interactive nature of the texts with a great deal of direct address from the author to readers. As Jenkins (1992) points out, "Fan reception cannot and does not exist in isolation, but is always shaped through input from other fans and motivated, at least partially, by a desire for further interaction with a larger social and cultural community" (p. 76). A/Ns are one means by which fans on FFN are able to initiate and engage in discussion with a larger fan community. Clearly, this is one point where online fan fiction writing diverges from the writing classroom, in the sense that fan authors assume an interactive, dialogic learning space where they are able to communicate with and receive almost immediate communication from readers through the Internet. Moreover, through A/Ns, writers are able to play a formative role in shaping the activity and to at least influence or make their preferences known in terms

of how the audience will provide feedback to their texts. This can be contrasted with classrooms, where the curriculum and the teacher largely determine the sort of activity and instruction taking place, and where student participation and peer feedback is generally guided by classroom rules, norms, and objectives. Thus, the A/Ns contribute not only to the interactive nature of online fan fiction but also to the reader's sense of being involved in the creation of each text and the broader fanon. Furthermore, the fact that the fan who signed the petition argues that there is nothing wrong with having a chapter that consists only of A/Ns to the readers underscores the social nature of the objective of participating in the fan fiction community.

Finally, in terms of social activism, fan fiction–related writing and activities have a great deal of potential for scaffolding critical media literacy. In a passage from their recent book dealing with critical media literacy in the classroom, Alvermann, Moon, and Hagood (1999) call attention to the growing need for students to develop critical media awareness as new ICTs allow mass media to permeate nearly every aspect of their daily lives:

> Teaching critical media literacy using popular culture texts is currently an undertheorized and underresearched topic in the field of literacy education. Yet its relevance for teaching and learning in the 21st century has never been greater. As the media continue to find ways of producing texts for imagining or transgressing life experiences, it will become increasingly important to engage students in reading critically for the assumptions underlying those texts. (p. 141)

As a genre, fan fiction provides a means of challenging and critically exploring the ideology and assumptions underlying media texts. For example, a small amount of work within literacy studies is beginning to address how young female writers draw from discourses about gender, sexuality, and relationships in both media and print texts to explore and possibly expand female spaces in a patriarchal society. And, they do this by creating fan fiction texts that feature strong female characters in roles generally reserved for men (Chandler-Olcott & Mahar, 2003a). Such research also provides insight into how female youth are using popular culture as a resource in their ongoing fan fiction-inspired social interactions and conversations about past and future roles available to them in a male-dominated society (Thomas, 2005). As such, fan fiction provides a format for using writing to develop critical media literacy skills through the creation and adaptation of texts and characters in ways that challenge or subvert typical representations of youth, gender, sexuality, race, and ability in the media. Such awareness and redesign of representation is a start to social activism and enacting broad change in how many groups are represented in the media.

Access, Affiliation, and Innovation

Experts on reading and writing foreground the importance of encouraging students to become active learners and showing them how to acquire power over their own processes of thinking and learning (Alvermann & Phelps, 2002; Atwell, 1998). However, as this chapter has shown, the institutional and disciplinary constraints in many Language Arts classrooms offer students little opportunity to control their own learning. It seems that one of the elements adolescents find so motivating about FFN is the potential for innovation and change that the site offers. In essence, it offers them power and control over their own thinking and learning. They write about topics of their own choosing and, through sophisticated, often transcendent, writing and reading practices, engage with texts that express tangible issues and concerns from their lives. Furthermore, through their local interactions and engagement with texts, they are able to shape the norms, artifacts, and tools of the fan fiction community on a global scale as they participate in the development of new fan fiction genres and contribute to changes in the online registers.

In addition, fan fiction authors seem to relish the opportunity to experiment with writing and welcome the opportunity to extend preexisting genres and media forms and to challenge a variety of text and language conventions. This points to the fact that students, especially ELLs and struggling writers and readers, need ample opportunities in school to display their talents and to display and build upon their personal strengths. Constant and rigid adherence to academic genres and grammar and language conventions may hinder rather than help students learn to write. It may be that through experimenting with different genres, conventions, and modes of expression, these youth gain meta-awareness and insight into how and why these genres and conventions exist, thus making them more inclined to use them when necessary. Finally, when students are given the opportunity to formulate their own rules and guidelines for writing and reviewing, they are much more likely to be meta-aware and critical of their own writing and review processes in reference to the guidelines, as they will understand them and be invested in following them because they had a hand in creating them.

The amount of parallel between practices in the Language Arts classroom and in fan fiction spaces seems to indicate that a great deal of potential exists for leveraging principles, tools, and knowledge from informal learning sites to inform pedagogies and practices in formal educational spaces. Analyses in this book have revealed but a few of the many features of online fan fiction that youth find compelling, such as the freedom to explore topics that are relevant to their lives, the authentic use of language in a highly networked and interactive

environment, the authentic use of technology to share knowledge and to form social connections, and the potential and power to shape and transform the writing space, all of which seem to provide ELLs with a strong impetus to read, compose, and interact in the fan community. Thus, I would like to propose that one of the real values of fan fiction spaces is not just for teaching young people, but it's also for listening to and learning from them and the activities that are consequential for them in their lifeworlds.

Popular culture does not carry the official capital that is "socially and insti-tutionally legitimated" and typically associated with academic and economic success (Fiske, 1992, p. 33). In fact, media texts that provide the initial fodder for fan fiction are often derided for being "lowbrow" forms of entertainment, dismissed as vacuous, and/or censored for violence and other explicit content. Many schools have even gone so far as to ban popular cultural artifacts because they are seen as a distraction and a frivolous waste of time. Such dismissals and indictments can serve to further alienate struggling and/or marginalized stu-dents who rely on such unofficial cultural capital in their social exchanges. However, in pop culture dominated spaces such as FFN, the expertise of a thir-teen-year-old ELL honed through playing video games or watching anime often trumps that of the adults or even the university professors participating in these sites. Thus, as Fiske (1992) points out, such fan spaces provide a means for stu-dents who are marginalized within the mainstream school community to display their expertise and abilities in a public forum.

> Fandom offers ways of filling cultural lack and provides the social prestige and self-esteem that go with cultural capital. As with economic capital, lack cannot be measured by objective means alone, for lack arises when the amount of capital possessed falls short of that which is desired or felt to be merited. Thus a low achiever at school will lack official cultural capital and the social, and therefore self-esteem that it brings. Some may well become fans, often of a musician or sports star, and through fan knowledge and appreciation, acquire an unofficial cultural capital that is a major source of self-esteem among the peer group. (Fiske, 1992, p. 33)

Furthermore, as Dyson (1997) argues, to disregard popular culture puts schools at risk for "reinforcing societal divisions in children's orientations to each other, to cultural art forms, and, to school itself" (p. 181). Such dismissals may also prevent educators and researchers from recognizing potential intersections between the learning and interactions going on in popular cultural realms and affinity spaces, and the sort of learning and abilities that are becoming increasingly more valuable in schools, social life, and contemporary workplaces.

The study of indigenous online writing communities such as FFN can yield useful insights into how technology and networked computer environments might be used to foster the development of classroom affinity spaces where

learners are engaged in learning activities that scaffold the active production and negotiation of meaning through language. Participation in such sites of learning can help ELLs move beyond mechanical aspects of decoding and encoding in the target language and instead provide them with access to the sort of discourse competence that will help them achieve what Chun and Plass (2000) call the "ultimate goal" of becoming literate in another language. This goal, according to the authors, is "to be able to successfully express one's own ideas and to comprehend the thoughts of others" (p. 153). Such studies can also yield nuanced understandings of how the genre of online fan fiction offers a range of multimodal, intertextual, and hybrid writing activities in which ELLs are able to draw on personal, academic, and community resources to express their ideas and to communicate with others in English while at the same time developing essential digital literacy and/or twenty-first century skills.

By maintaining an emphasis on the social nature of literacy and learning and exploring the possibilities that online spaces and new media and ICTs have to offer, educators may be able to develop safe, accessible environments for ELLs and struggling writers to take risks and experiment with new genres of composition and text-based forms of interaction. Also, by highlighting the social and interactive nature of literacy in this space, this study also addresses a larger question in education research—that of how to make literacy instruction relevant for students and their everyday lives. Bringing issues of innovation, identity, and the social to the forefront of the discussion shifts the focus away from a model in which reading and writing are viewed either as subject areas or as vehicles for learning content to a perspective where language, literacy, and text are seen as integral components of how adolescents construct and maintain their sense of place, identity, and value in our rapidly changing and continuously updated social and academic worlds.

Bibliography

Allen, K., & Ingulsrud, J. (2003). Manga literacy: Popular culture and the reading habits of Japanese college students. *Journal of Adolescent & Adult Literacy*, 46 (8), 674–683.

Allison, A. (2004). Cuteness as Japan's millennial product. In J. Tobin (Ed.), *Pikachu's global adventure: The rise and fall of Pokémon* (pp. 34–49). Durham, NC: Duke University Press.

Alvermann, D. E. (Ed.). (2002). *Adolescents and literacies in a digital world*. New York: Peter Lang.

———., & Hagood, M. (2000). Fandom and critical media literacy. *Journal of Adolescent & Adult Literacy*, 43, 436–446.

———., Moon, J. S., & Hagood, M. C. (1999). *Popular culture in the classroom: Teaching and researching critical media literacy*. Newark, DE: International Reading Association.

———., & Phelps, S. (2002). *Content reading and literacy: Succeeding in today's diverse classrooms*. Boston: Allyn & Bacon.

Appadurai, A. (Ed.). (2001). *Globalization*. Durham, NC: Duke University Press.

Atkinson, D. R., Morten, G., & Sue, D. W. (1983). *Counseling American minorities: A cross-cultural perspective*. Dubuque, IA: Wm. C. Brown.

Atwell, N. (1998). *In the middle: New understandings about writing, reading, and learning*. Portsmouth, NH: Boynton/Cook.

Bacon-Smith, C. (1992). *Enterprising women: Television fandom and the creation of popular myth*. Philadelphia, PA: University of Pennsylvania Press.

Bakhtin, M. M. (1981). *The dialogic imagination: Four essays by M.M. Bakhtin*. M. Holquist (Ed.), M. Holquist & C. Emerson (Trans.). Austin, TX: University of Texas Press.

Baym, N. (1995). The performance of humor in computer-mediated communication. *Journal of Computer-Mediated Communication*, 1 (2), Retrieved January 12, 2008, from http://jcmc.indiana.edu/vol1/issue2/baym.html.

———. (1996). Agreements and disagreements in a computer-mediated discussion. *Research on Language and Social Interaction*, 29 (4), 315–345.

Bekerman, Z., & Silberman-Keller, D. (2004). Non-formal pedagogy: Epistemology, rhetoric, and practice. *Education and Society*, 22 (1), 45-63.

Bhabha, H. K. (1994). The third space. In J. Rutherford (Ed.), *Identity, community, culture, difference* (pp. 207–221). London: Lawrence & Wishart.

Black, R. W. (2005). Access and affiliation: The literacy and composition practices of English language learners in an online fanfiction community. *Journal of Adolescent & Adult Literacy*, 49 (2), 118–128.

———. (2006). Language, culture, and identity in online fanfiction. *E-Learning*, 3 (2), 170–184.

——. (2007). Digital design: English language learners and reader reviews in online fanfiction. In M. Knobel & C. Lankshear (Eds.), *A new literacies sampler*. New York: Peter Lang.

——., & Steinkuehler, C. (in press). Literacy in virtual worlds. In L. Christenbury, R. Bomer, & P. Smagorinski (Eds.), *Handbook of adolescent literacy research*. New York: Guilford Press.

Bromley, H. (2004). Localizing Pokémon through narrative play. In J. Tobin (Ed.), *Pikachu's global adventure: The rise and fall of Pokémon* (pp. 211–225). Durham, NC: Duke University Press.

Brougère, G. (2004). How much is a Pokémon worth? In J. Tobin (Ed.), *Pikachu's global adventure: The rise and fall of Pokémon* (pp. 187–210). Durham, NC: Duke University Press.

Buckingham, D., & Sefton-Green, J. (2004). Structure, agency, and pedagogy in children's media culture. In J. Tobin (Ed.), *Pikachu's global adventure: The rise and fall of Pokémon* (pp. 12–33). Durham, NC: Duke University Press.

Burbules, N. (2004). Rethinking the virtual. *E-learning*, 1 (2), 162–183.

Busse, K. (2005). Digital get down: Postmodern boy band slash and the queer female space. In C. Malcolm & J. Nyman (Eds.), *Eroticism in American culture*. Gdansk: Gdansk University Press.

Calkins, L. M. (1994). The art of teaching writing. Portsmouth, NH: Heinemann.

Carlson, D. R. (2004). The chronology of Lydgate's Chaucer references. *The Chaucer Review*, 38 (3), 246-254.

Castells, M. (1996). *The rise of the network society. The information age: Economy, society and culture (Vol. 1)*. Malden, MA: Blackwell Publishers.

Cavanagh, A. (1999, August). Behavior in public? Ethics in online ethnography. *Cybersociology*. Retrieved January 3, 2008, from http://www.cybersociology.com/files/6_2_ethicsinonline ethnog.html.

Chandler-Olcott, K., & Mahar, D. (2003a). Adolescents' animé-inspired "fanfictions": An exploration of multiliteracies. *Journal of Adolescent & Adult Literacy*, 46, 556–566.

——., & Mahar, D. (2003b). Tech-savviness meets multiliteracies: Exploring adolescent girls' technology-mediated literacy practices. *Reading Research Quarterly*, 38, 356–385.

Cherny, L. (1995). The modal complexity of speech events in a social MUD. *Electronic Journal of Communication*, 5 (4), Retrieved January 12, 2008, from http://fragment.nl/mirror/Cherny/ The_modal_complexity.txt.

Chun, D. M., & Plass, J. L. (2000). Networked multimedia environments for second language acquisition. In M. Warschauer & M. Kern (Eds.), *Networked-based language teaching: Concepts and practice* (pp. 151–170). Cambridge: Cambridge University Press.

Cicioni, M. (1998). Male pair-bonds and female desire in fan slash writing. In C. Harris & A. Alexander (Eds.), *Theorizing fandom: Fans, subculture, and identity* (pp. 153–177). Cresskill, NJ: Hampton Press.

Clements, J., & McCarthy, H. (2001). *The anime encyclopedia: A guide to Japanese animation since 1917*. Berkeley, CA: Stone Bridge Press.

Coombe, R. J. (1998). *The cultural life of intellectual properties: Authorship, appropriation, and the law* (Post-contemporary interventions). Durham, NC: Duke University Press.

Cope, B., & Kalantzis, M. (1993). *The powers of literacy: A genre approach to teaching writing*. Pittsburgh: University of Pittsburgh Press.

——., & Kalantzis, M. (2000). *Multiliteracies: Literacy learning and the design of social futures*. London: Routledge.

Crawford, B. (1996). Emperor tomato-ketchup: Cartoon properties from Japan. In M. Broderick

(Ed.), *Hibakusha cinema: Hiroshima, Nagasaki and the nuclear image in Japanese film* (pp. 75–90). New York: Kegan Paul International.

Daiute, C. (2000). Writing and communication technologies. In R. Indrisano & J. R. Squire (Eds.), *Perspectives on writing: Research, theory, and practice* (pp. 251–276). Newark, DE: International Reading Association. Retrieved December 6, 2006, from http://www.readingonline.org/ research/daiute_excerpt/index.html.

Derecho, A. (2006). Archontic literature: A definition, a history, and several theories of fan fiction. In K. Hellekson & K. Busse (Eds.), *Fan fiction and fan communities in the age of the Internet* (pp. 61–78). Jefferson, NC: McFarland.

Drazen, P. (2002). *Anime explosion!: The what? why? and wow of Japanese animation*. Berkeley, CA: Stone Bridge Press.

Dyson, A. H. (1997). *Writing superheroes: Contemporary childhood, popular culture, and classroom literacy*. New York: Teachers College Press.

Eng, L. (2001a). *The politics of otaku*. Retrieved April 24, 2005, from http://www.cjas.org/ ~leng/otaku-p.htm.

——. (2001b). *The current status of "otaku" and Japan's latest youth crisis*. Retrieved May 1, 2005, from http://www.cjas.org/~leng/hikiko.htm.

——. (2002). *Otak-who? Technoculture, youth, consumption, and resistance: American representations of a Japanese youth subculture*. Retrieved May 1, 2005, from http://www.rpi.edu/~engl/otaku.pdf.

Fairclough, N. (2003). *Analyzing discourse: Textual analysis for social research*. London: Routledge.

Fanfiction Glossary. (2006). *Songfiction*. Retrieved January 15, 2006, from http://www.subreality. com/glossary/terms.htm#S.

Fiske, J. (1992). The cultural economy of Fandom. In L. Lewis (Ed.), *The adoring audience: Fan culture and popular media* (pp. 33–49). New York: Routledge.

Freeman, D. A., & Freeman, Y. S. (1994). *Between worlds: Access to second language acquisition*. Portsmouth, NH: Heinemann.

Freiberg, F. (1996). Akira and the postnuclear sublime. In M. Broderick (Ed.), *Hibakusha cinema: Hiroshima, Nagasaki and the nuclear image in Japanese film* (pp. 91–102). New York: Kegan Paul International.

Freire, P., & Macedo, D. (1987). *Literacy: Reading the word and the world*. Westport, CT: Bergin & Garvey.

Fujimoto, Y. (1991). A life-size mirror: Women's self-representation in girls' comics. *Review of Japanese Culture and Society*, 4, 53–57.

Gay, G. (1985). Implications of the selected models of ethnic identity development for educators. *Journal of Negro Education*, 54, 43–55.

Gee, J. P. (1986). Units in the production of narrative discourse. *Discourse Processes*, 9, 391–422.

——. (1996). *Social linguistics and literacies: Ideology in discourses*. London: Taylor and Francis.

——. (1999). *An introduction to discourse analysis*. London: Routledge.

——. (2001). Identity as an analytic lens for research in education. In W. G. Secada (Ed.), *Review of Research in Education* (Vol. 25, pp. 99–126). Washington, D.C.: American Educational Research Association.

——. (2003). *What video games have to teach us about learning and literacy*. New York: Palgrave Macmillan.

——. (2004a). Discourse analysis: What makes it critical? In R. Rogers (Ed.), *An introduction to*

critical discourse analysis in education (pp. 19–50). Mahwah, NJ: Lawerence Erlbaum.

———. (2004b). *Situated language and learning: A critique of traditional schooling.* New York: Routledge.

Geertz, C. (1973). Interpretation of cultures. New York: Basic Books.

Gilliam, L. (2002). Gather 'round the campfire: Fanfiction.net and participatory writing. *Fanfiction Symposium.* Retrieved January 16, 2006, from http://www.trickster.org/symposium/symp95.html.

Grigsby, M. (1998). Sailormoon manga (comics) and anime (cartoon) superheroine meets Barbie: Global entertainment commodity comes to the United States. *Journal of Popular Culture,* 32 (1), 59–80.

Guerrero, M., & Villamil, O. (2000). Activating the ZPD: Mutual scaffolding in L2 peer revision. *Modern Language Journal,* 84 (1), 51–68.

Gutiérrez, K., Baquedano-López, P., & Turner, M. G. (1997). Putting language back into Language Arts: When the radical middle meets the third space. *Language Arts,* 74 (5), 368–378.

———., Rymes, B., & Larson, J. (1995). Script, counterscript, and underlife in the classroom: James Brown versus Brown v. Board of Education. *Harvard Educational Review,* 65 (3), 445–471.

Guzzetti, B. J., & Gamboa, M. (2005). Online journaling: The informal writings of two adolescent girls. *Research in the Teaching of English,* 40, 168–206.

Halliday, M. A. K., & Matthiessen, C. M. I. M. (2004). *An introduction to functional grammar (3rd revised edition of Halliday's Introduction to functional grammar).* London: Hodder Arnold.

Hammerberg, D. (2001). Reading and writing hypertextually: Children's literature, technology, and early writing instruction. *Language Arts,* 78 (3), 207–216.

Harklau, L. (2007). The adolescent English language learner: Identities lost and found. In J. Cummings & C. Davison (Eds.), *Handbook of English language teaching* (pp. 574-588). New York: Springer.

Heath, S. B. (1983). *Ways with words: Language, life and work in community and classrooms.* Cambridge, MA: Harvard University Press.

Hicks, D. (2002). *Reading lives: Working class children and literacy learning.* New York: Teachers College Press.

Hine, C. (2000). *Virtual ethnography.* Thousand Oaks, CA: Sage.

Hirst, E. (2004). Diverse social contexts of a second-language classroom and the construction of identity. In K. M. Leander & M. Sheehy (Eds.), *Spatializing literacy research and practice* (pp. 39–66). New York: Peter Lang.

Howey, K., & Zimpher, N. (1989). Preservice teacher educators' role in programs for beginning teachers. *Elementary School Journal,* 89, 450–470.

Hull, G., & Schultz, K. (2002). *School's out: Bridging out-of-school literacies with classroom practice.* New York: Teachers College Press.

International Reading Association. (2001). *Integrating literacy and technology in the curriculum: A position statement of the International Reading Association.* Retrieved January 12, 2008, from http://www.reading.org/downloads/positions/ps1048_technology.pdf.

Ito, K. (1994). Images of women in weekly male comic magazines in Japan. *Journal of Popular Culture,* 27 (4), 81–95.

———. (2003). Japanese ladies' comics as agents of socialization: The lessons they teach. *International Journal of Comic Art,* 5, 425–436.

——. (2005). A history of manga in the context of Japanese culture and society. *Journal of Popular Culture*, 38, 456–475.

Ito, M. (2001). *Technologies of the childhood imagination: Media mixes, hypersociality, and recombinant cultural form.* Paper presented at the Society for the Social Studies of Science meeting, Boston, MA. Retrieved April 25, 2005, from http://www.itofisher.com/mito/archives/techno imagination.pdf.

Iwabuchi, K. (2004). How Japanese is Pokémon? In J. Tobin (Ed.), *Pikachu's global adventure: The rise and fall of Pokémon* (pp. 53–79). Durham, NC: Duke University Press.

Jeffres, L. W. (1983). Communication, social class, and culture. *Communication Research*, 10 (2), 220–246.

Jenkins, H. (1992). *Textual poachers: Television, fans, and participatory culture.* New York: Routledge.

——. (2004). Why Heather can write. *Technology Review.* Retrieved September 28, 2005, from http://www.technologyreview.com/articles/04/02/wo_jenkins020604.asp?p=1.

——. (2006). *Convergence culture: Where old and new media collide.* New York: New York University Press.

——. McPherson, T., & Shattuc, J. (Eds.). (2003). *Hop on pop: The politics and pleasures of popular culture.* Durham, NC: Duke University Press.

Jones, Q. (1997). Virtual-communities, virtual settlements & cyber-archaeology: A theoretical outline. *Journal of Computer-Mediated Communication*, 3 (3), Retrieved Janauary 12, 2008 from, http://jcmc.indiana.edu/vol3/issue3/jones.html.

Kalantzis, M., & Cope, B. (2000). Changing the role of schools. In B. Cope & M. Kalantzis (Eds.), *Multiliteracies: Literacy learning and the design of social futures* (pp. 121–148). London: Routledge.

Karpovich, A. I. (2006). The audience as editor: The role of beta readers in online fan fiction communities. In K. Hellekson & K. Busse (Eds.), *Fan fiction and fan communities in the age of the Internet* (pp. 171–188). Jefferson, NC: McFarland.

Katsuno, H., & Maret, J. (2004). Localizing the Pokémon TV series for the American market. In J. Tobin (Ed.), *Pikachu's global adventure: The rise and fall of Pokémon* (pp. 80–107). Durham, NC: Duke University Press.

Keunen, B. (2000). Bakhtin, genre formation, and the cognitive turn: Chronotopes as memory schemata. In *CLC Web: Comparative Literature and Culture: A WWWeb Journal.* Retrieved February 27, 2006, from http://clcwebjournal.lib.purdue.edu/clcweb00-2/keunen00.html.

Kinsella, S. (1998). Amateur manga subculture and the otaku panic. *Journal of Japanese Studies*, Summer, 289–316.

——. (2000). *Adult manga: Culture and power in contemporary Japanese society.* Honolulu, HI: University of Hawai'i Press.

Kustritz, A. (2003). Slashing the romance narrative. Journal of American Culture, 26, 371–384.

Labbo, L. D., Reinking, D., & McKenna, M. C. (1998). Technology and literacy education in the next century: Exploring the connection between work and schooling. *Peabody Journal of Education*, 73 (3&4), 273–289.

Lai, C. S. L., & Dixon, H. W. W. (2001). Japanese comics coming to Hong Kong. In B. Harumi & S. Guichard-Anguis (Eds.), *Globalizing Japan: Ethnography of the Japanese presence in Asia, Europe, and America* (pp. 111–120). London: Routledge.

Lam, W. S. E. (2000). Literacy and the design of the self: A case study of a teenager writing on the

Internet. *TESOL Quarterly*, 34, 457–482.

——. (2004). Second language socialization in a bilingual chat room: Global and local considerations. *Language Learning and Technology*, 8 (3), 44–65. Retrieved January 15, 2005, from http://llt.msu.edu/vol8num3/lam/.

——. (2006). Re-envisioning language, literacy, and the immigrant subject in new mediascapes. *Pedagogies: An International Journal*, 1 (3): 171–195. Retrieved January 3, 2008, from http://www.sesp.northwestern.edu/docs/publications/42746077444b48507d46af.pdf.

Lamb, P. F., & Veith, D. L. (1986). Romantic myth, transcendence, and Star Trek zines. In D. Palumbo (Ed.), *Erotic universe: Sexuality and fantastic literature* (pp. 235–255). New York: Greenwood.

Lankshear, C. (1999). Literacy studies in education. In M. Peters (Ed.), *After the disciplines*. Westport, CT: Greenwood Press. Retrieved February 12, 2006, from http://www.geocities.com/c.lankshear/literacystudies.html.Lankshear, C., & Knobel, M. (2002). Do we have your attention? New literacies, digital technologies and the education of adolescents. In D. Alvermann (Ed.), Adolescents and literacies in a digital world (pp. 19-39). New York: Peter Lang.

——., & Knobel, M. (2003). *New literacies: Changing knowledge and classroom learning*. Philadelphia, PA: Open University Press.

——., & Knobel, M. (2004). *New literacies: Research and social practice*. Plenary Address Paper presented at the Annual Meeting of the National Reading Conference. Retrieved May 3, 2005, from http://www.geocities.com/c.lankshear/nrc.html.

——., & Knobel, M. (2006). *New literacies: Changing knowledge and classroom learning (2nd ed.)*. Philadelphia, PA: Open University Press.

Lave, J., & Wenger, E. (1991). *Situated learning: Legitimate peripheral participation*. Cambridge: Cambridge University Press.

Leander, K. (2004). Reading the spatial histories of positioning in a classroom literacy event. In

K. M. Leander & M. Sheehy (Eds.), *Spatializing literacy research and practice* (pp. 115–142). New York: Peter Lang.

——., & McKim, K. K. (2003). Tracing the everyday "sitings" of adolescents on the Internet: A strategic adaptation of ethnography across online and offline spaces. *Education, Communication, & Information*, 3, 211–240.

——., & Sheehy, M. (Eds.). (2004). *Spatializing literacy research and practice*. New York: Peter Lang.

Ledden, S., & Fejes, F. (1987). Female gender role patterns in Japanese comic magazines. *Journal of Popular Culture*, 21, 155–176.

Ledoux, T. (Ed.). (1997). *Anime interviews: The first five years of Animerica Anime & Manga Monthly (1992–1997)*. San Francisco, CA: Viz Communications.

Ledoux, T., & Ranney, D. (1997). *The complete anime guide*. Issaquah, WA: Tiger Mountain Press.

Lemish, D., & Bloch, L. R. (2004). Pokémon in Israel. In J. Tobin (Ed.), *Pikachu's global adventure: The rise and fall of Pokémon* (pp. 165–186). Durham, NC: Duke University Press.

Lemke, J. (2004). *Learning across multiple places and their chronotopes*. Paper presented at the Annual Meeting of the American Educational Research Association, San Diego, CA.

——. (2005). Critical analysis across media: Games, franchises, and the new cultural order. In M. Labarto Postigo (Ed.), *Approaches to critical discourse analysis*. Valencia: University of Valencia (CD ROM edition).

Leonard, S. (2004). *Progress against the law: Fan distribution, copyright, and the explosive growth of Japanese animation*. Cambridge, MA: Massachusetts Institute of Technology.

Levi, A. (1996). *Samurai from outer space: Understanding Japanese animation*. Chicago: Open Court.

Levy, F., & Murnane, R. J. (2004). *The new division of labor: How computers are creating the next job market*. New York: Sage University Press.

Lewis, C., & Fabos, B. (2005). Instant messaging, literacies, and social identities. *Reading Research Quarterly*, 40 (4), 470–501.

Luke, C. (2000). Cyber-schooling and technological change: Multiliteracies for new times. In B. Cope & M. Kalantzis (Eds.), *Multiliteracies: Literacy learning and the design of social futures* (pp. 69–91). London: Routledge.

Luke, A., & Carrington, V. (2002). Globalisation, literacy, curriculum practice. In R. Fisher, M. Lewis, & G. Brooks (Eds.), *Language and literacy in action*. London: Routledge/Falmer. Retrieved October 25, 2007, from http://wwwfp.education.tas.gov.au/English/luke3.htm.

Marcus, G. E. (1995). Ethnography in/of the world system: The emergence of multi-sited ethnography. *Annual Review of Anthropology*, 24, 95–117.

Matsui, M. (1993). Little girls were little boys: Displaced femininity in the representation of homosexuality in Japanese girls' comics. In S. Gunew & A. Yeatman (Eds.), *Feminism and the politics of difference* (pp. 177–196). St. Leonards, Australia: Allen & Unwin.

McCardle, M. (2003). Fanfiction, fandom, and fanfare: What's all the fuss? *BostonUniversity Journal of Science Technology & Law*, 9 (2). Retrieved May 1, 2005, from http://www.bu.edu/law/scitech/volume9issue2/McCardleWebPDF.pdf.

McCarthy, H. (1996). *The anime! movie guide*. Woodstock, NY: Overlook Press.

McCarthey, S. J., & Moje, E. B. (2002). Identity matters. *Reading Research Quarterly*, 37 (2), 228–238.

McLelland, M. (2000a). Male homosexuality and popular culture in modern Japan. *Intersections*, 3. Retrieved March 23, 2005, from http://wwwsshe.murdoch.edu.au/intersections/issue3/mclelland2.html.

———. (2000b). No climax, no point, no meaning? Japanese women's boy love sites on the Internet. *Journal of Communication Inquiry*, 24, 274–291.

Merchant, G. (2001). Teenagers in cyberspace: An investigation of language use and language change in Internet chatrooms. *Journal of Research in Reading*, 24 (3), 293–306.

Merchant, G. (2006). Identity, social networks and online communication. *E-Learning*, 3 (2), 235–244.

Mitra, A. (1997). Virtual commonality: Looking for India on the Internet. In S. G. Jones (Ed.), *Virtual culture: Identity and communication in cybersociety* (pp. 55–79). Thousand Oaks, CA: Sage.

———. (1999). Characteristics of the WWW text: Tracing discursive strategies. *Journal of Computer-Mediated Communication*, 5 (1), Retrieved January 12, 2008 from, http://jcmc.indiana.edu/vol5/issue1/mitra.html.

Moje, E., Willes, D., & Fassio, K. (2001). Constructing and negotiating literacy in a writer's workshop: Literacy teaching and learning in the seventh grade. In E. Moje & D. O'Brien (Eds.), *Constructions of literacy: Studies of teaching and learning in and out of schools*. Mahwah, NJ: Lawrence Erlbaum.

Morris-Suzuki, T., & Rimmer, P. (2002). Virtual memories: Japanese history debates in manga and cyberspace. *Asian Studies Review*, 26, 147–164.

Napier, S. J. (1993). Panic sites: The Japanese imagination of disaster from Godzilla to Akira.

Journal of Japanese Studies, 19, 327–351.

——. (1998). Vampires, psychic girls, flying women and sailor scouts: Four faces of the young female in Japanese popular culture. In D. Martinez (Ed.), *The worlds of Japanese popular culture: Gender, shifting boundaries and global cultures* (pp. 91–109). Cambridge: Cambridge University Press.

——. (2001). *Anime: From Akira to Princess Mononoke: Experiencing contemporary Japanese animation.* New York: Palgrave.

New London Group. (1996). A pedagogy of multiliteracies: Designing social futures. *Harvard Educational Review*, 66, 60–92.

Newitz, A. (1994). Anime otaku: Japanese animation fans outside of Japan. *Bad Subjects,* 13. Retrieved May 1, 2005, from http://bad.eserver.org/issues/1994/13/newitz.html.

——. (1995). Magical girls and atomic bomb sperm: Japanese animation in America. *Film Quarterly*, 49 (1), 2–15.

Newkirk, T. (2000). Misreading masculinity: Speculations on the great gender gap in writing. *Language Arts*, 77 (4), 294–300.

——. (2002). *Misreading masculinity: Boys, literacy, and popular culture.* Portsmouth, NH: Heinemann-Boynton/Cook.

Northwest Central Regional Educational Laboratory. (2003). 21st century skills: *Literacy in the digital age.* Retrieved February 15, 2007, from http://www.ncrel.org/engauge/skills/skills. htm.

Nystrand, M. (1986). *The structure of written communication: Studies in reciprocity between writers and readers.* Orlando and London: Academic Press.

——. (1997). Dialogic instruction: When recitation becomes conversation. In M. Nystrand, A. Gamoran, R. Kachur, & C. Prendergast (Eds.), *Opening dialogue: Understanding the dynamics of language and learning in the English classroom.* New York: Teachers College Press.

Ogi, F. (2001). Gender insubordination in Japanese comics (manga) for girls. In J. Lent (Ed.), *Illustrating Asia: Comics, humor magazines, and picture books* (pp. 171–186). Honolulu, HI: University of Hawai'i Press.

Orbaugh, S. (2003). Busty battlin' babes: The evolution of the shojo in 1990s visual culture. In J. Mostow, N. Bryson, & M. Graybill (Eds.), *Gender and power in the Japanese visual field* (pp. 201–228). Honolulu, HI: University of Hawai'i Press.

Pandey, R. (2000). The medieval in manga. *Postcolonial Studies*, 3 (1), 19–32.

Partnership for 21st Century Skills. (2004). *Framework Overview.* Retrieved September 30, 2007, from http://www.21stcenturyskills.org/index.php?option=com_content&task=view&id= 254 &It emid=120.

Patten, F. (2004). *Watching anime, reading manga.* Berkeley, CA: Stone Bridge Press.

Pelletier, C. J. (Ed.). (2000). *Anime: A guide to Japanese animation (1958–1988).* Montreal: Protoculture.

Penley, C. (1991). Brownian motion: Women, tactics, and technology. In C. Penley & A. Ross (Eds.), *Technoculture* (pp. 135–161). Minneapolis, MN: University of Minnesota Press.

Perper, T., & Cornog, M. (2002). Eroticism for the masses: Japanese manga comics and their assimilation into the U.S. *Sexuality & Culture*, 6 (1), 3–126.

Phinney, J. S. (1990). Ethnic identity in adolescents and adults: Review of research. *Psychological Bulletin*, 108 (3), 499–514.

Poitras, G. (1999). *The anime companion: What's Japanese in Japanese animation?* Berkeley, CA: Stone Bridge Press.

Poitras, G. (2001). *Anime essentials: Everything a fan needs to know.* Berkeley, CA: Stone Bridge Press.

Pugh, S. (2004). The democratic genre: Fanfiction in a literary context. *Refractory*, 5. Retrieved October 26, 2005, from http://www.refractory.unimelb.edu.au/journalissues/vol5/pugh .htm.

———. (2005). *The democratic genre: Fan fiction in a literary context.* Brigend, U.K.: Seren Press.

Purushotma, R. (2005). Commentary: You're not studying, you're just… *Language Learning and Technology*, 9 (1), 80-96. Retrieved December 16, 2006, from http://llt.msu.edu/vol9num1/ purushotma/default.html.

Purves, A. (1998). Flies in the web of hypertext. In D. Reinking, M. McKenna, L. Labbo, & R. Kieffer (Eds.), *Handbook of literacy and technology: Transformations in a post-typographic world* (pp. 235–251). Mahwah, NJ: Lawrence Erlbaum.

Rampton, B. (1990). Displacing the "native speaker": Expertise, affiliation and inheritance. *ELT Journal*, 44, 97–101.

Rheingold, H. (1993). *Virtual community: Homesteading on the electronic frontier.* Boston: Addison Wesley.

Robison, A. J. (2006). What videogame designers can teach literacy instructors. In R. Matzen & J. Cheng-Levine (Eds.), *Reformation: The teaching and learning of English in electronic environments.* Taipei, Taiwan: Tamkang University.

Rogers, R. (Ed.). (2004). *An introduction to critical discourse analysis in education.* Mahwah, NJ: Lawrence Erlbaum.

Rommetveit, R. (1974). *On message structure.* New York: John Wiley & Sons.

Russ, J. (1985). Magic mommas, trembling sisters, puritans and perverts: Feminist essays. Trumansburg, NY: *Crossing*. Retrieved May 1, 2005, from http://www.totse.com/en/ erotica/erotic_fiction_o_to_p/pornogra.html.

Russo, J. L. (2002). NEW VOY "cyborg sex" J/7 [NC-17] 1/1: New methodologies, new fantasies. *The Slash Reader*, August. Retrieved January 12, 2008, from http://j-l-r.org/asmic/ fanfic/print/jlr-cyborgsex.pdf.

Sabucco, V. (2003). Guided fanfiction: Western "readings" of Japanese homosexual-themed texts. In C. Berry, F. Martin, & A. Yue (Eds.), *Mobile cultures: New media in queer Asia* (pp. 70–86). Durham, NC: Duke University Press.

Scardamalia, M., & Bereiter, C. (1994). Computer support for knowledge-building communities. *Journal of the Learning Sciences*, 3 (3), 265–283.

Schodt, F. L. (1983). *Manga! manga! The world of Japanese comics.* New York: Kodansha International.

———. (1996). *Dreamland Japan: Writings on modern manga.* Berkeley, CA: Stone Bridge Press.

Scodari, C., & Felder, J. L. (2000). Creating a Pocket Universe: "Shippers," Fanfiction, and The X-Files Online. *Communication Studies*, 51, Fall. Retrieved October 26, 2005, from http://www.angelfire.com/sc3/detour_xf/infotrac___x_files_online.htm.

Scribner, S., & Cole, M. (1981). *The psychology of literacy.* Cambridge, MA: Harvard University Press.

Shiokawa, K. (1999). Cute but deadly: Women and violence in Japanese comics. In J. Lent (Ed.), *Themes and issues in Asian cartooning: Cute, cheap, mad and sexy* (pp. 93–125). Bowling Green, OH: Bowling Green State University Popular Press.

Soja, E. W. (1993). History: Geography: Modernity. In S. During (Ed.), *The cultural studies reader*

(2nd ed., pp. 133–125). New York: Routledge.

——. (2004). Preface. In K. M. Leander & M. Sheehy (Eds.), *Spatializing literacy research and practice* (pp. x–xv). New York: Peter Lang.

Somogyi, V. (2002). Complexity of desire: Janeway/Chakotay fanfiction. *Journal of American & Comparative Cultures*, Fall–Winter, 399–405.

Squire, K. D. (2002). Rethinking the role of games in education. *Game Studies*, 3 (1), Retrieved January 12, 2008, from http://www.gamestudies.org/0102/squire/.

——., & Jenkins, H. (2003). Harnessing the power of games in education. *Insight*, 3 (1), 5–33.

Steinkuehler, C. A. (2006). Massively multiplayer online videogaming as participation in a discourse. *Mind, Culture, and Activity: An International Journal*, 13 (1), 38–52.

——., Black, R. W., & Clinton, K. A. (2005). Researching literacy as tool, place, and way of being. *Reading Research Quarterly*, 40 (1), 7–12.

——., & Williams, D. (2006). Where everybody knows your (screen) name: Online games as "third places." *Journal of Computer-Mediated Communication*, 11 (4), Retrieved January 12, 2008, from http://jcmc.indiana.edu/vol11/issue4/steinkuehler.html.

Stone, J. C. (2005). Lessons on teaching writing from website design. *New Horizons for Learning*, 11 (2). Retrieved January 12, 2008, from http://www.newhorizons.org/strategies/literacy/stone.htm.

——. (2007). Popular websites in adolescents' out-of-school lives: Critical lessons on literacy. In M. Knobel & C. Lankshear (Eds.), *A new literacies sampler*. New York: Peter Lang.

Street, B. (1984). *Literacy in theory and practice*. Cambridge, MA: Harvard University Press.

Suarez-Orozco, M., & Qin-Hilliard, D. B. (Eds.). (2004). *Globalization: Culture and education in the new millennium*. Berkeley: University of California Press.

Super Cat. (1999). A (very) brief history of fanfic. *The Fanfic Symposium*. Retrieved May 1, 2005, from http://www.trickster.org/symposium/colyear.html#2003.

Swartz, E. (2003). Teaching white preservice teachers. Pedagogy for change. *Urban Education*, 38 (3), 255–627.

Thomas, A. (2004). Digital literacies of the cybergirl. *E-Learning*, 1, 358–382. Retrieved May 1, 2005, from http://www.wwwords.co.uk/pdf/viewpdf.asp?j=elea&vol=1&issue=3&year =2004&article=3_Thomas_ELEA_1_3_web&id=65.30.211.33.

——. (2005). *Positioning the reader: The affordances of digital fiction*. Paper presented at the State Conference of the Queensland Council for Adult Literacy, Brisbane, Australia.

——. (2007). Blurring and breaking through the boundaries of narrative, literacy, and identity in adolescent fan fiction. In M. Knobel & C. Lankshear (Eds.), *A new literacies sampler*. New York: Peter Lang.

Thorne, S. L. (forthcoming). Transcultural communication in open Internet environments and massively multiplayer online games. In S. Magnan (Ed.), *Mediating discourse online*. Amsterdam: John.

——., & Black, R. (forthcoming). Language and literacy development in computer-mediated contexts and communities. *Annual Review of Applied Linguistics*, 28.

Tobin, J. (2000). *Good guys don't wear hats: Children's talk about the media*. New York: Teachers College Press.

——. (Ed.). (2004). *Pikachu's global adventure: The rise and fall of Pokémon*. Durham, NC: Duke University Press.

Tobin, S. (2004). Masculinity, maturity, and the end of Pokémon. In J. Tobin (Ed.), *Pikachu's global adventure: The rise and fall of Pokémon* (pp. 241–256). Durham, NC: Duke University Press.

Tomkins, G. E. (1990). *Teaching writing: Balancing process and product.* Columbus, OH: Merrill Publishing Company.

Turkle, S. (1994). Constructions and reconstructions of self in virtual reality: Playing in the MUDs. *Mind, Culture, and Activity: An International Journal,* 1 (3), 158–167.

——. (1995). *Life on the screen.* New York: Touchstone.

Tushnet, R. (1997). Legal fictions: Copyright, fanfiction, and a new common law. *Loyola of Los Angeles Entertainment Law Journal,* 17. Retrieved May 25, 2005, from http://www.tushnet. com/legalfictions.pdf.

21st Century Workforce Commission. (June 2000). *A Nation of Opportunity Building America's 21st century workforce.* Retrieved January 12, 2008, from http://digitalcommons.ilr.cornell.edu/ cgi/viewcontent.cgi?article=1003&context=key_workplace.

U.S. Department of Education. (2001). *The condition of education: 2001.* Washington, D.C.: Author.

Vasquez, V. (2003). What Pokémon can teach us about learning and literacy. *Language Arts,* 81, 118–125.

Volker, G. (1990). *"I'm alone, but not lonely": Japanese Otaku-Kids colonize the realm of information and media.* Retrieved May 1, 2005, from http://www.cjas.org/~leng/otaku-e.htm.

Warschauer, M. (2000). On-line learning in second language classrooms: An ethnographic study. In M. Warschauer & M. Kern (Eds.), *Networked-based language teaching: Concepts and practice* (pp. 41–58). Cambridge: Cambridge University Press.

——. (2003). *Technology and social inclusion: Rethinking the digital divide.* Boston: MIT Press.

——., & Kern, R. (2000). Networked-based language teaching: Concepts and practice. Cambridge: Cambridge University Press.

Wenger, E. (1998). *Communities of practice: Learning, meaning, and identity.* Cambridge: Cambridge University Press.

Wikipedia. (2005). *Anime.* Retrieved May 1, 2005, from http://en.wikipedia.org/wiki/Anime# Genres.

——. (2006). *Fanfiction.net.* Retrieved May 1, 2005, from http://en.wikipedia.org/wiki /Fanfiction.net.

——. (2006). *Hanyu Pinyin.* Retrieved May 1, 2005, from http://en.wikipedia.org/wiki/ Hanyu_pinyin.

Willett, R. (2004). The multiple identities of Pokémon fans. In J. Tobin (Ed.), *Pikachu's global adventure: The rise and fall of Pokémon* (pp. 226–240). Durham, NC: Duke University Press.

Yano, C. R. (2004). Panic attacks: Anti-Pokémon voices in global markets. In J. Tobin (Ed.), *Pikachu's global adventure: The rise and fall of Pokémon* (pp. 108–140). Durham, NC: Duke University Press.

Yi, Y. (2005). Asian adolescents' out-of-school encounters with English and Korean literacy. *Journal of Asian Pacific Communication,* 15 (1), 57–77.

——. (2007). Engaging literacy: A biliterate student's composing practices beyond school. *Journal of Second Language Writing,* 16 (1), 23–39.

——. (in press). "Relay writing" in an adolescent online community, Welcome to Buckeye City. *Journal of Adolescent & Adult Literacy.*

Yon, D. (2000). *Elusive culture: Schooling, race, and identity in global times.* New York: State University

of New York Press.

Zuengler, J. (2003). Jackie Chan drinks Mountain Dew: Constructing cultural models of citizenship. In L. Harklau and J. Zuengler (Eds.), *Special Issue on "Popular Culture and Classroom Language Learning," Linguistics and Education*, 14 (3–4), 277–304.

Index

Colin Lankshear, Michele Knobel,
& Michael Peters
*General Editor*s

New literacies and new knowledges are being invented "in the streets" as people from all walks of life wrestle with new technologies, shifting values, changing institutions, and new structures of personality and temperament emerging in a global informational age. These new literacies and ways of knowing remain absent from classrooms. Many education administrators, teachers, teacher educators, and academics seem largely unaware of them. Others actively oppose them. Yet, they increasingly shape the engagements and worlds of young people in societies like our own. The *New Literacies and Digital Epistemologies* series will explore this terrain with a view to informing educational theory and practice in constructively critical ways.

For further information about the series and submitting manuscripts, please contact:

> Michele Knobel & Colin Lankshear
> Montclair State University
> Dept. of Education and Human Services
> 3173 University Hall
> Montclair, NJ 07043
> michele@coatepec.net

To order other books in this series, please contact our Customer Service Department at:

> (800) 770-LANG (within the U.S.)
> (212) 647-7706 (outside the U.S.)
> (212) 647-7707 FAX

Or browse online by series at:

> www.peterlang.com